MAPPING

COLUMBIA BOOKS ON ARCHITECTURE AND THE CITY

MALCOLM

EDITED BY NAJHA ZIGBI-JOHNSON

MEDITATIONS

NAJHA
ZIGBI-JOHNSON

ON
MALCOLM

NAJHA ZIGBI-JOHNSON is an independent writer and cultural curator. She currently teaches political science at the Macaulay Honors College at the City College of New York. Zigbi-Johnson was formerly the Director of Institutional Advancement at The Malcolm X and Dr. Betty Shabazz Memorial and Educational Center. She holds a BS and MTS in African and African American comparative religious histories from Guilford College and Harvard Divinity School, and was a 2021–2022 Community Fellow at the Graduate School of Architecture, Planning, and Preservation at Columbia University. She was raised in and currently resides in Harlem.

Right before the sun sets over the Hudson River, it vibrates across the windows that line the corner of the Audubon Ballroom. The second floor is bathed in a warm orange glow and everything feels still before the sun dips below the horizon and the blackness of night drapes 165th Street and Broadway. These were some of my favorite moments in the Audubon Ballroom, alone with all that history and light.

NAJHA ZIGBI-JOHNSON

In these moments, I'd imagine the heavy drapery and wooden stage once at the front of the Ballroom. I'd imagine all the chairs in rows, and the Black faces tilted up, pulled toward Malcolm. And Malcolm would stand tall, with his feet planted firmly as he painted new worlds full of dignity, beauty, and possibility. Malcolm X had this cosmic energy that seemed to collapse space and time. These visions often feel like a conjuring of spirit. Maybe that is why being in the Ballroom always felt electrifying and unnerving. I have yet to make full sense of my experience, working alone in the corner office on the second floor, but I do know it was those visions of Malcolm that demanded I learn to make way for more life through his memory.

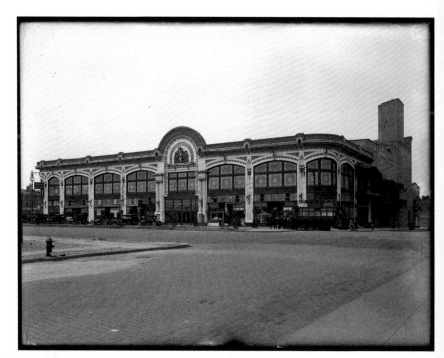

Audubon Ballroom, 3490 Broadway at West 165th Street, New York City, 1917. Photograph by William D. Hassler. Courtesy of William D. Hassler photograph collection, PR 083, New-York Historical Society. Photography © New-York Historical Society.

X

I grew up in central Harlem on Malcolm X Boulevard, just two blocks from Muhammad Mosque No. 7, where members of the Nation of Islam (NOI) still sell bean pies and copies of the *Final Call*.[1] Nearly four decades separate my childhood in Harlem from Malcolm's last year of life. And yet Malcolm feels so close. Some of my earliest memories of Malcolm X have to do with passing that mosque, which was built in the wake of his assassination in 1965.[2] For as long as I have lived, Malcolm's presence has been ubiquitous across Harlem. I am not sure it ever registered to me as a kid that Malcolm was dead—in that he was not alive in corporeal form. Beyond this literal and arguably limited configuration of death, Malcolm has always been alive in Harlem; his presence, politics, and spirit continues to reshape the neighborhood through a new spatial framework.

All along the Harlem corridor of Sixth Avenue, from 110th to 146th Street, there are Malcolm X Boulevard signs. Whether by name, image, or association, Malcolm animates the street. On the corner of 125th Street and old Broadway is a mural of him and the late anti-imperial organizer Yuri Kochiyama, with whom he shared a deep kinship. It graces the side of the old soul food restaurant and nightclub Concerto West, across from the Manhattanville Projects, where Yuri lived with her family. On the mural is a quote of Malcolm's that reads, "The only way we'll get freedom is to identify ourselves with every oppressed peoples in the world." In middle school I took summer enrichment classes atop the Hotel Theresa, some floors above where Malcolm and Fidel Castro

[1] The *Final Call* is the official newspaper for the Nation of Islam. It was founded in 1979 by Minister Louis Farrakhan.

[2] In 1946, the original Temple No. 7 (now Muhammad Mosque No. 7) was first founded at the Harlem-branch YMCA on 135th Street between Lenox and Seventh Avenue, and then moved to the Lenox Casino at 102 West 116th Street on the corner of Lenox Avenue upon Malcolm X being officially named minister by Elijah Muhammad ten years later. Shortly after Malcolm's assassination, the Temple was destroyed in a bombing, forcing the NOI to move the Mosque to 106 West 127th Street.

13

NAJHA ZIGBI-JOHNSON

once shared stories of solidarity and struggle. It is said that Malcolm helped arrange for Castro and his cabinet to stay there during a 1960 visit to the United Nations.[3] Later, the hotel would become one of the meeting points for Malcolm's political group, The Organization of Afro-American Unity (OAAU), as well as for numerous Third World leaders and members of the Black elite who remained shut out of downtown Manhattan, which enforced its own poisonous form of social, political, and economic racism. Outside my apartment building is a plaque commemorating the old Harlem-based restaurant 22 West, which Malcolm referred to as his "home away from home," and where Civil Rights leaders and everyday people congregated and broke bread over salmon cakes and collard greens.

3
Rosemari Mealy, *Fidel and Malcolm: Memories of a Meeting* (Baltimore: Black Classic Press, 2013); and Joy James, "Review / Harlem Hospitality and Political History: Malcolm X and Fidel Castro at the Hotel Theresa," *Contributions in Black Studies: Journal of African and Afro-American Studies* 12, no. 1 (1994): 107–110.

Before I was ever old enough to read Alex Haley's *The Autobiography of Malcolm X* or watch Spike Lee's 1992 epic, this was how I learned of Malcolm—through the Harlem cityscape and the collection of markers, memorials, and social infrastructures consecrating our history in a country that otherwise actively works to erase Black consciousness from the American psyche. It is Harlem that taught me about Malcolm—about his brilliance, beauty, and swagger. It is Harlem that gave me Malcolm the ordained orator alongside Malcolm the dreamer, the scholar, the father, husband, and comrade to the globe who was so in touch with his humanity that even death could not have the final word. Malcolm's vision and spirit remain etched in city street names, window signs, and buildings, injecting my neighborhood with a revolutionary fervor that grates against the years of structural racism codified into law and practice. In this way, Malcolm is in the best of Harlem, and also in the most difficult parts. His humanitarian and activist-oriented ethos echoes out from

the gentrified developments unconcerned with the histories they erase as they encroach upon land once animated by Black businesses and dynamic community-based ecosystems of mutual aid and support. But even so, Harlem insists that we know who we are, and from where we come.

In the words of Habiba Ibrahim and Badia Ahad, "Time is at once drawn out and compressed."[4] In so many ways, the parameters of Black life continue to be informed by a particular historical framework rooted in the violence of chattel slavery and its afterlife, manifested in the anti-Black carceral state, in discriminatory housing practices, and in economic apartheid as evinced by the legacies of redlining that have reshaped communities like Harlem across the United States. To better understand this temporal frame, I continue to return to the work of Saidiya Hartman, whose seminal book *Lose Your Mother: A Journey Along the Atlantic Slave Route* traces the history of the slave trade and, in doing so, conceives of a new, Black diasporic temporality. "History doesn't unfold with one era bound to and determining the next in an unbroken chain of causality," Hartman writes. Instead, it continues to unfold in the absence of freedom, creating a temporal register not bound to forward moving time. "So the point isn't the impossibility of escaping the stranglehold of the past," she writes, "or that history is a succession of uninterrupted defeats, or that the virulence and tenacity of racism is inexorable. But rather that the perilous conditions of the present establish the link between our age and a previous one in which freedom too was yet to be realized."[5] Through

4
Habiba Ibrahim and Badia Ahad, introduction to "Black Temporality in Times of Crisis," special issue, *South Atlantic Quarterly* 121, no. 1 (January 2022): 3.

5
Saidiya Hartman, *Lose Your Mother: A Journey Along the Atlantic Slave Route* (New York: Farrar, Straus and Giroux, 2017), 133.

15

Hartman's work, I have come to see how the present continues to be informed by slavery's proximate past. For me, this understanding of Black temporality helps to situate the continued relevance of Malcolm's political analysis that, at its core, was most concerned with dismantling white supremacy, settler colonialism, and racial capitalism as the means to realizing Black self-determination.[6] And, like Hartman, my personal experiences, ancestral assemblages, and social location inform the scholarship I seek to produce, which in turn becomes its own self-reflective methodology. In learning about Malcolm, I deepen my own capacity to connect with the most elemental parts of humanity that affirm the interconnected nature of our world.

It is precisely because we remain in a continued struggle for liberation that Malcolm's global analysis remains so significant. It helps us see not just across time but also across borders, political geographies, and global struggles, and in doing so has brought forth new possibilities for social and spatial transformation. In this way, Malcolm's anti-imperial vision of liberation continues to shape the political, visual, sonic, and poetic vernaculars of our contemporary freedom movements both in and far beyond Harlem. Many of Malcolm's speeches throughout his public career reflect this awareness of the unchanging and, at best, incremental nature of structural change in the United States.

On July 5, 1964, during his second official speech addressed to his newly formed Pan-Africanist, Harlem-based political group, the OAAU, Malcolm spoke out in disdain against the virtue signaling of the 1964 Civil Rights Act, which legally outlawed Jim Crow discrimination. He remained concerned with the violent racism that con-

6
I remain moved by the work of the late James H. Cone, whose revelations in *A Black Theology of Liberation* continue to inform my understanding of the human being as endowed with inherent freedom. In the chapter "The Human Being in Black Theology," Cone writes, "To be human is to be free, and to be free is to be human. The liberated, the free, are the ones who define the meaning of their being in terms of the oppressed of the land by participating in their liberation, fighting against everything that opposes integral humanity. Only the oppressed are truly free." This sentiment animates my understanding of and commitment to Black self-determination as essential and indispensable to being in possession of our full humanity as a people. James H. Cone, "The Human Being in Black Theology," in *A Black Theology of Liberation* (Maryknoll, NY: Orbis Books, 2015), 92–93.

16

tinued throughout the United States, despite tremendous efforts made possible by the work of Black organizers and everyday people who mobilized across the American South for decades in pursuit of structural change. Instead, Malcolm called for a type of political and intellectual vigilance that would help Black Americans discern the facade of racial progression and pointed to the recent lynching of a fourteen-year-old Black boy in Georgia, alongside the institutional forms of discriminatory job practices that continued across New York City, as examples of the act's inefficacy. Malcolm likened the political actors in Washington, DC, at that time to plantation bosses across the Antebellum South, declaring,

Prior to one hundred years ago, they didn't need tricks. They had chains. And they needed the chains because you and I hadn't yet been brainwashed thoroughly enough to submit to their brutal acts of violence submissively. Prior to a hundred years ago, you had men like Nat Turner, that Brother Benjamin was talking about, and others, Toussaint L'Ouverture. None of them would submit to slavery. They'd fight back *by any means necessary.*[7] And it was only after the spirit of the Black man was completely broken and his desire to be a man was completely destroyed, then they had to use different tricks. They just took the physical chains from his ankles and put them on his mind. And from then on, the type of slavery that you and I have been experiencing, we've been kept in it, year in and year out, by a change of tricks. Never do they

7
Pausing here as I am reminded of an event hosted by Columbia GSAPP, where Sandi Hilal, of Decolonizing Architecture, commented on how it is only permissable to talk, write, imagine, teach, and advocate for decolonization in the past and future but not in the present. In many ways, this sentiment extends to how we have come to understand—culturally—the idea of "by any means necessary." Why are acts of resistance, "by any means necessary" demonized in the present? Perhaps the cultural demonization of violent, decolonial struggle should be connected to this question of time. What would it mean to instead understand the present, the now, through Black diasporic temporalities? Like Malcolm, Hilal affirms the urgency of decoloniality within our lifetime, and not simply as a theoretical abstraction posited in the future. "Columbia GSAPP Affirmations: Sandi Hilal, Alessandro Petti, and Denise Ferreira da Silva," Graduate School of Architecture, Planning, and Preservation, Columbia University, presented virtually via Zoom, December 4, 2023, 1:10:50 to 1:12:00, https://www.youtube.com/watch?v=Hm45czItVko.

17

NAJHA ZIGBI-JOHNSON

change our condition or the slavery. They only change the tricks.[8]

While Malcolm is often cast in opposition to the leaders and tactics of the Civil Rights movement, it was more specifically the progressive facade of its associated legislation, which failed to change the material conditions of Black life, that Malcolm detested. It was also his belief that nonviolence represented a type of political and ethical neutrality that could not be accepted as a legitimate response to the noxious extremism of, in his words "racialism," which stood in opposition to his moral sensibilities. The utter extremism of racial terror, economic apartheid, and second-class citizenry could not be met with defenselessness or demands for integration into a system he fundamentally eschewed.[9]

For Malcolm, time was at once stretched and compressed. He stressed that the ugliness and brutality of racism persisted despite its form, and that only the tactics used to suppress Black life had changed. The resonance of his words speaks to the ongoing crisis of structural violence and dispossession that has plagued Black life since the first Portuguese ships set sail to the Western coast of Africa nearly 600 years ago.[10]

It is indeed the many afterlives of slavery that shape my particular understanding of Black temporality as a worldview connecting Malcolm's construction of religio-political space across Harlem to the neighborhood I know today.[11] While Black

8
"Malcolm X at the Second Organization of Afro-American Unity Rally (July 5, 1964)," ICIT Digital Library, https://www.icit-digital.org/articles/malcolm-x-at-the-second-oaau-rally-july-5-1964.

9
After his final tour across Africa and the Middle East, Malcolm made his way to Oxford University in England, where he was invited to engage in the now famed debate addressing the notion that "extremism in the defense of liberty is no vice; moderation in the pursuit of justice is no virtue," which was originally declared by Republican US Senator Barry Goldwater. During this debate, Malcolm expressed much of what would come to be understood as one of his final and most complete public analyses of global solidarity and the persistence of racism, in which he situated the necessity of extreme tactics (and interracial coalition building) as "an intelligently directed" response to the extremism embedded in what he termed "racialism" (racist ideology). "Malcolm X. Oxford University Union Debate in 1964," Black History Month, https://www.blackhistorymonth.org.uk/article/video/malcolm-x-oxford-union-debate-dec-3-1964.

10
Malcolm internationalized the plight for Black American self-determination, declaring that the OAAU would bring a formal charge against the racist brutalism of the United States government to the United Nations, to be tried before the Organization of American States, the multilateral regional body focused on human rights, electoral oversight, social and economic development, and security across the Western Hemisphere.

11
Hartman, *Lose Your Mother*, 111.

temporality remains marked by persistent and interlocking systems of oppression and brutality—systems that construct the material and psychological conditions in which Black people exist—I believe it also points toward a new architecture of life that is infinite in its capaciousness for human wholeness and creative expression. In this way, I also understand Black temporality as a nonlinear time-space continuum that is registered through both our quest for freedom and the embodiment of liberation as an everyday praxis. Through this reading, Malcolm X, the freedom-fighter-turned-ancestor, remains an active agent in this world, helping to pave our way forward.

Iba Egbe Orún.
Iba Egungun.
We pay homage to our heavenly comrades.
We pay homage to our ancestors.[12]

In keeping with the wide range of African diasporic and global Indigenous religio-cultural traditions that honor the active presence of the ancestors as everyday agents in our worldmaking process, I look to the enduring wisdom of my heavenly comrades and familial ancestors as co-conspirators in our collective liberation. Historical and moral clarity, and the courage to continue forward, are made possible through their wisdom. As I write these words, I think about the collective state of grief that has enveloped so many of us in this time. And simultaneously, it is the vision of our greatest freedom fighters and love warriors like Malcolm X, Patrice Lumumba, Ella Baker, Edward Said, and

19

12
In the Yorùbá religio-spiritual tradition of Ifá, adherents recite compulsory and ritualistic oral poetry each morning as a way to honor and affirm the ancestral powers and the pantheon of Orishas that guide and affirm all aspects of sentience and human destiny. For over 5,000 years, peoples across Yorùbáland consisting of modern-day Togo, Benin, and Nigeria, alongside people across the African diaspora, have recited Ibas with the morning sun.

NAJHA ZIGBI-JOHNSON

Audre Lorde that are summoned as whole generations have taken to the streets to demand an end to occupation and genocide globally with a new political fervor triggered by the Israeli siege on Gaza in October 2023.[13] Homemade signs bearing their words are held aloft by crowds of protestors who are unflinching in their demand for "freedom, justice, and equality," the NOI edict Malcolm emphatically returned to in his many speeches and diary entries.[14] Malcolm, alongside a cadre of radical visionaries, has put forth a powerful, anti-imperialist worldview designed to offer new material, pedagogical, and psychospiritual possibilities for human wholeness. Together, their vision for a more just and sustainable world has reconfigured how we employ and carry forward a sociopolitical and cross-cultural analysis of justice and power that can serve as an everyday praxis in our personal lives and professional disciplines. As an assemblage of thoughts, memories, histories, and visual meditations, *Mapping Malcolm* is an invocation of this enduring wisdom and spirit that may guide us forward as we build toward repair.

13
In 1964, Malcolm X traveled to the Gaza Strip with the late Palestinian poet, Harun Hashim Rasheed. While in Palestine, Malcolm visited refugee camps and makeshift hospitals, and met with political leaders, allowing him to come face to face with the reality of inhumane displacement at the behest of the Israeli state. Malcolm X's articulation in "Zionist Logic," published in September 1964 in the *Egyptian Gazette*, made bare the irreducible violence of the Zionist project as a form of unflinching white supremacy and Islamophobia.

14
Maytha Alhassen, "To Tell What the Eye Beholds: A Post 1945 Transnational History of Afro-Arab Solidarity Politics," (PhD Diss., University of Southern California, 2017).

Gordon Parks, "Black Muslims," *Life*, May 31, 1963, 32–33. Courtesy of *Life* magazine and The Gordon Parks Foundation.

Throughout his life, Malcolm X maintained a commitment to mobilizing "the political and moral agency of the most marginalized," an allegiance that developed into a deft, militant-like critique of prisons, the public educational system, the United States government, its foreign policy across the Global South, and other state-sanctioned systems expressed as extensions of virulent white supremacy.[15] Malcolm's various reflections on his experience in prison, his organizing work with the NOI and his subsequent political work through the OAAU helped elucidate the necessity of Black-led structural change (alongside a turn toward Islam) as the remedy to, in his words, "the cancer of racism." While always resonant, Malcolm's vision took on new meaning and clarity amidst the interlocking crises that emerged with the COVID-19 pandemic and the immensity of police violence that struck a powerful chord with the masses as global solidarities were formed, confirmed, and formed anew.

A deepened understanding of mutual aid, care, and possibility was forged through the death and despair of the pandemic-turned-racial-reckoning. National discourse returned to historic accounts of resistance, survival, and the political formation of Black radical organizations from the Universal Negro Improvement Association and the Black Panther Party to the modern-day Black Lives Matter Movement that was birthed in the wake of Trayvon Martin's 2012 vigilante-perpetrated murder.[16] The imperative of "freedom dreaming"—born, in the words of Robin D.G. Kelley, "of fascist nightmares, or better yet, born against fascist nightmares"—became indispensable to the fight for justice.[17] In a quest to make sense of slavery's haunting afterlife and to fortify national and international social movement efforts, Malcolm X quotes, like his famed

[15] Brandon M. Terry, "Malcolm's Ministry," *New York Review of Books*, February 25, 2021, https://www.nybooks.com/articles/2021/02/25/malcolm-x-ministry.

[16] At the age of seventeen, Trayvon Benjamin Martin, the son of Sybrina Fulton and Tracy Martin, was shot and killed by a Twin Lakes Neighborhood Watch member on his way home from a convenience store. Martin's killer, George Zimmerman, was acquitted of second-degree murder under Florida's stand-your-ground statute. This modern-day lynching made way for the subsequent Black Lives Matter Movement, catapulting the United States into a new iteration of Black Power and Civil Rights organizing.

NAJHA ZIGBI-JOHNSON

"by any means necessary," emerged alongside video clips, and related literature including Garrett Felber's *Those Who Don't Say: The Nation of Islam, the Black Freedom Movement, and the Carceral State* and Tamara and Les Payne's Pulitzer Prize–winning biography, *The Dead Are Arising: The Life of Malcolm X,* as the world sought to make sense of the acute anti-Black racism and police violence that in 2020 alone killed 257 Black people in the United States.[18] Like so many others, I turned to Malcolm for his political and moral clarity as I joined the abolitionist and Black-led efforts to reimagine and expand our political, cultural, and community-based institutions. Amongst many other contemporary Black liberation-oriented organizations, it was the nationally focused work heralded by young organizers a part of Dream Defenders, Black Youth Project 100, Black Men Build, and the creative projects stewarded by the Caribbean Cultural Center and African Diaspora Institute, alongside the political clarity of the transnational advocacy organization, Black Women Radicals that helped me appreciate the importance of Malcolm's legacy during the "Black Spring" rebellion of 2020.[19]

During this time, I found myself reading and rereading sections of Malcolm's 1964 speech at the OAAU's founding rally at the Audubon Ballroom. This speech has helped to deepen my understanding of how we collectively build generative, life-giving power that stands in opposition to the death-dealing realities of racial terror. In this address, Malcolm outlined the aims and objectives of his newly formed political party, declaring,

> The purpose of our organization is to start right here in Harlem, which has the largest concentration of people

17
Robin D.G. Kelley, "Twenty Years of Freedom Dreams," *Boston Review,* August 1, 2022, https://www.bostonreview.net/articles/twenty-years-of-freedom-dreams.

18
Mapping Police Violence, https://mappingpoliceviolence.org.

19
Kelley, "Twenty Years of Freedom Dreams."

of African descent that exists anywhere on this earth. There are more Africans in Harlem than exist in any city on the African continent. Because that's what you and I are, Africans... So we start in New York City first. We start in Harlem—and by Harlem we mean Bedford-Stuyvesant, any place in this area where you and I live, that's Harlem with the intention of spreading throughout the state, and from the state throughout the country, and from the country throughout the Western Hemisphere.[20]

20
Malcolm X, "(1964) Malcolm X's Speech at the Founding Rally of the Organization of Afro-American Unity," *BlackPast*, October 15, 2007, https://www.blackpast. org/african-american-history/speeches-african-american-history/1964-malcolm-x-s-speech-founding-rally-organization-afro-american-unity.

Though brief, the formal existence of the OAAU as a political party reflected Harlem's growing radicalism and centrality within Black social movements throughout the 1960s. The OAAU was a multi-racial, Black Power coalition that, in the words of Garrett Felber, formed through "a coalescence of strategies such as community control, grassroots organizing, cultural nationalism, and a Black bloc voting at the crucial intersection of the Civil Rights and Black Power movements."[21] As a locally focused but internationally oriented vision of Black self-determination and anti-imperialism, the OAAU sought to address structural racism through the establishment of political education programming, a deepened involvement in local politics, the establishment of community-run child care programs, cultural and artistic events, and self-defense classes.[22] From the Audubon Ballroom and the Manhattanville Projects to the Hotel Theresa, the OAAU positioned Harlem as the physical locus from which a new Black freedom struggle would emerge, situating the neighborhood as a key spatial and temporal site of global Black politicking.

23

21
Garrett Felber, "Harlem is the Black World: The Organization of Afro-American Unity at the Grassroots," *Journal of African American History* 100, no. 2 (Spring 2015): 200.

22
Felber, "Harlem is the Black World," 201.

NAJHA ZIGBI-JOHNSON

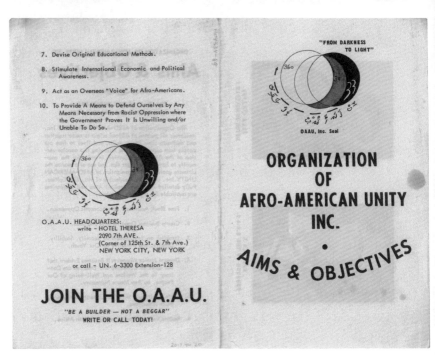

7. Devise Original Educational Methods.

8. Stimulate International Economic and Political Awareness.

9. Act as an Overseas "Voice" for Afro-Americans.

10. To Provide A Means to Defend Ourselves by Any Means Necessary from Racist Oppression where the Government Proves It Is Unwilling and/or Unable To Do So.

O.A.A.U. HEADQUARTERS:
write – HOTEL THERESA
2090 7th AVE.
(Corner of 125th St. & 7th Ave.)
NEW YORK CITY, NEW YORK

or call – UN. 6-3300 Extension-128

JOIN THE O.A.A.U.

"BE A BUILDER — NOT A BEGGAR"
WRITE OR CALL TODAY!

"FROM DARKNESS TO LIGHT"

OAAU, Inc. Seal

ORGANIZATION OF AFRO-AMERICAN UNITY INC.

•

AIMS & OBJECTIVES

Organization of Afro-American Unity Inc. leaflet, ink on paper, 1964. Collection of the Smithsonian National Museum of African American History and Culture.

While the OAAU is no longer active as a political organization, its legacy continues to inform Harlem's social movement infrastructure and memory. From June 1964 until Malcolm's martyrdom on February 21, 1965, the Audubon Ballroom served as the OAAU headquarters. Each week hundreds of people—both eager participants and a few ever-present government informants—packed the second-floor ballroom to listen to Malcolm's emphatic speeches. His magnetic words, imbued with divine meaning and purpose echoed across the open space, helping to catalyze Harlem into action on issues including police violence, housing justice, and building the capacity of Black politicians across the Northeast. However brief, the OAAU's historical presence at the Audubon Ballroom

helped shape the burgeoning Black Power movement that erupted in the wake of Malcolm X and Martin Luther King's high-profile assassinations. The organization, which reflected Malcolm's evolving and increasingly internationalist politics may ultimately be understood as the coalescence of a new Black political imagination, generated through collective struggle and ideation. Beyond individual OAAU members, organizers, and onlookers, it is the Audubon Ballroom, as a physical site and witness, that safeguards these critical struggles alongside the memory of the political organizing work that took place within its walls. I believe it is this embodied memory that continues to inform the building's complicated afterlife. The Audubon Ballroom remains at once a site of sorrow and pilgrimage, of possibility and action.

After more than a decade away, I made my way back to Harlem in September 2020—back to my neighbor Hope, to the blaring sirens, to Black cool, to Marcus Garvey Park, and to Malcolm X Boulevard. I returned in the thick of the pandemic, when glimmers of new worlds arose from mass protest, coalition-building, and abolition-dreaming. 2020 was so full of death. But in that tension, so many of us strategized and worked to build alternative futures premised on demands for respect of our *full* humanity. In this spirit, I joined The Malcolm X and Dr. Betty Shabazz Memorial and Educational Center (The Shabazz Center) as the Director of Institutional Advancement. This time spent at The Shabazz Center, housed in the Audubon Ballroom has, more than anything, tied me to Brother Malcolm. I was able to learn about Malcolm's

25

life and legacy from a global cadre of community organizers, elders, religious leaders, griots, artists, educators, everyday people, and his very own family members.

It is important to note that it was Dr. Shabazz's vision to turn what was once a site of tragedy into a space of triumph. Dr. Shabazz's spirit continues to animate The Shabazz Center's mission and vision. It is this reason that The Shabazz Center is often referred to as "the home that Betty built." While *Mapping Malcolm* is chiefly concerned with Malcolm X, may it not be lost on us that this very project and the world's collective understanding of Malcolm has in so many ways been made possible by Dr. Shabazz's tremendous efforts, vision, and lifelong commitment to safeguarding and uplifting her husband's legacy.

I remember my first day alone on the second floor of the Audubon Ballroom, and the bright, west-facing windows with all that light pouring in from the river. I remember the kinetic energy that seemed to bounce off the floors, and the silence that filled the oversized space. As a witness to history, and container for Malcolm and his beloved Betty's indomitable spirit, I was moved (surely by a force greater than myself) to honor the ballroom and its sacred memories with reverence and care. Walking the perimeter of the second floor, I took in the history. Time and space collapsed once again. Upon reflection, I understand that my time spent working at The Shabazz Center was not simply a job I once held but, more aptly, a job that required a new level of unwavering moral clarity and fortitude.

In the months and years that followed, I wrestled with the contradiction of Malcolm X's relevance within radical social movements and the academy alongside the concerted material disinvestment of his legacy, manifested in the historic under-resourcing of

The Shabazz Center as a New York State designated historic site. The lack of institutional support for the continuation of Malcolm X and Dr. Shabazz's legacies must be situated within the decades-long, state-sanctioned campaign to rewrite and delegitimize Malcolm's religio-political and cultural contributions. This misappropriation of his legacy has manifested in a lack of primary and secondary education on Malcolm X.[23]

23
The daughter of Malcolm X and Dr. Betty Shabazz, Ilyasah Shabazz, has authored numerous children's and young adult books on the life and legacy of her parents. Her books, including *Malcolm Little: The Boy Who Grew Up to Become Malcolm X* (New York: Atheneum Books for Young Readers, 2014), *Betty Before X* (New York: Farrar, Straus and Giroux, 2018), and *The Awakening of Malcolm X: A Novel* (New York: Farrar, Straus and Giroux, 2021), are some of the few children's-age books that explore the globally focused humanitarian efforts of Malcolm X and Dr. Betty Shabazz.

While popular culture tends to historicize Malcolm as a polarizing minister and orator, he was also so much more. In word, life, and deed, Malcolm exemplified a type of spiritual self-emptying. He gave his people and the movements to which he belonged everything, and all the while his politics and religious beliefs evolved publicly. Malcolm was not above growth or reproach, and in doing so, he set a new standard of embodied morality. In order to fully appreciate the depths of his commitment to the project of liberation and human wholeness, we must sit with Malcolm's unabashed acceptance of death as an imminent consequence of truth-telling.

On Sunday, February 21, 1965, Malcolm X was assassinated on the second floor of the Audubon Ballroom, before he could even begin his remarks. Dr. Shabazz, who at the time was pregnant with their youngest twins, sat with their four other daughters in the front row, alongside a room full of OAAU members including friends and comrades Yuri Kochiyama and Peter Bailey. Also present were police informants and hired assassins, who after multiple botched attempts, succeeded in taking his life. Twenty-one shotgun bullets

27

pierced through Malcolm's upper body, striking him down right before his family's own eyes.[24] It is not lost on history that Malcolm's last public utterance was the customary greeting اَلسَّلَامُ عَلَيْكُمْ, as-salamu alaykum, "peace be upon you." These quotidian words reflect his most fundamental political, religious, and ethical commitments to humankind. After failed attempts to resuscitate Malcolm's lifeless body, he was carted to Columbia University's New York Presbyterian Medical Center—just a thousand feet from the Audubon Ballroom—where he was pronounced dead.

24
Manning Marable, *Malcolm X: A Life of Reinvention* (New York: Viking Penguin, 2011), 450.

Days later, the noted Black American artist and Civil Rights activist, Ossie Davis would eulogize Malcolm X as "our own shining Black Prince," reflecting the simultaneous tragedy and victory of Malcolm's short but prolific life. Indeed, Harlem will never forget Malcolm X, because to do so would be to deny the very essence of ourselves and the ancestral assemblages to which we are tied. Every May 19th, Malcolm's birthday is celebrated, rain or shine, with a rally along 125th Street. Businesses shut down for the afternoon and speakers assemble below the Harlem State Office Building to commemorate his legacy. A caravan makes its way to Ferncliff Cemetery in Westchester County, where Malcolm is buried alongside his wife. For decades, The Shabazz Center has marked this day with a powerful celebration in the Audubon Ballroom, where musicians, poets, elders, organizers, and politicians reflect upon Malcolm's courageous spirit and legacy, and community members gather to share in libation and commemoration. The event is planned by Malcolm and Dr. Shabazz's daughter, Ilyasah Shabazz, who resides as chairperson of The Shabazz Center. While Malcolm experienced both literal death and social death—in the caricaturing of his politics and worldview, in the systematic underfunding of his legacy, and so on—

he continues to be reclaimed by the commons, his memory maintained by the countless people who find meaning and relevance in his life's work.

I am not an architect, a planner, or a preservationist, nor have I ever formally studied these disciplines. I instead approach the built environment through an interpersonal spatial relationship, in which I understand Harlem, Washington Heights, Columbia University, and the Audubon Ballroom as part and parcel of communities to which I belong or engage. In this sense, I approach the built environment through my own personal relationship and material engagement with political and urban history, with a primacy placed on emic knowledge and perspectives. Rather than writing from within any of the aforementioned disciplines, I am decidedly an interlocutor, whose central concern is with the ethical stewardship of people and land, and all sentience within its sphere. It is through this framing that I make sense of the Audubon Ballroom's urban and architecturally situated history.

In 1967, after the Audubon Ballroom closed following Malcolm's assassination, the City of New York assumed ownership over the building, which quickly fell into decay. For decades, the fate of the Audubon Ballroom was uncertain and became more precarious as Columbia University, the largest private landowner in New York City, expanded its already imposing reach into Manhattan's northernmost neighborhoods, Washington Heights and Inwood, lands once tended to by the Indigenous peoples of Lenapehoking for more than 3,000 years.[25]

25
Matthew Hagg and Meredith Kolodner, "'The Untouchables': How Columbia and NYU Benefit from Tax Breaks," *New York Times*, September 26, 2023, https://www.nytimes.com/2023/09/26/nyregion/columbia-university-property-tax-nyc.htm.

29

Throughout the late 1980s and 1990s, the university accelerated its land acquisitions and development plans uptown as it began to design its Biotechnical campus around the Columbia Presbyterian Medical Center. In 1989, it partnered with the Port Authority of New York and New Jersey in the proposed demolition of the Audubon Ballroom, to make room for a $22 million dollar construction that would bring more class, office, lab, and proprietary space to the new Biotechnical campus.[26]

Commissioned by William Fox, the founder of Twentieth Century Fox, and designed by the noted theater architect Thomas Lamb, the Audubon Ballroom was initially built in 1912 as a vaudeville theater.[27] It lived many lives following its original use. From a motion picture theater to a congregation space for Washington Heights' Jewish population in the 1930s, and a transit workers union meeting space, to a dance hall, and site for boxing matches, the Ballroom's adaptive use for over a hundred years reflects the changing racial demographics of its neighborhood.[28] Community organizers attempted to persuade the New York City Landmarks Preservation Commission to give the building landmark status; however, these efforts failed after the commission refused to hold a hearing to discuss the Ballroom's designation. "Even so, community-based coalitions continued to fight for the building's preservation with the Municipal Art Society assembling a pro bono team of architects who assessed the Audubon Ballroom's structure to see if any parts of the building could be saved."[29]

26
Irene Madrigal, "What Happened to NYC's Audubon Ballroom: The Site of Malcolm's Assassination?" *Untapped New York*, December 2, 2021, https://untappedcities.com/2022/02/21/audubon-ballroom-malcolm-x-assassination.

27
"Audubon Ballroom," New York Preservation Archive Project, accessed December 5, 2023, https://www.nypap.org/preservation-history/audubon-ballroom.

28
At the turn of the twentieth century, with the extension of the Broadway and Seventh Avenue subway lines up to 191st Street, the Washington Heights area experienced a rise in middle class residential construction in the years leading up to World War I. European immigrants who had first crowded into small tenement apartments throughout the Lower East Side of Manhattan began making their way north, to Washington Heights. In the 1930s, nearly a quarter of Manhattan's Jewish population lived north of 155th Street. These immigrants reflected the growing refugee population of Ashkenazi Jews escaping the horrors of the Holocaust. In the 1950s, 1960s, and 1970s, the demographics of Washington Heights abruptly changed as Puerto Rican, Cuban, and Dominican immigrants migrated to this northern tip of Manhattan, which uncoincidentally coincided with the repressive thirty-year Trujillo dictatorship in the Dominican Republic. The influx of Spanish-speaking Caribbean immigrants marked the beginning of white flight and the policy-driven economic disinvestment of Washington Heights, a community that continues to be informed by this legacy today.

29
Madrigal, "What Happened to NYC's Audubon Ballroom."

In accordance with the plans in place, a coalition of community leaders, student organizers, and elders led by Dr. Shabazz came together with shared visions of preserving the Audubon Ballroom. In the end, a plan was composed that included the repurposing of the Audubon Ballroom into Columbia University–affiliated research space, while maintaining the building's ornate, terracotta facade. Accordingly, 44 percent of the original Audubon Ballroom structure was preserved for the establishment of The Shabazz Center. Both The Shabazz Center and the Audubon Biomedical Science and Technology Park for Columbia University were designed by the famed late Black American architect J. Max Bond Jr., who served on the Architects Renewal Committee in Harlem from 1967–1968, and on the New York City Planning Commission from 1980–1986. Bond's architectural firm Bond Ryder & Associates also designed many of the most prominent African American historical institutes across the United States, including the Schomburg Center for Research in Black Culture and the Studio Museum, both located in Central Harlem, as well as the Birmingham Civil Rights Institute in Alabama.[30]

Today, the officially state-designated historic site and global educational institute remains committed to honoring the humanitarian legacies of Malcolm X and Dr. Shabazz. The historic fight for memorializing the Audubon Ballroom has since resulted in the preservation of less than half of the building's original interior and few other material offerings made at the administrative level by Columbia University. This must be contextualized within the decades-long battle between Harlem and the university's governing bodies.[31]

30
"J. Max Bond Jr. (1935–2009)," *National Museum of African American History and Culture*, accessed December 5, 2023, https://nmaahc.si.edu/design/j-max-bond-jr.

31
In the early 2000s, Columbia University alongside The Shabazz Center—with scholarly oversight from the Institute for Research in African American Studies, led at the time by the late Dr. Manning Marable—commissioned the Malcolm X Project, one of the most comprehensive, multimedia projects and digital archives on Malcolm X and Dr. Betty Shabazz's lives and legacies to date. Interviews, interactive maps, and historical information were digitized and reproduced on six touch screen kiosks that lined the walls of The Shabazz Center's lobby.

NAJHA ZIGBI-JOHNSON

Columbia University's Board of Trustees and Overseers have largely directed the institution's predatory real estate acquisitions and subsequent reconfiguration of West Harlem and Washington Heights, much to the chagrin of community residents who have not reaped equal material benefits and increased access to Columbia's extensive educational and social capital. Columbia University remains the largest single landowner in New York City by the number of addresses it manages, totaling 13.9 million square feet of real estate across 245 properties as of April 2023.[32] Situating the establishment of The Shabazz Center as a memorial and cultural space against Columbia University's rapacious expansionist project helps contextualize the inequitable relationships established by land-grabbing institutions who continue to overdetermine the physical spaces in which they exist. Within this particular context, I look directly to Malcolm's praxis-oriented conception of power and his political analysis to frame and reframe the relationship that Columbia University has imposed upon the Harlem and Washington Heights cityscape.

32
Amira McKee, "Exceeding Previous Estimates, Columbia Is the Largest Private Landowner in New York City, City Data Reveals," *The Columbia Spectator*, April 20, 2023, https://www.columbiaspectator.com/city-news/2023/04/20/exceeding-previous-estimates-columbia-is-the-largest-private-landowner-in-new-york-city-city-data-reveals/#:~:text=A%20Spectator%20analysis%20of%20the,estimates%20by%20nearly%2030%20properties.

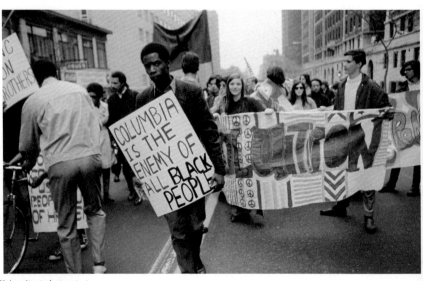

Columbia University student protest, 1968. The protest was staged against the university's association with the US Department of Defense think tank, Institute for Defense Analyses, and, by extension, the Vietnam War. Photograph by Steve Schapiro. Courtesy of Corbis via Getty Images.

In my conceptualization of Black space-making, I am informed by the scholarship of Elleza Kelley, whose theorizations on Black geography help make the cartographic relationship between Malcolm X and Harlem legible. Through a multi-dialogic exploration of visual art, conversation, and historical analysis, it becomes clear that Malcolm X's life and work is itself embodied in the built environment. In this way, *Mapping Malcolm* is more interested in resurfacing the ways in which Black spatial forms are the byproduct of Black culture and politics than it is in formal mapping. In a sense, offering up a literal cartographic rendering of Malcolm's Harlem would oversimplify and necessarily miss the many ways in which space is produced through a confluence of social and environmental processes. Forged through the generative production of Black religiosity, radical politicking, community-building, and protest, alongside the production of internationally oriented art and culture, this book project situates the continued relevance of Malcolm X through an interdisciplinary understanding of public history and placemaking.

In a conversation held as a part of the "Black Counter Cartographies" series hosted by architectural scholar Mabel O. Wilson and the Institute for Research in African American Studies at Columbia University, Kelley framed her ongoing research around a particular articulation of Black spatial practice as "the unique and specific modes of perceiving, engaging with, and transforming the built and unbuilt environment that are expressed and preserved in Black cultural production."[33] Kelley noted that, rather than deferring to planners, architects, or cartographers as the chief bearers of geographic

33
"Black Counter Cartographies with Dr. Tonya Foster & Dr. Elleza Kelley," Institute for Research in African American Studies and the African American and African Diaspora Studies Department, Columbia University, presented virtually via Zoom, April 7, 2023, 26:34 to 27:29, https://www.youtube.com/watch?v=QxtwgeQ9LCA.

NAJHA ZIGBI-JOHNSON

histories, she looks and learns first from Black communities, whose everyday engagement with the built environment can (also) be read as an epistemology and critique of Western space-making. This practice of Black counter cartography has expanded my own understanding of spatial history, and how we also come to produce it. Following Kelley,

34
"Black Counter Cartographies with Dr. Tonya Foster & Dr. Elleza Kelley," 28:20 to 28:38.

I ask: How can exploring the legacy of Malcolm X unfold a "critical cartography of Harlem"?[34]

As a publication, *Mapping Malcolm* looks directly to the range of community-based social projects, scholarly research, and archives being tended to by Columbia-affiliated students and faculty, as well as by urban studies scholars across New York City. It is precisely because the university remains a contested site of imperial domination that its students, faculty, and surrounding community push a range of radically aligned scholarship forward, demanding the institution contend with its role as an intellectual steward. Research projects like Wilson's "Black Counter Cartographies," alongside the historic Malcolm X Project produced by the Institute for Research in African American Studies at Columbia University in 2001, as well as the decades-long, student-led campaign pushing the institution to divest from prisons and fossil fuels, and the ongoing Boycott, Divest, and Sanctions movement reflects a critical engagement and active critique of power relations between the university and the Harlem-based community in which it resides.

My hope is that *Mapping Malcolm* may be understood as indebted to this legacy of radical scholarship, public intellectualism, and direct action-work that wrestles with the inherent contradictions of scholar-activism, while also asserting the position of the community-scholar as being not *of* the institution but rather *of* the commons—the people and community to whom they belong. In doing so, I hope to

reflect the visions and demands of my community that stand in opposition to the hegemonic power structure of the ivy league project, which excessively hoards resources as a means of asserting power and of, too often, maintaining the status quo. Through exploring and employing Malcolm X's global conception of community development and anti-imperialism, we may come to see this worldview as both a pedagogy and an everyday praxis that can be employed across disciplines, helping us move toward a more just, sustainable, and symbiotic relationship between community and institutions, and between people and power.

As much as I look to the university as a site of cultural production, resistance, and domination, I also look to the work of a diverse range of visual artists, designers, storytellers, organizers, archivists, and healers who offer us new renderings of history and alternative visions of our collective freedom in their creative expression. The pages that follow unsettle space and time to trace Malcolm through sonic landscapes, Black radical geographies, archival undertakings, sacred travels, and cooking practices, through the use of visual art, historical work, poetry, transcription, and critical conversation.

In many ways, *Mapping Malcolm* began through a 2022 talk I 35 gave titled, "Reframing Power: Exploring the Politics and Legacy of Malcolm X as a Social Justice Framework in Preservation and Beyond," as part of the Graduate School of Architecture, Planning, and Preservation lecture series at Columbia University. It was in this time that I began to articulate Malcolm's worldmaking process as a praxis-oriented pedagogy that could be understood through and employed across a range of disciplines, particularly those whose work engages the built environment. Since then, the project has come to include a collection of voices and perspectives who

offer their own meditations on the legacy of Malcolm X. In this way, *Mapping Malcolm* has become a decidedly collaborative endeavor that has employed a synergetic approach to scholarly production and creative development. While this project is a reflection of my own interaction with Harlem, it is also a reflection of the political clarity and moral groundedness from which Columbia Books on Architecture and the City makes space for new and necessary perspectives within architectural discourse.

Through this multi-dialogic approach to public history and placemaking, we may be able to better re-examine the disciplines of planning, architecture, preservation, and design with a new lens rooted in the transdisciplinary field of Black radical studies. This project is at once an ode to Malcolm and an ode to Harlem, acknowledging the co-constructive relationship between people and place. Inasmuch as *Mapping Malcolm* is an academic publication, it is also a collaborative project that exists beyond the confines of any one discipline and is meant to be an entry point into the world of Black space-making, Malcolm's Harlem, and the Harlem I know today. This project is for anyone that is curious about freedom and committed to their wholeness. It is for the youth, for the designers, for the elders, and for the academics; it is for Brother Malcolm and Sister Betty; it is for Harlem, and for the world.

Birthed from jazz and poetry, from renaissance and resistance, Harlem is its own freedom dream. Majestic and unnerving, it is everything all at once. The rhythm of the neighborhood is uniquely distinct, with its own temporal register and metronomic beat that reverberates across the diasporic world. You've got to feel Harlem to know Harlem. And Malcolm was in lockstep.

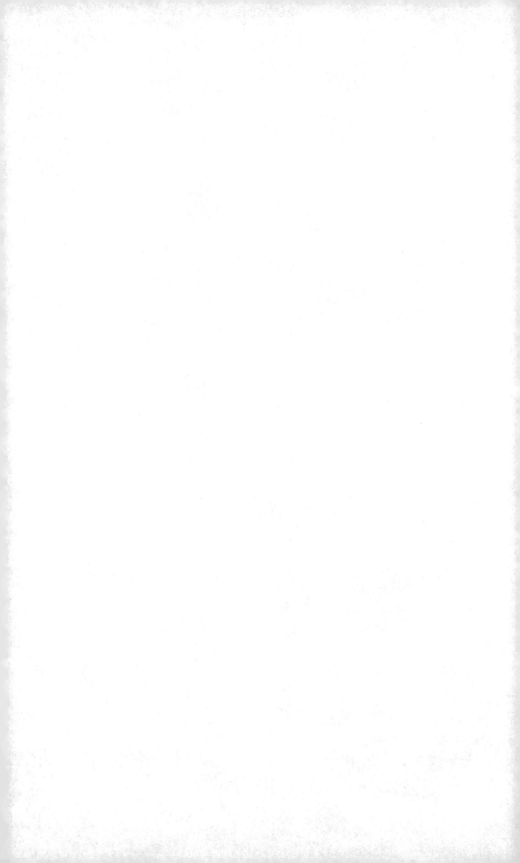

NOT WITHOUT

A
CONVERSATION

MARC

PEERS

WITH

LAMONT HILL

MARC LAMONT HILL is currently the host of *BET News, TheGrio, Al Jazeera UpFront,* and the *Coffee and Books* podcast. An award-winning journalist, Dr. Hill is the author or co-author of eight books, including *Nobody: Casualties of America's War on The Vulnerable from Ferguson to Flint and Beyond* (Atria Books, 2017); *We Still Here: Pandemic, Policing, Protest, and Possibility* (Haymarket Books, 2020); *Except For Palestine: The Limits of Progressive Politics* (The New Press, 2021); among others. He is a Presidential Professor of Anthropology and Urban Education at the City University of New York Graduate Center. His current research and writing explore the relationships between race, culture, politics, and education in the United States and the Middle East.

NAJHA ZIGBI-JOHNSON (NZJ) Thank you so much for making time for this conversation. The goal of this book is to gather artists, organizers, and historians who are thinking through Malcolm's legacy and to explore the spatial history of Harlem through the sociopolitical history of Brother Malcolm. I also want this book to serve as a pedagogical tool, one that will help reframe our understandings of power between communities. It is an invitation to people who are thinking about the built environment to really center Black folks and to center Black sovereignty, liberation, and the politics of Malcolm in the work they do. And so it is meant to be an expansive project. I also hope our conversation and the questions that I ask you allow for an intimacy to be shared around Brother Malcolm—an intimacy that feels so pertinent to how we remember, in the words of Ossie Davis, "our own shining Black Prince."

When did you first learn about Malcolm X?

MARC LAMONT HILL (MLH) I first learned about Malcolm X in middle school. Someone in my class had compared him to Martin Luther King, Jr. They said something like, "Like Martin Luther King, not like Malcolm X, who just wants to go around killing white boys." I was bussed to a working-class, white middle school at the time. So that was the context and the first time I really registered Malcolm. I'd heard his name before, but I didn't know much about him.

And I hadn't heard anything particularly positive or negative. But, from the start, he was sort of imprinted on me as someone who stood in contrast to King.

He was on my Uncle Bobbie's coffee table. He was in pictures on the wall. It was that kind of thing until, like most people of my generation, I was more deeply introduced to him through the *Autobiography*.[1] I was in high school, and my brother, I believe, told me I should read it. He was a Five Percenter.[2] And he was beginning to give me information. He was reading a lot. I would notice the books in his room. I didn't see his lessons, but I remember seeing the *Isis Papers*[3] and books by Walter Rodney[4] laying around. The *Autobiography of Malcolm X* was one of those books, and I read it. I encountered *Malcolm X* the book and the movie not that far from each other—so, in many ways, they were both powerful introductions to how I understood Malcolm X and who I understood him to be.

The *Autobiography of Malcolm X* expanded my political imagination. I went through personal changes in terms of religion, education, and what I was doing. I spent more time in Black bookstores—I wanted to know more about who Malcolm was, but, probably more importantly and more fundamentally, I wanted to know the things Malcolm was teaching us about. It wasn't Malcolm worship so much as: Malcolm is Muslim, so I want to be

1
Malcolm X and Alex Haley, *The Autobiography of Malcolm X* (New York: Ballantine Books, 1965).

2
Five Percenters belong to the Five Percent Nation, a Black nationalist movement founded in Harlem. Although its leaders draw on certain tenets of Islam to formulate the group's ideologies, the Five Percent Nation is presented less as a religious practice and more as a culture or way of life. Five Percenter beliefs and values have been formative to the genre of hip-hop, with artists like Kendrick Lamar, The Wu Tang Clan, and Queen Latifah citing their influence.

3
Frances Cres Welsing, *The Isis Papers: The Keys to The Colors* (Chicago: Third World Press, 1991).

4
See, for example, Walter Rodney, *How Europe Underdeveloped Africa* (London: Bogle-L'Ouverture Publications, 1973); Walter Rodney, *The Groundings with My Brothers* (London: Bogle-L'Ouverture Publications, 1969).

Muslim; Malcolm is doing organizing work, so I want to do organizing work; Malcolm is talking about Fidel, so let me read about Cuba and about Ché. Malcolm was my entry point and, in many ways, my first teacher of radical politics.

NZJ: There are many ways to remember Malcolm, but there's a necessary recentering that we must do, that we are obligated to do, in how we remember, imagine, and employ Brother Malcolm's sociopolitical and religious legacy today. I'm curious: how do you remember Malcolm? How do you speak about him? How do you employ Malcolm's political vision? And, maybe this is a bit separate, but what do you want generations coming up, the babies, to know about Malcolm?

MLH: There are many people who want to hold Malcolm X to a particular moment or period. There are people in the Nation of Islam (NOI), for example, who stress how little time Malcolm spent not in the Nation, as a counter to his having split with them in 1963, and I don't think that's unimportant. Much of the narrative of Malcolm, even Malcolm as a kind of paragon of masculinity (I'm thinking of that image of Malcolm on the board writing "Father," explaining what a father is, or the image of Malcolm with his babies), has to do with the Nation of Islam— in terms of both him being in the Nation and their

43

actual manhood training program. It's part of what it means to be a Fruit of Islam. It's part of what it means to be a Muslim man and a Muslim father. And so there are people who want to disconnect Malcolm from that for all kinds of reasons. But then there are other people who want to lock him in there in such a way that you almost forget that he left and that, regardless of the why, he was also killed by members of the Nation of Islam.

There are also people who want to lock him into a kind of Muslim multiculturalism, who think that prior to his death he discovered a proper, true Islam in Saudi Arabia, that somehow the presence of white Muslims caused a conversion experience for him from "bad Islam to good Islam," from bad, wrong, heretical Muslim to a proper, pious universalist. People want to lock him there and want to remember him as the man who no longer believed or made the ontological claim that white people were

44

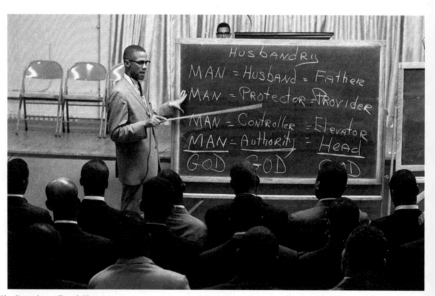

Malcolm X leading a class at Temple No. 7. Gordon Parks, *Untitled*, Chicago, Illinois, 1963. Courtesy of and © The Gordon Parks Foundation.

the devil. But I think this vision of Malcolm falls short for lots of reasons, not the least of which is that he had a much more nuanced and complicated understanding of whiteness, of Islam, of the role of race and racialization and white supremacy in the United States, versus in a global context. So it wasn't that simple. We also know that 1964 wasn't the first time Malcolm saw white Muslims. He saw them in 1959, when he traveled as a member of the Nation of Islam. The Nation has always had an international-ist politic underneath it, even though it was fraught with contradictions and conservatism. It was still an internationalist vision to be an Asiatic Black man, to talk about how many Muslims there are in the world. One of the thirty-six lessons in the Nation of Islam is a call toward internationalism or toward an internationalist political imaginary that says, when we count ourselves, we shouldn't only be counting ourselves here in the States; we should be counting ourselves as part of a global network. To call your- 45 self an Afro-Asiatic Black man is to put yourself in an Afro-Asian political imaginary.

This is all happening at the same time. Malcolm shouldn't be locked into any single place or narra-tive. For me, I remember Malcolm as someone who was constantly transforming. I don't remember Malcolm in his "final moment" in the Audubon Ballroom. This is not the only story or the best story of Malcolm. In many ways, when we talk about

MARC LAMONT HILL

Malcolm, the victories were in the struggle. It's the journey from 1925, rooted in an internationalist family and political structure, taking him through Lansing, taking him through Roxbury, taking him through Harlem and through Philadelphia—we can't ignore Philly. It's impossible to understand Malcolm without understanding all these spaces as constituting the person that we're talking about and understanding that, if Malcolm had lived another ten or twenty or thirty years, he would have continued to transform and change, because that was integral to who he was as a human being. He had a particular type of commitment and, I would argue, humility: a kind of intellectual and political humility that said, "I know I don't know enough to be complete. I am beginning from the presumption that there may be an ultimate capital-T truth out there, but I don't have access to it. But I'm going to continue to search and struggle and fight for this." I think that's part of the brilliance of Malcolm: his ability and his commitment to that kind of truth journey. And so I remember Malcolm in all these moments.

I try to remember Malcolm the prisoner. It is a narrative that I want to complicate. From 1946 to 1952 he underwent perhaps his most radical transformation. And that transformation was animated by the things I think mark Malcolm's life in really interesting and complicated ways, particularly his education. If you read some of Malcolm's prison let-

ters, you learn that Malcolm was trying to transfer to different prisons to get access to better educational programs. Some people think he didn't have anything but his dictionary, that he was just stuck in a room with his dictionary. But that's the Hollywood construction of Malcolm's educational journey. There were really important educational programs that helped him develop as a writer and helped him develop as a thinker and helped him make persuasive arguments. That's why he's on these debate teams in prison. That's why he was reading the dictionary. It wasn't to learn English: it was to sharpen his abilities and enrich his vocabulary. So there was that education.

There was also the role of Black women. Malcolm's life was protected and sustained and enhanced by Black women. His mother, who was also a Garveyite,[5] although we don't spotlight that enough, and his sister, who was there when his mother couldn't protect him anymore because of the extraordinary violence that befell the family and the health issues that she struggled with. His sister saved him. Betty Shabazz, Maya Angelou... Black women at various points of his life have always saved, protected, and strengthened Malcolm; they enriched Malcolm's life. Prison was no different. There is, of course, also a way that Malcolm's prison story can be used in problematic ways, like to suggest that prison can be redemptive. Because of Malcolm, so

5
Garveyites are followers of the teachings of Marcus Garvey, a Jamaican Pan-Africanist organizer and founder of the Universal Negro Improvement Association and African Communities League.

47

many people have this idea of the prison as a site of transformation; of intellectual, scholarly conversion; of political, spiritual conversion; of radicalization. How many people become Muslim in prison? This misses the point.

People are transforming *despite* prison. The death-dealing context of prison has forced us to struggle, to survive, to do all sorts of things to try to hold on to humanity. I don't want to romanticize or normalize these conditions. These conditions can be produced outside of prison if we can give people spaces for radical education, political education, if we can give people access to love.

It was the love of Elijah Muhammad, and the Nation more broadly, that was transformative for Malcolm. What kind of spaces can give that radical love intervention? What kind of spaces can give an educational experience that's responsive to our cultural norms, our political needs and economic realities? In many ways, for me, Malcolm's prison period represents what's possible for human transformation. But, with an abolitionist vision, I'm asking: How can we replicate the transformation Malcolm experienced outside the context of prison? So when I think of Malcolm, I think of his time in prison just as much as I think of that letter from Jeddah[6] he wrote, just as much as I think of him starting the Organization of Afro-American Unity (OAAU)[7] or the Muslim Mosque, Inc.[8] These moments are just as

48

6
See Malcolm X and Haley, *Autobiography*, 339–342. Malcolm also wrote a letter to Haley from Mecca in 1964, detailing his spiritual transformation after completing *Hajj*. See Malcolm X, "Mecca, Saudi Arabia – April 26, 1964," reproduced at https://momentsintime.com/the-most-remarkable-revelatory-letter-ever-written-by-malcolm-x.

7
The Organization of Afro-American Unity (OAAU) was a secular Black nationalist movement founded by Malcolm X in 1964 with the purpose of establishing the right to self-determination and economic independence by uniting Black Americans with their African heritage. The organization disbanded in the wake of Malcolm's assassination a year later.

8
Malcolm founded Muslim Mosque, Inc. just after his departure from the NOI in 1964. The organization modeled and mirrored Malcolm's religious evolution in the final year of his life but, like the OAAU, disbanded in the wake of his assassination.

important and just as transformative. I don't think it's helpful to think about transformation as a linear or upward progression. It's not like he's starting at the bottom and ending closer to a fulfilled human being. I think it's a much more dynamic and complicated process of exploring who he is and who he was becoming. So when I think about the memory of Malcolm for young people, I'm preoccupied with the process so much more than the product.

NZJ: Thank you.

I want to return to this point about women. You mentioned Louise Norton Little, his mother, who was born in Grenada; spoke Creole, French, and English; and was deeply involved in and shaped by the nation-building and Pan-Africanist politics of the Universal Negro Improvement Association.[9] And we also know that Malcolm continued to be informed by women, and built deep kinships with Yuri Kochiyama, Shirley Graham Du Bois, and Maya Angelou. Dr. Betty Shabazz was his North Star in so many ways. And he was a girl dad too! I always imagine Malcolm having his little girls running around the house and just being blissed out with them.

I'm really interested in exploring themes of womanhood and how the experience of structural, state-sanctioned violence against women may have informed Malcolm's own anti-imperial and interna-

9
The Universal Negro Improvement Association and African Communities League (UNIA) was founded by Marcus Garvey in 1916 to foster racial pride and economic self-sufficiency. Among the group's primary objectives was also the establishment of a Black nation on the African continent. The UNIA is recognized as having laid formative groundwork for the Black nationalist movements that arose in the aftermath of World War II.

49

tionalist politics, which were deeply shaped by the women in his life. I'm curious to know what your thoughts are on this, on how we can frame some of the women in his life as shaping or helping to evolve Malcolm's politics over time.

MLH: I think it's important to highlight that these women weren't just helpmates in the Biblical sense: They weren't just there to support his calls. They weren't cheerleaders. They weren't personal assistants. They were his interlocutors. They were his teachers, counselors, and leaders in lots of ways. And I think that's important. We often talk about extraordinary figures, like Du Bois, in the individual sense. I do believe Du Bois was the towering Black intellectual of the twentieth century. But he was not without peers, colleagues, and teachers. Maria Stewart and Lorraine Hansberry weren't just people that sat at his feet. They helped shape him and reshape his vision of the world. They challenged him and dared him to be better. They pushed him in new directions. bell hooks was not just a conversation partner with Cornel West, nor was Nikki Giovanni with James Baldwin. We can look at all these moments and say these are men who were taught, shaped, and challenged by women often at the same that their work and their legacies have trumped and overshadowed these very women.

While it is certainly important that both of Malcolm's parents were Garveyites—his father, for

example, was a preacher and teacher, and vocal in the patriarchal arrangements of political organizations, as well as family structures—Louise Little wasn't just a registered member of the Universal Negro Improvement Association. She really helped the organization and also her husband and children to understand white supremacy, colonialism, and capitalism within a global power structure. That she was from Grenada was critical for expanding Malcolm's political imagination beyond the United States and her husband's understanding of American imperialism's impact throughout the Caribbean, Latin America, and the continent of Africa; it was critical for the development of a radical politics and for a political vision or telos that didn't necessarily end in America.

The teachings of the Honorable Elijah Muhammad were brought to Malcolm by his brother Philbert, yes, but also by his sister Ella. She gave them validity. He trusted her, and she believed in the teachings. She helped connect dots between their father and his political vision as a Garveyite and the teachings and lessons that Malcolm was getting from the Nation of Islam—teachings that were directed toward Negroes in the United States, but with the understanding that this country was only home by virtue of the tragedies and contradictions of history, and that we should imagine ourselves beyond this place.

10
Muslim Girls' Training (MGT) and General Civilization Class (GCC) are courses given by the NOI to instruct young women and girls in the particularities of domestic life—how to keep house, raise children, sew, cook, and the like.

Betty Shabazz was an extraordinary woman, an extraordinary educator, and an extraordinary leader. Even during her time in the Nation, her commitment to developing and nurturing the lives of Black women and girls, when you think about MGT[10] trainings, helped to develop Malcolm's understanding of the relationship between women's wellness, mental health, physical wellness, spiritual health, and the development of a community. Now, Malcolm's vision of women and the role of women in society are certainly shot through with patriarchy. I don't think there's anybody who could grow up in this country—at any point but especially in the fifties and sixties—without being deeply influenced by patriarchal ideas. Women are still the recipients of a certain kind of protection and investment that frames men as being in control of their destinies. But Malcolm understood that women had something to contribute, that women weren't just here to raise children. Although he may have seen that as a primary role and responsibility, particularly given his Nation training, he also understood that women were intellectuals. He understood that women were leaders. There's a reason that Maya Angelou came back from the Continent when Malcolm was really struggling in the last months of his life to support him. It's because of what she meant to him, not just as a friend but as someone with a cultural and political vision. I mean Malcolm dies literally in the arms

of Yuri Kochiyama, who was no wallflower. Yuri was a radical political thinker, organizer, and activist. You're talking about someone whose internationalist vision didn't just inspire Malcolm but shaped how he approached his work. There's a reason why the OAAU was developed at that moment, distinct from Muslim Mosque, Inc., as a mechanism of not just replicating the political vision of the Organization of African Unity but of understanding the possibilities that could emerge when we frame white supremacy, capitalism, imperialism as global forces that can only be dismantled with a global political analysis and also global organizing strategy.

· ORGANIZATION OF AFRO-AMERICAN UNITY ·

Mary Kochiyama

is a member of the
Organization of Afro-American Unity

......_Malcolm X_........ Chairman

June, 1964 65

53

Organization of Afro-American Unity Membership Card signed by Mary (Yuri) Kochiyama, June 1965. Yuri and Bill Kochiyama Papers, Malcolm X Scrapbook, Rare Book and Manuscript Library, Columbia University Library.

NZJ: Yuri was a card-holding member of the OAAU, and the stories of Malcolm going to her apartment in the Manhattanville Projects and meeting Japanese

anti-imperial organizers who came to the United States to "learn from Brother Malcolm" speak to his politics. I'm so interested and moved by the ways in which women shaped Malcolm's political vision and shaped his global awareness of the world.

How do you think we ensure there's space for young people, women, Queer folks, immigrants, and people across the Muslim diaspora to meaningfully engage Brother Malcolm's legacy and feel a part of it? I ask this in response to what I think is the often patriarchal tilt that our Black nationalist movements tend to have in how we speak about Malcolm, how we remember Malcolm, and how we construct Black masculinity.

MLH: Yeah, that's a wonderful question. You know, making room for Malcolm, or rather making room for various communities as we hold on to Malcolm's legacy, is critical. Part of that job is to properly remember Malcolm—understanding the complexity and dynamic nature of Malcolm's identity and political work. His commitment to creating the Organization of Afro-American Unity as distinct from Muslim Mosque, Inc. is critical for thinking about the ways that Malcolm had a vision of a freedom project that stood aside from his personal faith tradition. This is something that he started to invoke in his speeches, like "The Ballot or the Bullet,"[11] or when he started to say, "We ain't catching hell because of this thing over here; we're catching

11
Malcolm X, "The Ballot or the Bullet," in *Malcolm X Speaks*, ed. George Breitman (New York: Grove Press, 1965), 23–44.

12

"You don't catch hell because you're a Baptist, and you don't catch hell because you're a Methodist. You don't catch hell because you're a Methodist or Baptist, you don't catch hell because you're a Democrat or a Republican, you don't catch hell because you're a Mason or an Elk, and you sure don't catch hell because you're an American; because if you were an American, you wouldn't catch hell. You catch hell because you're a Black man. You catch hell, all of us catch hell, for the same reason." Malcolm X, "Message to the Grassroots," November 10, 1963, in *Malcolm X Speaks*, ed. George Breitman (New York: Grove Press, 1965), 4.

hell because of these factors over there."[12] I think that alone means we can think of Malcolm outside the context of his Muslim identity. We can't erase Malcolm's identity, and Malcolm's Muslim identity shaped so much of who he was and how he moved through the world, but Malcolm understood himself as being beyond the limitations or the boundaries of his faith tradition, and I think reminding people of that is critical for how we think and talk about Malcolm.

Connecting Malcolm to Islam is easy, because he and Muhammad Ali are the two most significant figures in Black Islam in the United States, and maybe of Islam period in the United States. I mean, Malcolm is responsible for more conversions probably than anybody ever. I'm not worried about Malcolm being lost to Muslims. I'm not worried about Malcolm being lost to Black nationalists, because, I think, when people hear Malcolm, that part is clear. Malcolm's public work was much more about politics than faith. He was always more political than spiritual in that way, in terms of his public declarations. So much of how we remember him as a Muslim is largely branding. His story is so secure in the American Muslim mind and imagination. I'm not worried about that. What I worry about sometimes is that, because the Black nationalist tradition here in the United States has held Malcolm so tightly, we lose sight of the internationalist vision. I remember when I was catching hell for my advocacy of Palestinian self-determination, people said I needed to

55

MARC LAMONT HILL

be more like Malcolm. That was actually a critique I got: "You're worried about everybody over there when you should worry about what's over here." Malcolm was in Palestine. Malcolm wrote the essay "Zionist Logic" for the *Egyptian Gazette* in 1964.[13] Malcolm was in Ghana; Malcolm was in Cuba. The point is we have a memory of Malcolm that has been reduced in so many ways. I think part of how we give people more access to Malcolm in this tradition and legacy is by giving people access to more than just a single speech or a single image or a single story, and paying careful attention to the various parts of his legacy that are often obscured and allow those parts of his legacy to be instructive. We prioritize the pedagogical possibilities of showing Malcolm in Cuba, or not just showing Malcolm saying "by any means necessary," but playing Malcolm talking about Phạm Văn Đồng[14] and what a revolution is. We don't want to strip down Malcolm into a kind of liberal multicultural action figure by having a Disney narrative of his religious conversion. I think we have to also give people access to Malcolm's full diaries and full legacy, full letters that show he still thought whiteness—not white people—was evil: whiteness as constituted and constructed within a white supremacist world.[15]

Some of this is because of how we teach Malcolm, where we teach Malcolm in school, the spaces upon which we place Malcolm's name. I don't just mean at the discursive level; I mean in terms of

13
Malcolm X, "Zionist Logic," *Egyptian Gazette*, September 17, 1964.

14
Phạm Văn Đồng was a Communist and the Prime Minister of North Vietnam from 1955–1976 and, following the reunification of North and South Vietnam, the Prime Minister of Vietnam from 1976–1987.

15
The Diary of Malcolm X: El-Hajj Malik El-Shabbaz, 1964, ed. Herb Boyd and Ilyasah Shabbaz (Chicago: Third World Press, 2013); The Malcolm X Collection: Papers [1948–1965], The New York Public Library, https://archives.nypl.org/scm/21896; Primary Sources: People-Civil Rights in America: X, Malcolm, Christopher Newport University, https://cnu.libguides.com/peoplecivilrightsam/malcolmx; Malcolm X Project Record, Columbia University, https://findingaids.library.columbia.edu/ead/nnc-rb/ld-pd_11138357.

the built environments, you know? I wonder what it would mean for us to place Malcolm's name in different spaces. Linking the built environment to Malcolm's name can open up pedagogical possibilities for how the public remembers and understands who Malcolm is.

NZJ: Yes. Absolutely. Historically, there's been a collective decision to not properly fund Malcolm and his legacy. Columbia University tried to tear the Audubon Ballroom down as it made way for a biotechnical campus in Washington Heights, as part of its rapacious gentrification project in the 1990s. And so the ways in which we invest or build up the built environment is reflective of our collective values and understanding of United States history. This is history that we must remember and reclaim. We have chosen in our own ways to establish space that marks Malcolm's time and legacy on this earth. And that's part of what this book is trying to do. It's being assembled against the state-sanctioned project to forget Malcolm. It's like he experienced literal death and then metaphorical social death. I do think Black spaces are working against that. You know, I grew up on Lenox Avenue, Malcolm X Boulevard, and that's how we remember...

I really do see myself and this book project as trying to create space for people who may not feel like they have access to Malcolm or don't know what

MARC LAMONT HILL

their entry point would be, to create that access. If it's for the planners, sure, then let's create an access point to Malcolm and learn about the history. If it's for people, including women and femmes who may feel uneasy about Nation politics or what Black nationalism has to say about women and Queer folks, come and engage the legacy of Malcolm through the lens of a whole range of folks who are critical of these systems and still look to Malcolm as a barometer for what our ethical and moral values should be.

What do you think power meant for Malcolm, and, as Black folks, how do we steward power responsibly, given the global, political legacy of Malcolm X?

MLH: I think that's the right question. I think "Message to the Grassroots," in many ways, is a powerful space for him to make clear at least what power wasn't. For him, it wasn't cultural politics; it wasn't symbolic power. That's not to say that Malcolm didn't understand the importance of cultural nationalism and symbolic power. I mean, you can't name yourself Malcolm X or El-Hajj Malik El-Shabazz and not have some understanding of this. You can't take on names and not understand the power of naming as a part of a kind of cultural politics. Malcolm ultimately understood that a true revolution, a Black revolution, requires land; it requires resources and a restructuring of the world. Malcolm, I think, both understood power through the lens of cultural na-

tionalism, which said we have to define the world on our terms, through our lens, with our standards of beauty, our gods, our folkways, and also understood that power would only come if we could develop a kind of worldmaking project that wasn't just dependent upon us assuming the reins of power, like becoming a Black president or a Black CEO. That it was about actually reimagining the relations of power such that our lives and our futures, our safety and our work and our humanity weren't measured or determined by a class-dependent state. Malcolm's vision of power was us being able to define ourselves and our legacy and controlling our own social, economic, and political destiny.

And that vision was necessarily bound up in a dismantling of the world as it is—not a rearrangement of power relations, but a dismantling of the power structures and power arrangements such that we can engage in a project of worldmaking that would produce new possibilities, new ideas, new selves, new humanities, new worlds, new norms. That's what Malcolm was fundamentally committed to. That's what power would have looked like for Malcolm.

NZJ: Thank you.

MALCOLM X,

THE ENVIRONMENT, REVOLU

POTENTIAL

THE BUILT AND

...IONARY OF GEOGRAPHY

JAMES A. TYNER

JAMES A. TYNER is a professor of geography at Kent State University and a fellow of the American Association of Geographers. He is the author of twenty-five books, including *The Geography of Malcolm X: Black Radicalism and the Remaking of American Space*. His academic honors include the AAG Glenda Laws Award, which recognizes outstanding contributions to geographic research on social issues.

On February 14, 1965, Malcolm X spoke to an audience of 400 attendees at the Ford Auditorium in Detroit, Michigan. Just hours earlier, Malcolm's house had been firebombed. Undeterred, however, Malcolm X went to Detroit, insisting that the attack made it all the more important that he continue to speak out. The speech would be his last public appearance before his assassination one week later.

JAMES A. TYNER

The mood was somber in the auditorium as he called attention to the civil unrest that had occurred the previous summer, notably the Harlem uprisings in July that followed the police shooting and killing of James Powell, a fifteen-year-old Black American. Of the uprisings, Malcolm X observed that the press coverage referred to Black American protestors as "vandals, hoodlums, thieves" and effectively blamed them for the damages that resulted. However, Malcolm X explained, the so-called "riots" were not all what they appeared. Instead, Malcolm X charged, the actions of the "rioters" spoke to deeper social and financial struggles experienced by Black Americans—a prescient argument, given the mainstream discourse and ongoing media vilification of Black Americans in the twenty-first century. Indeed, in the wake of continual acts of police violence—notably the killing of Black Americans—a growing number of scholar-activists are rethinking "looting" as a radical strategy of resistance. Echoing Malcolm X, for example, Vicky Osterweil explains that "looting rejects the legitimacy of ownership rights and property, the moral injunction to work for a living, and the 'justice' of law and order." In other words, looting exposes the injustices of the built landscape and lays bare "the white supremacist juncture of property and race."[1] For Malcolm X, the control of economic resources by exploitative (and often absentee) white merchants and landlords "is what makes [rioters] knock down the store windows and set fire to things." "It's not that they're thieves," Malcolm X concluded, but that "it's a corrupt, vicious hypocritical system that has castrated the Black man, and the only way the Black man can get back at it is to strike it in the only way he knows how."[2]

1
Vicky Osterweil, *In Defense of Looting: A Riotous History of Uncivil Action* (New York: Bold Type Books, 2020), 7. See also Joshua Clover, *Riot. Strike. Riot: The New Era of Uprisings* (New York: Verso Books, 2019); William E. Scheuerman, "Politically Motivated Property Damage," *The Harvard Review of Philosophy* 28 (2021): 89-106; and Billie Murray, "Violence and Nonviolence in the Rhetoric of Social Protest," *Rhetoric and Public Affairs* 25, no. 3 (2022): 145-166.

2
Malcolm X, *Malcolm X on Afro-American History* (New York: Pathfinder, 1967), 28-29.

The conclusions drawn by Malcolm X are significant not because he seems to justify the use of violence, but because he decenters the Black American community and centers white supremacy and the oppressive systems it has built as the instigators of violence. Notably, the system entails not only unequal social relations marked and marred by racial prejudice but also the material infrastructure born of centuries of white supremacy. Indeed, Malcolm X intuited much work by sociologists, geographers, and urban studies scholars—notably, but not limited to, Prentiss A. Dantzler, Margaret Marietta Ramírez, and Sara Safransky—through his understanding of how the built environment both constitutes and is constituted by the inequalities and injustices inherent to racial capitalism.[3] Ultimately, Malcolm X demonstrated the revolutionary potential of geography.

Malcolm X was—and remains—a controversial figure of the twentieth century. His religious, political, and philosophical roots are the subject of considerable scholarship.[4] To this body of work, I add the argument that the *geography* of Malcolm X was inarguably one of producing space for social justice.[5] Geography, in this context, presents two faces: on the one hand, we can speak of the intellectual spaces opened by Malcolm X to more critically understand the intersections of racism and the built environment, and, on the other hand, we can excavate the concrete landscapes observed and experienced by Malcolm X. Combined, we can better appreciate the arguments put forth by Malcolm X that Black liberation was possible only through the material transformation of American society, literally, from the ground up.

3
Sara Safransky, "Rethinking Land Struggle in the Postindustrial City," *Antipode* 49, no. 4 (2017): 1079–1100; Margaret Marietta Ramírez, "Take the Houses Back/Take the Land Back: Black and Indigenous Urban Futures in Oakland," *Urban Geography* 41, no. 5 (2020): 682–693; and Prentiss A. Dantzler, "The Urban Process Under Racial Capitalism" *Journal of Race, Ethnicity and the City* 2, no. 2 (2021): 113–134.

4
George Breitman, *The Last Year of Malcolm X: Evolution of a Revolutionary* (New York: Schocken, 1968); James H. Cone, *Martin & Malcolm & America: A Dream or a Nightmare?* (Maryknoll, NY: Orbis, 1991); Bruce Perry, *Malcolm X: The Life of the Man Who Changed Black America* (Barrytown, NY: Station Hill, 1991); Michael Eric Dyson, *Making Malcolm: The Myth and Meaning of Malcolm X* (New York: Oxford University Press, 1995); Louis A. De Caro, Jr., *On the Side of My People: A Religious Life of Malcolm X* (New York: New York University Press, 1996); Kofi Natambu, *The Life and Work of Malcolm X* (Indianapolis: Alpha, 2002); Manning Marable, *Malcolm X: A Life of Reinvention* (New York: Penguin, 2011); and Peniel Joseph, *The Sword and the Shield: The Revolutionary Lives of Malcolm X and Martin Luther King, Jr.* (New York: Basic, 2020).

5
For a more extensive elaboration of this thesis, see James A. Tyner, *The Geography of Malcolm X: Black Radicalism and the Remaking of American Space* (New York: Routledge, 2006).

65

JAMES A. TYNER

Malcolm X did not use the terms "racial capitalism" or "built environment" (or "infrastructure"). His understandings of how racism, capitalism, and the built environment intersected in the struggle for Black liberation preceded, by many years, the widespread articulation of these terms. "Racial capitalism" emerged more discursively in the 1980s, with the publication of *Black Marxism* by Cedric Robinson. Robinson deployed the term to refer to the myriad ways in which racism and racialism permeate the social structures emergent from capitalism. "Infrastructure" gained traction even later, in the twenty-first century. In part, infrastructure is synonymous with the built environment, that is, the roads, bridges, ports, and buildings that materially comprise society. However, infrastructure *understood critically* refers not exclusively to built "things" but instead to the panoply of social relations and labor processes, all mediated by race, gender, class, and so on.[6] As such, Malcolm X foreshadows many of the battles currently underway in the United States to dismantle the scaffolds of white supremacy that continue to frame the lives of Black Americans and other marginalized populations.

Racial capitalism forwards the idea that racist practices—notably, white supremacy—are central to the historical development of capitalism.[7] Put directly, as Malcolm X states in a series of re-

[6] On racial capitalism, see Cedric J. Robinson, *Black Marxism: The Making of the Black Radical Tradition* (Chapel Hill: University of North Carolina Press, 1983). On the "infrastructural turn," see Laura Cesafsky, "How to Mend a Fragmented City: a Critique of 'Infrastructural Solidarity,'" *International Journal of Urban and Regional Research* 41, no. 1 (2017): 145–161; Alan Latham and Jack Layton, "Social Infrastructure and the Public Life of Cities: Studying Urban Sociality and Public Spaces," *Geography Compass* 13, no. 7 (2019); Deborah Cowen, "Following the Infrastructure of Empire: Notes on Cities, Settler Colonialism, and Method," *Urban Geography* 41, no. 4 (2020): 469–486; and Joshua F.J. Inwood, "The Modern Infrastructure Landscape and the Legacy of Slavery," *The Professional Geographer* 75, no. 1 (2023): 44–51.

[7] White supremacy is a politically charged term, and any strict definition threatens to undermine or circumscribe its purchase. Following Laura Pulido, it is helpful to contrast "white supremacy" with "white privilege." In the 1990s, white privilege gained popularity to call out the material and psychological benefits enjoyed by white people because of their skin color. However, as Pulido explains, the term too often overlooks the processes of taking: for example, the taking of land, wages, life, liberty, health, community, and social status. White supremacy redirects the conversation toward the power structures that give rise to white privilege, as well as the ideological belief in white racial superiority that support and perpetuate white privileges. See Laura Pulido, "Geographies of Race and Ethnicity I: White Supremacy vs White Privilege in Environmental Racism Research," *Progress in Human Geography* 39, no. 6 (2015): 812.

marks delivered at the symposium organized by the Militant Labor Forum, "You can't have capitalism without racism."[8] Malcolm's comments came on the heels of his recent travels abroad, and, while his understanding of race and racism broadened extensively from these international ventures, his experiences did not dampen his conviction that racism in the United States is irredeemably connected to America's economic system. Thus, Malcolm X was fully aware that racism and capitalism are co-constitutive and that the built environment—our neighbors and communities—reflects materially the interplay of both. Indeed, Malcolm X, during many of his final speeches, increasingly highlighted the legacies of colonialism on the plight of Black Americans, drawing connections with ongoing revolutions throughout the Global South. To this point, as Laura Pulido explains, "a focus on racial capitalism requires greater attention to the essential processes that shaped the modern world, such as colonization, primitive accumulation, slavery, and imperialism." She elaborates that, "by insisting that we are still living with the legacy of these processes, racial capitalism requires that we place contemporary forms of racial inequality in a materialist, ideological and historical framework."[9]

8
Malcolm X, "The Harlem 'Hate-Gang' Scare," in *Malcolm X Speaks: Selected Speeches and Statements*, ed. George Breitman (New York: Grove Weidenfeld, 1965), 69.

9
Laura Pulido, "Geographies of Race and Ethnicity II: Environmental Racism, Racial Capitalism and State-Sanctioned Violence," *Progress in Human Geography* 41, no. 4 (2017): 526–527.

67

Malcolm X's understanding was grounded in the materiality of the built environment, that is, the grocery stores, banks, tenement houses, and myriad other physical structures that give form to our neighborhoods and communities. However, Malcolm X also anticipated how conversations regarding racial capitalism and the built environment are problematic, in part because the latter term is frustratingly vague. On the one hand, the built environment refers concretely to the buildings, roads, and other material

JAMES A. TYNER

structures inhabited by people. On the other hand, the term hides multiple layers of complex social, spatial, and temporal relations. Each reading points in different directions—toward matter, toward labor, toward form, toward how that form takes shape—and asks a different set of questions: Who, for example, built the material structures and under what conditions? With wage laborers? Enslaved persons? And, importantly, under whose ownership? In other words, our landscape is not merely a stage but a coproduction of countless processes that reveal unequal, inequitable, and unjust power relations. For Malcolm X, it was imperative therefore that his audiences understood how the observable landscape—the shops and banks and hair salons—is often produced under oppressive and exploitative circumstances.

In recent years, scholars have grappled with the material legacies of racial capitalism and white supremacy and how they give form to the world around us. In particular, work has focused on (re)covering the brutal histories of enslavement and the (literal) building of the United States. Notably, this work also has expanded the geographic horizons of these histories, no longer limiting the harmful consequences of white supremacy and racial capitalism to the American South.[10] As Evelyn Brooks Higginbotham explains, when it comes to the spatial inheritances of slavery in the United States, "positions do not fall neatly into categories such as North versus South, antebellum versus postbellum, and virtuous versus complicit... The North and South continued their complicitous relationship with regard to white supremacy into the nineteenth century and into the twentieth."[11] Even New York City, Malcolm X's long-time home, owed much of its growth to enslaved labor. As Ann

10
A.B. Assensoh and Yvette M. Alex-Assensoh, "The Political Economy of Land and Reparations: The Case of Reparations for African Americans in the 21st Century," *American Journal of Economics and Sociology* 80, no. 2 (2021): 704.

11
Evelyn Brooks Higginbotham, foreword to Ann Farrow, Joel Lang, and Jennifer Frank, *Complicity: How the North Promoted, Prolonged, and Profited from Slavery* (New York: Random House, 2005), xvi.

Farrow and colleagues detail, in the decades preceding the American Civil War, "New York became the fulcrum of the US cotton trade" as "merchants, shippers, auctioneers, bankers, brokers, insurers, and thousands of others were drawn to the burgeoning urban center."[12] Simply put, as Joshua Inwood concludes, instead of seeing slavery as something in a distant past or something that happened "over there," a reading of the contemporary built environment locates slavery in the here and now of capital accumulation and extends our understanding of the role slavery plays within the broader national landscape.[13]

Such an understanding pivots on the control of property. Property is generally understood as "self-evident": as that which belongs to someone or something.[14] However, as Malini Ranganathan and Anne Bonds explain, this rudimentary notion of property obscures the web of social and power relations that must be performed to produce property as legitimate. They elaborate that property "is not only an essential component of capitalist political economy but is also a shifting social formation animated by contextual assemblages of race, class, ethnicity, gender, and citizenship."[15]

Malcolm X does not refer to "property" in his speeches but rather uses the more general term "land." However, a close reading of those addresses demonstrates clearly that his conception of land is that of propertied land. Thus, when Malcolm X refers to uprisings, such as those in Harlem in July 1964, he underscores how Black Americans are not landlords and that the buildings in which they live are owned by someone else. Black Americans are "victims of economic exploitation, political exploitation, and every other kind."[16] Likewise, in his critiques of

12
Ann Farrow, Joel Lang, and Jennifer Frank, *Complicity: How the North Promoted, Prolonged, and Profited from Slavery* (New York: Random House, 2005), 4.

13
Joshua F.J. Inwood, "The Modern Infrastructure Landscape and the Legacy of Slavery," *The Professional Geographer* 75, no. 1 (2023): 46.

14
Nicholas Blomley, *Unsettling the City: Urban Land and the Politics of Poverty* (New York: Routledge, 2004), 2.

15
Malini Ranganathan and Anne Bonds, introduction to "Racial Regimes of Property," special issue, *EPD: Society and Space* 40, no. 2 (2022): 198.

16
Malcolm X, "Not Just an American Problem," in *Malcolm X: The Last Speeches*, ed. Bruce Perry (New York: Pathfinder, 1989), 154.

segregation, Malcolm X underscores how land/property "depends on historical and renewed modes of racial and other forms of differentiation."[17] Subsequently, he helped invigorate a "land question" that preoccupied many Black American theorists and activists from the late 1960s onward. Indeed, as Russell Rickford identifies, numerous Black scholars recognized that "liberation was worthless... unless it delivered meaningful Black sovereignty—a goal that required control of the critical social space, natural resources, and means of production that land embodied."[18]

THE BUILT ENVIRONMENT OF
MALCOLM X

The built environment occupied a central place in Malcolm X's articulation of Black liberation. Chiefly, Malcolm X discerned how the built environment revealed the exploitative relations inherent to racial capitalism and how these continued to oppress Black Americans. As Inwood writes, "It is not only that enslaved people worked to create myriad roads, rail lines, and water improvements, among other examples; it is that slavery itself creates an infrastructure of control, a framework for understanding the place of different racialized populations within the broader racial hierarchy that has developed out of the system of forced labor, what we might term the broader racial caste system."[19]

Frequently, Malcolm X singled out Harlem to illustrate his thesis. In Harlem, he explains, "all of the stores are owned by white people, all of the

70

17
Ranganathan and Bonds, "Racial Regimes of Property," 199; see also Brenna Bhandar, *Colonial Lives of Property: Law, Land and Racial Regimes of Ownership* (Durham, NC: Duke University Press, 2018).

18
Russell Rickford, "'We Can't Grow Food on All This Concrete': The Land Question, Agrarianism, and Black Nationalist Thought in the Late 1960s and 1970s," *Journal of American History* 103, no. 4 (2017): 956.

19
Inwood, "Modern Infrastructure," 46.

buildings are owned by white people. Black people are just there, paying rent, buying the groceries. But they don't own the stores, clothing stores, food stores, any kind of stores; don't even own the homes that they live in. This is all owned by outsiders."[20] In this passage—delivered just one week prior to his death—Malcolm X begins to delineate how Black liberation rested on the dismantling of not only exploitative and oppressive social relations but also the underlying political and legal structures that maintain economic inequalities. And the consequences, Malcolm X understood, were grave. In simple but straightforward language, Malcolm X calls attention to how "the white merchants charge us more money for food in Harlem—and it's the cheap food, it's the worst food; and we have to pay more money for it than the man has to pay for it downtown."[21] Malcolm X was not a trained academic, but he observed, he questioned, and he made connections that would resonate with his Black American audiences and their experiences. Malcolm X didn't need to define racism in this setting, but he was compelled to point out connections that might otherwise remain hidden, especially when the white-controlled media inevitably portrayed the so-called "ghetto problem" as failures of the Black American community itself. "These bad housing conditions that continue to exist up there," Malcolm X explains, "keep our people victims of health problems—high infant and adult mortality rates, higher in Harlem than any other part of the city."[22] These conditions were not the fault of Black Americans, Malcolm affirmed, or of any perceived lack of understanding of sanitation and hygiene on the part of Black

20
Malcolm X, "Educate Our People in the Science of Politics," in *Malcolm X February 1965: The Final Speeches*, ed. Steve Clark (New York: Pathfinder, 1992), 91.

21
Malcolm X, "Educate Our People," 91. For an overview of food deserts and the subsequent health crises among African Americans, see Renee E. Walker, Christopher R. Keane, and Jessica G. Burke, "Disparities and Access to Healthy Food in the United States: A Review of Food Deserts Literature," *Health & Place* 16, no. 5 (2010): 876-884; Hilda E. Kurtz, "Linking Food Deserts and Racial Segregation: Challenges and Limitations," in *Geographies of Race and Food*, ed. Rachel Slocum and Arun Saldanha (Aldershot, UK: Ashgate), 247-264; and Michelle L. Frisco, Kelsey Shaulis, Jennifer Van Hook, and Robert A. Hummer, "Racial and Ethnic Disparities in US Obesity Prevalence: What Have We Learned from Demographic and Population Health Science?" in *International Handbook of the Demography of Obesity*, ed. Ginny Garcia-Alexander and Dudley L. Poston, Jr. (Cham, Switzerland: Springer International, 2022), 137-152.

22
Malcolm X, "Prospects for Freedom in 1965," in *Malcolm X Speaks: Selected Speeches and Statements*, ed. George Breitman (New York: Grove Weidenfeld, 1965), 154.

JAMES A. TYNER

Americans. Rather, these social conditions were the direct manifestation of a racial capitalist system that exploited and oppressed one group of people—Black Americans—to enrich other groups of people -white Americans.

Impoverished conditions that directly impacted the survivability of Black Americans were (and remain) the legacy of racial capitalism and the forced labor of enslaved people. Who built America—and who prospered? For Malcolm X, there was no mystery, for it was plain to see on the land. As he identifies, "Three hundred and ten years we worked in this country without a dime in return—I mean without a *dime* in return. You let the white man walk around here talking about how rich this country is, but you never stop to think how it got rich so quick. It got rich because you [Black Americans] made it rich."[23] Black Americans were robbed of their free labor and their blood; they made greater contributions to the built landscape of the United States and have collected less in return.[24] This, markedly, is the basis of contemporary demands for reparations.[25]

Repeatedly, Malcolm X was accused of inciting violence, of advocating "race riots" while other Civil Rights leaders, notably Martin Luther King, Jr., forwarded an agenda of nonviolence and peaceful protest.[26] And, repeatedly, Malcolm X denied these accusations, pointing instead to the pent-up anger experienced by Black Americans compelled to live in segregated spaces: "It's the city structure that incites," Malcolm X proclaims:

23
Malcolm X, "The Ballot or the Bullet," in *Malcolm X Speaks: Selected Speeches and Statements*, ed. George Breitman (New York: Grove Weidenfeld, 1965), 32.

24
Malcolm X, "The Ballot or the Bullet," 33.

25
See for example Milfred Fierce, "Black Struggle for Land During Reconstruction," *Black Scholar* 5, no. 5 (1974): 13–18; William E. Nelson, "Black Political Power and the Decline of Black Land Ownership," *Review of Black Political Economy* 8, no. 3 (1978): 253–265; Randall Robinson, *The Debt: What America Owes to Blacks* (New York: Penguin, 2001); Joe R. Feagin, "Documenting the Costs of Slavery, Segregation, and Contemporary Racism: Why Reparations are in Order for African Americans," *Harvard Black Letter Law Journal* 20 (2004): 49–81; and Akon Baba, Robert Zabawa, and Andrew Zekeri, "Utilization of Property among African American Heir and Titled Landowners in Alabama's Black Belt," *Review of Black Political Economy* 45, no. 4 (2018): 325–338.

26
Just as the image of Malcolm X was distorted by white spokespersons, so too was King's. In fact, on many issues, including their critiques of capitalism, Malcolm X and King shared common ground. However, it was beneficial for white liberals to widen the differences of the two most outspoken Civil Rights leaders in an effort to forward their own, privileged position that would ultimately maintain white supremacy.

A city that continues to let people live in rat-nest dens in Harlem and pay higher rent in Harlem than they pay downtown. That is what incites it. Who lets merchants outcharge or overcharge people for their groceries and their clothing and other commodities in Harlem, while you pay less for it downtown. That is what incites it. A city that will not create some kind of employment for people who are barred from having jobs just because their skin is Black. That's what incites it. Don't ever accuse a Black man for voicing his resentment and dissatisfaction over the criminal condition of his people as being responsible for inciting a situation. You have to indict the society that allows these things to exist.[27]

27
Malcolm X, "The Black Muslim Movement," in *Malcolm X February 1965: The Final Speeches*, ed. Steve Clark (New York: Pathfinder, 1992), 237.

But Malcolm X also knew that (white) society was not prepared to indict itself. White supremacist elements, he realized, would continuously use legal—and extralegal—force to maintain the status quo. The deployment of law enforcement officers, for example, to predominantly Black American communities was never about the safety of residents but always about the protection of white-owned properties. Harlem, for example, was "a police state." So too were (and are) most other urban areas across the United States. Drawing parallels with other occupied territories in the Global South, Malcolm X explains: "The police in Harlem, their presence is like occupation forces, like an occupying army. They're not in Harlem to protect us; they're not in Harlem to look out for our welfare; they're here in Harlem to protect the interests of the businessmen who don't even live there."[28] As such, the prospect for violence was always a possibility, for the simple reason that, in the words of Malcolm X, "in areas of this

73

28
Malcolm X, "The Harlem 'Hate-Gang' Scare," 66.

country where the government has proven its... inability or its unwillingness to protect the lives and property of our people, then it's only fair to expect us to do whatever is necessary to protect ourselves."[29]

29
Malcolm X, "Whatever is Necessary to Protect Ourselves," in *Malcolm X: The Last Speeches*, ed. Bruce Perry (New York: Pathfinder, 1989), 83.

And to that end, Malcolm X's fiery rhetoric was often just that: an exhortation for *practical* change.

THE SPATIAL STRUGGLES OF
BLACK LIBERATION

"A geographical imperative," Ruth Wilson Gilmore writes, "lies at the heart of every struggle for social justice." And to that end, she continues: "If justice is embodied, it is then therefore always spatial, which is to say, part of a process of making a place."[30] These words would no doubt have resonated with Malcolm X. He understood the centrality of geography to the liberation struggles of Black Americans. "Land," Malcolm X declares, "is the basis of all independence. Land is the basis of freedom, justice, and equality."[31] Revolutions are thus "fought to get control of land, to remove the absentee landlord and gain control of the land and the institutions that flow from that land."[32] In this way, Malcolm X differentiated his position from the broader Civil Rights movement. "This is a real revolution," he says, in that "revolution is never based on begging somebody for an integrated cup of coffee. Revolutions are never fought by turning the other cheek. Revolutions are never based upon love-your-enemy and pray-for-those-who-spitefully-use-you. And revolutions are never waged singed 'We Shall Overcome.'"[33]

74

30
Ruth Wilson Gilmore, "Fatal Couplings of Power and Difference: Notes on Racism and Geography," *The Professional Geographer* 54, no. 1 (2002): 16.

31
Malcolm X, "Message to the Grass Roots," in *Malcolm X Speaks: Selected Speeches and Statements*, ed. George Breitman (New York: Grove Weidenfeld, 1965), 9.

32
Malcolm X, "The Black Revolution," in *Malcolm X Speaks: Selected Speeches and Statements*, ed. George Breitman (New York: Grove Weidenfeld, 1965), 57.

33
Malcolm X, "The Black Revolution," 50.

Education is crucial to the struggle for social justice; however, much of this education would of necessity be embodied, that is, based on the actual lived experiences of Black Americans. Pale demands for equal rights were insufficient to truly challenge white supremacy. Speaking in December 1964 at the Audubon Ballroom, during an event which featured the head of the Mississippi Freedom Democratic party, Fannie Lou Hamer, Malcolm X explains, "If you give people a thorough understanding of what it is that confronts them and the basic causes that produce it, they'll create their own program; and when the people create a program, you get action."[34] Here, Malcolm X puts forth a revolutionary strategy that emanates from the grassroots: one grounded in the lived, everyday spatial practices of Black Americans, such as Hamer.[35] For Malcolm X, liberation was not some abstract idea or ideal but instead the connective tissue of daily life.

Liberation requires an awareness of the socio-spatial relations that structure American society. In other words, there has always been a materiality to knowledge-production. For Malcolm X, this translated into an awareness of the exploitative practices that are foundational to racial capitalism. "Our people have to be made to see," he explains, "that any time you take your dollar out of your community and spend it in a community where you don't live, the community where you live will get poorer and poorer, and the community where you spend your money will get richer and richer."[36] In fact, the situation was even more dire for Black Americans, who, for the most part, did not own the properties within their communities. "Not only do we lose [revenue] when we spend it out of the community," Malcolm X clarifies, "but the white man has got all our stores in

34
Malcolm X, "At the Audubon," in *Malcolm X Speaks: Selected Speeches and Statements*, ed. George Breitman (New York: Grove Weidenfeld, 1965), 118.

35
See Chana Kai Lee, *For Freedom's Sake: The Life of Fannie Lou Hamer* (Urbana: University of Illinois Press, 1999); Kay Mills, *This Little Light of Mine: The Life of Fannie Lou Hamer* (Lexington: University Press of Kentucky, 2007); and Maegan Parker Brooks, *Fannie Lou Hamer: America's Freedom Fighting Woman* (Lanham, MD: Rowman & Littlefield Publishers, 2020).

36
Malcolm X, "The Ballot or the Bullet," 39.

the community tied up; so that though we spend it in the community, at sundown the man who runs the stores takes it over across town somewhere. He's got us in a vise."[37]

Spatial segregation—manifested concretely in the built environment—is the crux of white supremacy. Malcolm X elaborates: "A segregated district or community is a community in which people live, but outsiders control the politics and the economy of that community."[38] This fundamental relation, however, is masked by disinformation campaigns forwarded by white supremacists. Racists in power use "the press skillfully to feed statistics to the public to make it appear that the rate of crime in the Black community, or community of nonwhite people, is at such a high level. It gives the impression or the image that everyone in that community is criminal." Consequently, Malcolm X points out, "as soon as the public accepts the fact that the dark-skinned community consists largely of criminals or people who are dirty, then it makes it possible for the power structure to set up a police-state system." In turn, Malcolm X concludes, this makes it possible for white people to support "all kinds of police methods to brutally suppress the struggle on the part of [Black Americans and other nonwhites] against segregation, discrimination, and other acts that are unleashed against them that are absolutely unjust."[39]

"They never refer to the white section as a segregated community," Malcolm X insists. Instead, "it's the all-Negro section that's a segregated community. Why? The white man controls his own school, his own bank, his own economy, his own politics, his own everything. When you're under someone else's control, you're segregated."[40] For this reason, Malcolm X advocated *spatial separation.*

37
Malcolm X, "The Ballot or the Bullet," 39.

38
Malcolm X, "The Ballot or the Bullet," 42.

39
Malcolm X, "The Oppressed Masses of the World Cry Out for Action Against the Common Oppressor," in *Malcolm X February 1965: The Final Speeches,* ed. Steve Clark (New York: Pathfinder, 1992), 47.

"Segregation means that he puts you away from him, but not far enough for you to be out of his jurisdiction; separation means you're gone. And the white man will integrate faster than he'll let you separate. So we will work with you against the segregated school system because it's criminal, because it is absolutely destructive, in every way imaginable, to the minds of the children who have to be exposed to that type of crippling education."[41] In the end, separation, for Malcolm X, was a strategy that would most effectively empower Black Americans to make their place in American society through the re-appropriation of space.

The geographic remaking of American society championed by Malcolm X remains unfinished—and community leaders in Harlem (and elsewhere) continue to follow the path charted by their slain leader. In the intervening decades since the death of Malcolm X, grassroots movements have rallied around a variety of social and environmental justice issues, including the siting of toxic facilities near or in Black American communities; local organizers also have tackled head on discriminatory educational systems, racist law enforcement agencies, and the inadequate provision of health facilities. In addition, activists have pushed forward positive projects: for example, new parks, restored waterfronts, and improved transportation corridors.[42] Collectively, these activities demonstrate a commitment to forward-looking solutions that build on the strength of Harlem's residents and, in doing so, capture the spirit of Malcolm X.

In 2020, then US President Donald Trump issued an executive order limiting the ability of diversity training programs in federal offices and attached this order to public education. Widely seen

40
Malcolm X, "The Ballot or the Bullet," 42.

41
Malcolm X, "The Ballot or the Bullet," 42-43.

42
See Vernice Miller, Moya Hallstein, and Susan Qyass, "Feminist Politics and Environmental Justice: Women's Community Activism in West Harlem," in *Feminist Political Ecology: Global Issues and Local Experience*, ed. Dianna Rocheleau et al. (New York: Routledge, 2013), 62–85; Carol R. Horowitz, Agueda Arniella, Sherline James, and Nina A. Bickell, "Using Community-Based Participatory Research to Reduce Health Disparities in East and Central Harlem," *Mt. Sinai Journal of Medicine* 71, no. 6 (2004): 368–374; Celene Krauss, "Mothering at the Crossroads: African American Women and the Emergence of the Movement Against Environmental Racism," in *New Millennium: Global Perspectives on Race, Ethnicity, and Human Rights*, ed. Filonina Chioma Steady (New York: St. Martin's Press, 2008), 65–89; and Melissa Checker, "Environmental Justice and Gentrification in New York City," *Environment* 63, no. 2 (2021): 16–27.

77

JAMES A. TYNER

as a clarion call to white supremacists, Trump's order galvanized a much broader attack on the progress toward racial understanding, inclusion, and justice.[43] As Vivian Hamilton summarizes, "Ongoing conversations about and growing consciousness of pervasive structural and unexamined individual racism... have generated resentment among many white people unaccustomed to (and uncomfortable with) addressing race."[44] Accordingly, a conservative backlash is underway, with concerted and coordinated attacks directed against a so-called "woke" agenda. In the wake of Trump's actions, state and federal Republican lawmakers nationwide introduced myriad legislative and policy measures aimed at prohibiting public schools and universities from educating students about race and racism in the United States.[45] Ultimately, as Christina Accomando and Kristin Anderson lament, these efforts—and countless others—are "intended to silence teachers, mobilize the Trump base, and suppress an honest grappling with this nation's history and present."[46]

Sadly, Malcolm X would recognize our contemporary society. Of the continuation of race prejudice in the United States, Malcolm X knew all too well its fundamental cause: "Ignorance and greed. And a skillfully designed program of miseducation that goes right along with the American system of exploitation and oppression."[47] Malcolm knew that that a heavy burden must fall on white society to exorcise its racist elements and its implicit or explicit support of white supremacy. As Malcolm X concludes, "If the entire American population were properly educated—by properly educated, I mean given a true picture of the history and contributions of the Black man—

78

43
Allison L. Palmadessa, "Misunderstanding Reinvigorates Racism: The Case of Critical Race Theory in the Public Sphere," in *Globalization, Human Rights and Populism*, ed. Adebowale Akande (Cham, Switzerland: Springer, 2023), 648.

44
Vivian E. Hamilton, "Reform, Retrench, Repeat: The Campaign against Critical Race Theory, Through the Lens of Critical Race Theory," *William & Mary Journal of Race, Gender, and Social Justice* 28, no. 1 (2021): 63.

45
Hamilton, "Reform, Retrench, Repeat," 64.

46
Christina Hsu Accomando and Kristin J. Anderson, "Our Silence Will Not Protect Us... and Neither Will J. Edgar Hoover," *Humboldt Journal of Social Relations* 44 (2022): 9.

47
Malcolm X, "Last Answers and Interviews," in *Malcolm X Speaks: Selected Speeches and Statements*, ed. George Breitman (New York: Grove Weidenfeld, 1965), 196. This statement was made during an interview on January 18, 1965, just weeks before his assassination.

I think many whites would be less racist in their feelings. They would have more respect for the Black man as a human being."[48] That said, Malcolm X knew better than to wait on white society to change. Instead, as generations of local Black American organizers and community leaders have demonstrated in their daily efforts, it is necessary to draft one's own destiny.

48
Malcolm X, "Last Answers and Interviews,"
196.

Malcolm X was not a trained geographer, but he was a cartographer of community-building. Especially in the last months of his life, Malcolm X blazed a new geography for Black American liberation, an intellectual space that he mapped onto the concrete contours of Harlem and other urban areas. In his condemnation of racist practices, Malcolm X called to question the political, economic, and legal control of everyday life. The struggle for social justice, Malcolm X understood, was and remains a spatial struggle.

79

JAMES A. TYNER

ARCHITECTING

A SPATIAL CO

AND

EL-HAJJ MALIK

LISA BEYELER

DENISE LIM

FRIENDSHIP: MMEMORATION OF YURI KOCHIYAMA

EL-SHABAZZ/ MALCOLM X

VARRA AND

LISA BEYELER-YVARRA is a landscape designer and doctoral candidate pursuing a combined degree in the Department of Religious Studies and the School of Architecture at Yale University. Her research examines religious and racial imaginaries that co-construct supposedly secular architectures, with special interest in transpacific colonial infrastructures.

DENISE LIM is an assistant professor in Art and Design History and Theory at The New School's Parsons School of Design. Her work focuses on the material and visual cultures of diverse African communities, including South Africa's rich cultural heritage in art, architecture, and design.

Moving between family photographs and axonometric drawings produced by South African architects Zakiyyah Haffejee and Adam Osman, this multimedia conversation honors the radical friendship between Japanese American activist Yuri Kochiyama[1] and Black nationalist leader El-Hajj Malik El-Shabazz (الحاجّ مالك الشباز or Malcolm X).[2] As a spatial commemoration, these drawings and multi-temporal artifacts offer a mediated remembering of the Hiroshima-Nagasaki World Peace Study reception that took place in the Kochiyama home on June 6, 1964. Zakiyyah and Adam's drawings use spatial memory and mapping as a method to represent how Black-Asian solidarity and co-conspiratorship were architected in the lives of two friends.

1
We extend our immense gratitude to Akemi Kochiyama for sharing her memories of her late grandparents, Yuri and Bill Kochiyama, through personal stories, drawings, and photographs.

2
Cedric Dewayne Burrows, "El-Hajj Malik El-Shabazz or Malcolm X: The Construction of El-Hajj Malik El-Shabazz's Religious Identity in Composition Readers," *Journal of Africana Religions* 3, no. 1 (2015). 01 43. *El-Hajj* is an honorific title given to those who complete pilgrimage to Mecca, the first name *Malik* means "king," and *El-Shabazz* references an ancient African tribe that, according to the Nation of Islam, originated from Mecca and populated Central Africa. To honor and respect this important name change, we refer to Malcolm X heretofore as El-Hajj Malik El-Shabazz.

83

LISA BEYELER-YVARRA AND DENISE LIM

DENISE LIM (DL) I would love to start our conversation with this photograph of Yuri and Bill Kochiyama's kitchen table at their Manhattanville Houses apartment in Harlem, New York. When I first saw this photograph, I never would have guessed that this table was meant for dining. It looks like it belongs in an office!

The Kochiyama family kitchen table at their Manhattanville Houses apartment in Harlem, New York, 1996. Yuri Kochiyama pictured on the right. Courtesy of the Kochiyama family.

3
Akemi Kochiyama (scholar-activist and granddaughter of Yuri Kochiyama), in discussion with the authors, September 24, 2022.

Yuri's granddaughter Akemi indeed told us that the kitchen was an extension of the living room—that it was Yuri's makeshift mailroom.[3] She kept all her important papers, political flyers, leaflets, and notebooks there. Akemi also recalled that the ironing board in her grandmother's living room was often used as a desk (see page 98, M03). Yuri liked not only that the ironing board

could easily fold up when they needed more space in the living room but that its placement meant she was close enough to the kitchen, the extension of her makeshift office. These were the rooms guests would encounter when first entering the apartment. It seems fitting that we would treat these spaces as a literal and figurative entry and exit point for our discussions.

LISA BEYELER-YVARRA AND DENISE LIM

LISA BEYELER-YVARRA (LBY) Yes, in fact, this photograph of the Kochiyama kitchen table was the latent entry point to this project. It is an image that has ambled in the recesses of my imagination for years. In 2015, I happened upon Maya Kochiyama's archival project, "My Journey to Discover the Legacy of my Grandma, Yuri Kochiyama," on *Discover Nikkei* and quickly became engrossed by the Kochiyama family's kitchen table—a place where, as Maya annotated, "all the magic happened."[4] I was fascinated by the assemblage of objects heaped, strewn, and multiplied on top and around the kitchen table—letters to political prisoners, protest flyers, souvenirs from demonstrations, instant noodle packages, origami paper cranes, manuscripts, newspaper clippings, photographs of loved ones, and Yuri's own artistically rendered picket signs—and how this perpetually expansive and kaleidoscopic "architecture" of political organizing illuminated the spatial and temporal intimacies between localized experiences and national and global realities, from family histories to Third World solidarity movements (see page 98, M01).[5]

DL: Absolutely. What impresses me about this kitchen, too, is that it speaks to the ways in which visual analyses of Yuri's domestic space and its material referents provoke nonlinear and multilayered understandings of how social issues, regardless of time or place, con-

4
Maya Kochiyama, "My Journey to Discover the Legacy of my Grandma, Yuri Kochiyama," *Discover Nikkei*, last modified November 9, 2011, https://discovernikkei.org/en/nikkeialbum/albums/472.

5
Jaimee A. Swift, "Celebrating 100 Years of Yuri Kochiyama: Akemi Kochiyama on Her Grandmother's Life, Leadership, and Legacy," *The Margins*, May 19, 2021, https://aaww.org/celebrating-100-years-of-yuri-kochiyama.

verge at the table. The one item I noticed immediately in the photograph was the "Free Mumia" flyer, referring to Mumia Abu-Jamal, the African American activist and journalist who was convicted and sentenced to death for the murder of Philadelphia police officer Daniel Faulkner on December 9, 1981. Though the original flyer Yuri had hanging above her kitchen table simply read, "FREE MUMIA," our speculative drawing includes another archival poster that we spotted on a kitchen cabinet in a personal photograph of granddaughter Akemi Kochiyama and her partner Marc Sardinha. Yuri took this photograph of them in her kitchen sometime between 1997–1998, but a partial view of the poster is seen on the cabinet above the coffee machine (see page 98, M08). Unlike the yellow flyer, the declaration "abolish the death penalty" is prominent in the text.

Akemi Kochiyama and her partner Marc Sardinha in the kitchen of the Kochiyamas' Manhattanville Houses apartment in Harlem, New York, ca. 1997–1998. Courtesy of the Kochiyama family.

LISA BEYELER-YVARRA AND DENISE LIM

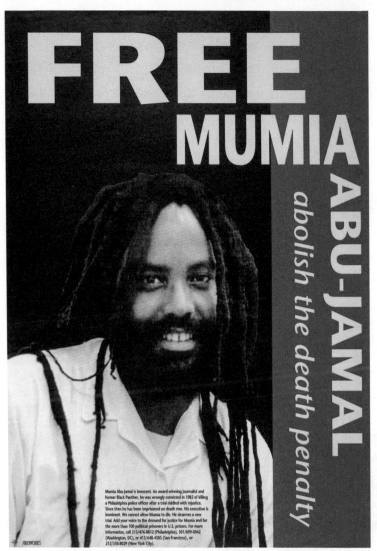

Mumia Abu-Jamal is innocent. An award-winning journalist and former Black Panther, he was wrongly convicted in 1982 of killing a Philadelphia police officer after a trial riddled with injustice. Since then he has been imprisoned on death row. His execution is imminent. We cannot allow Mumia to die. He deserves a new trial. Add your voice to the demand for justice for Mumia and for the more than 100 political prisoners in U.S. prisons. For more information, call 215/476-8812 (Philadelphia), 301/699-0042 (Washington, DC), or 415/648-4505 (San Francisco), or 212/330-8029 (New York City).

"Free Mumia Abu-Jamal: abolish the death penalty" poster, 1995. Courtesy of Fireworks Graphics/Henry Bortman.

Mumia was one of the most famous political prisoners in the country. He was a former member of the Black Panther Party and a supporter of Philadelphia's MOVE, a radical organization dedicated to Black liberation, anarcho-primitivism, and

environmentalism.[6] He not only served as president of the Philadelphia Association of Black Journalists from 1978–1980 but also covered the 1978 shootout between the Philadelphia Police Department (PPD) and nine members of MOVE: Chuck, Delbert, Janet, Janine, Merle, Michael, Phil, and Debbie Sims Africa.[7] In an attempt to forcibly remove MOVE from their Powelton Village property on August 8, 1978, PPD Officer James Ramp was killed by gunshot in a shootout. Though MOVE members surrendered, maintaining that they did not shoot Ramp,

> television cameras filmed a police officer striking Delbert Africa... with the butt of a shotgun and then dragging him along the ground as other police officers kicked him. Police bulldozed the house to the ground the following day, destroying the crime scene and making analysis of many of the day's events impossible.[8]

All nine MOVE members were convicted of third-degree murder and sentenced to a maximum of 100 years in prison. Mumia published articles openly condemning the wrongful and excessive force used by police against MOVE members and declared the trial unfair.

In 1981, MOVE relocated their headquarters to 6221 Osage Avenue, another row house in West

6
Denise Lim's colleague at The New School, Dr. Brittnay L. Proctor-Habil, suggested mentioning Abu Jamal's history with MOVE. The authors remain indebted to Dr. Proctor-Habil's incisive feedback and are grateful for her prompting to expound upon this history as we reflect on the intertwined lives of Yuri Kochiyama, Mumia Abu-Jamal, and El-Hajj Malik El-Shabazz.

7
MOVE members all changed their surnames to Africa, after the organization's founder, John Africa (born Vincent Leaphart), and after what they considered to be their mother continent.

8
Amnesty International, *USA: A Life in the Balance—The Case of Mumia Abu-Jamal* (London: Amnesty International, February 2000), https://www.amnesty.org/en/wp-content/uploads/2021/06/amr510012000en.pdf.

89

LISA BEYELER-YVARRA AND DENISE LIM

Philadelphia. In 1985, in response to complaints from neighbors, police obtained arrest warrants for four MOVE members—a court order reflective of the hostile, anti-Black political culture at the time. Despite Philadelphia mayor Wilson Goode being the first Black man to hold that office, he and police commissioner Gregore J. Sambor classified MOVE a terrorist organization. After evacuating residents in the neighborhood, approximately 500 police officers surrounded the house and forcibly removed thirteen MOVE members. A PPD helicopter dropped two 1-pound bombs onto the roof of the house, killing eleven people—founder John Africa, five other adults, and five children ages seven to thirteen. The ensuing fire spread and destroyed nearly sixty-five neighboring homes. Mumia famously wrote and published "The Mother's Day Massacre" from prison that same year to protest the bombing of MOVE's headquarters. He declared, "It doesn't take a Rhodes scholar to figure out that the 1978 arrests, trial, and convictions of nine MOVE men and women in connection with the death of a city cop was a setup from the word go."[9]

Yuri was one of many activists who fought to prove Mumia's innocence. I point this out, because here we are in 2023, looking at a photograph from the Manhattanville Houses in New York from 1996, and contained within this artifact from Yuri's home is another: a flyer referencing a Philadelphia court

9
Mumia Abu-Jamal, "The Mother's Day Massacre," in *Writing on the Wall: Selected Prison Writings of Mumia Abu-Jamal*, ed. Johanna Fernandez (San Francisco: City Lights Publishers, 2015), 20.

case from 1982. Though Mumia's death penalty charge was dropped in 2011, he is still serving a life sentence without parole and is now entering a forty-two-year quest to overturn his conviction. The issue of racial inequity in the criminal justice system is not new. Black Americans are still incarcerated in state prisons at five times the rate of whites.[10] This violent reality remains pertinent given that Black liberation movements have historically been and continue to be criminalized. The more recent memory of Black Lives Matter (BLM) protests spanning 2013 to the present is a case in point. Particularly after the murder of George Floyd by a white police officer in Minneapolis, Minnesota, BLM became an international phenomenon and inspired solidarity protests worldwide.

10
Ashley Nellis, *The Color of Justice: Racial and Ethnic Disparity in State Prisons* (Washington, DC: The Sentencing Project, August 2022), https://www.sentencingproject.org/app/uploads/2022/08/The-Color-of-Justice-Racial-and-Ethnic-Disparity-in-State-Prisons.pdf.

LBY: Denise, I'm struck by your remarks on the temporal and spatial throughlines between 2023, 1996, and 1982, and Philadelphia and Harlem. In this photograph, I also see the way the kitchen table visualizes the entangled proximities of racialized state violence, forced migration, and incarceration in the lives of Mumia, the MOVE collective, and Yuri. Almost from their foundation, MOVE members were repeatedly arrested, brutalized, and evicted from their homes. Not only were they violently removed from Powelton Village and later Osage Avenue, through the fire-bombing and gunfire execution of

91

Tomaso, Phil, Zanetta, Delisha, Katricia, Theresa, Rhonda, Raymond, Frank, Conrad, and John Africa, but the government-sanctioned bombing of MOVE headquarters also leveled two neighborhood blocks and left over 200 West Philadelphian residents unhoused. Even the victims of the massacre were displaced after death: the remains of Katricia were contained at the Penn Museum without consent by the University of Pennsylvania until they were repatriated to her family in 2021, and the remains of Delisha—and at least one unrelinquished bone fragment of Katricia—are allegedly still being forcibly held by the Penn Museum.[11]

We also see these entanglements of dispossession and displacement in Yuri's lived experience as the daughter of Japanese immigrants in San Pedro, California, who, after Executive Order 9066, lost her family home and was incarcerated first in a horse stable in Santa Anita and then in a concentration camp in Jerome, Arkansas. Yet, what also remains with me from this photograph of the kitchen table is the way that—within and despite these violent conditions—Yuri and Mumia were able to build long-standing coalitions of mutuality that could not be fully extinguished by the state.

DL: Absolutely. Yuri's support of Mumia, even thirty-three years after his conviction, struck me as a deferential nod to what she believed the late El-Hajj

11
Abdul-Aliy A. Muhammad, "Statement on the New Evidence About MOVE Remains Held at Penn Museum," Gran Varones, August 31, 2023, https://granvarones.com/press-release-statement-on-new-evidence-about-move-remains-held-at-penn-museum.

Malik El-Shabazz stood for. He not only had his own radical awakening during his time in prison but also led an impassioned cause against racialized police brutality in 1962, when Nation of Islam member Ronald Stokes was fatally shot by Los Angeles police. In a press conference held on April 4, 1996, at the Pennsylvania State Capital building, Yuri not only protested the execution of Mumia Abu-Jamal but was also entrusted to read a statement on behalf of the Shabazz family. Theologian Mark Lewis Taylor, founder of Educators for Mumia Abu-Jamal, recalled Yuri's speech that day: "What was memorable about her speech... was that Yuri Kochiyama linked her advocacy for Mumia to the struggles of nearly all other marginalized and oppressed groups and their political prisoners." For Yuri, Mumia was "one of the best exemplifications of a principle of human activism that she expressed in her first letter to Malcolm X: the 'togetherness of all peoples.'"[12] After Yuri passed away on June 1, 2014, Mumia commemorated her by audio recording an obituary he composed. His remembrances concluded with: "Yuri Kochiyama, freedom fighter, after 93 summers, has become an ancestor."[13] Just as Mumia and Yuri thought of El-Hajj Malik El-Shabazz as an important ancestor to the movement, Mumia recognized Yuri as one too.

LBY: Another object that speaks to me in the photograph of Yuri's kitchen table is the ring of origami paper

12
Mark Lewis Taylor, "She 'Has Become an Ancestor'—Yuri Kochiyama's Legacy: I Remember," Mark Lewis Taylor: Professor of Theology and Culture, Princeton Theological Seminary (blog), June 3, 2014, http://marklewistaylor.net/blog/she-has-become-an-ancestor-yuri-kochiyamas-legacy-i-remember.

13
Mumia Abu-Jamal, "Yuri Kochiyama," Prison Radio, June 2, 2014, https://www.prisonradio.org/commentary/yuri-kochiyama.

93

cranes that circle a solitary crane against a coral sky. The wreath recalls a *senbazuru* 千羽鶴, or string of 1,000 origami paper cranes, a material representation of collective prayers for peace and healing famously associated with the Hiroshima Peace Memorial Park and its Children's Peace Monument (see page 98, M05). It speaks to me of Yuri's lifelong commitment to nuclear disarmament.[14] Perhaps, in a different register, it might be read as a trace reminder of the Hiroshima-Nagasaki World Peace Study Mission reception, which was held in the Kochiyama apartment thirty-two years before this photograph was taken.

The Hiroshima-Nagasaki World Peace Study Mission reception honored three *hibakusha* 被爆者 (atomic bomb survivors) journalists who participated in a two-year-long world tour to advocate for the abolition of war.[15] "Our place was jampacked," Yuri recalled, "from the living room, kitchen, all the way to the back bedrooms, and in the hallway, with civil rights activists as well as three writers and some other Japanese *hibakusha* (see page 98, M07)."[16] To the unexpected delight of the *hibakusha* journalists, the person they wanted to meet "more than anyone else in the United States," El-Hajj Malik, joined the reception to meet and address those gathered.[17] In his reception speech, he brought together the suffering of the *hibakusha* with the plight of those facing diasporic dispossession in Harlem, saying, "You have been scarred by the atomic bomb... we have also been scarred. The bomb

14
Diane Fujino Carol, *Heartbeat of a Struggle: The Revolutionary Life of Yuri Kochiyama* (Minneapolis: University of Minnesota Press, 2005), 242. As Fujino notes, Yuri delivered Hiroshima Day speeches "annually from 1965 to 1971 and intermittently into the 1990s."

15
"A-Bomb Survivors Begin World Trip; Japanese on Peace Mission Make US First Stop," *New York Times*, April 26, 1964.

16
Yuri Kochiyama, "The Impact of Malcolm X on Asian-American Politics and Activism," in *Blacks, Latinos, and Asians in Urban America: Status and Prospects for Politics and Activism*, ed. James Jennings (London: Praeger, 1994), 132.

17
Fujino Carol, *Heartbeat of a Struggle*, 140.

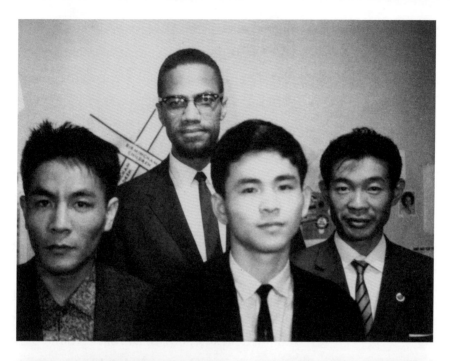

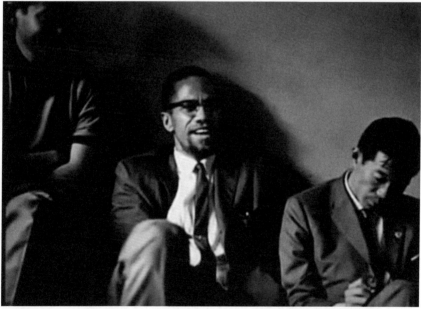

Photographs of Malcolm X and the *hibakusha* journalists at the Hiroshima-Nagasaki World Peace Study Mission reception, 1964. Yuri and Bill Kochiyama Papers, Malcolm X Scrapbook, Rare Book and Manuscript Library, Columbia University Library.

LISA BEYELER-YVARRA AND DENISE LIM

18
Yuri Kochiyama, *Passing It On: A Memoir*, ed. Audee Kochiyama-Holman, Akemi Kochiyama-Sardinha, and Majorie Lee (Los Angeles: UCLA Asian American Studies Center Press, 2004), 69.

19
Kochiyama, *Passing It On*, 69.

20
Kochiyama, *Passing It On*, 69.

that hit us was racism (see page 98, M02)."[18] From the co-constitutive devastations of Hiroshima, Nagasaki, and Harlem, El-Hajj Malik went on to connect these sufferings to the American war in Vietnam, casting the war as the "struggle of the whole Third World."[19] Just as Yuri's kitchen table was a crucible that gathered ostensibly divergent networks together, El-Hajj Malik's speech articulated an essential throughline between atomic suffering, racism, and war that revealed a global "struggle against colonialism, neocolonialism, and imperialism."[20]

In this way, the wreath of cranes is a critical landmark in the story of Yuri and El-Hajj Malik's enduring friendship. In the background of the few photographs we have of the Kochiyama's Hiroshima-

Late summer family gathering with friends at the Kochiyamas' Manhattanville Houses apartment in Harlem, New York, ca. 1997. At the center of the picture is baby Kai Naima Willams, Yuri's first great grandchild. Photograph taken by Yuri in her living room. Courtesy of the Kochiyama family.

Nagasaki reception is the specter of the kitchen table. The Kochiyama's kitchen table, a spatial datum in the vestige photographs of the event, endured as a silent witness to the local and global solidarities that convened together on that summer night in 1964, and throughout the thirty-eight years that the Kochiyama family lived and labored in the Manhattanville Houses.

DL: I love how you describe the kitchen table as a spatial datum, because it speaks to one of our aspirations with the project. We wanted to explore what it might look like to tell the story of their friendship through speculative drawing. How does the specificity of a place prompt these unexplored memories and histories? In architecture, axonometric drawing is a method of illustrating three-dimensional objects in two-dimensional space. This full axonometric view of the Kochiyama apartment allows us to rotate the apartment on one or more axes and reveal multiple sides, angles, and perspectives. We wanted to zoom in and out of specific rooms, focusing on certain details that were central to the memories of Yuri and her progeny. We liked, for example, elements such as the noren 暖簾 (see page 98, M06), a Japanese curtain or fabric divider that traditionally serves to protect a home from sun, wind, dust, or rain. It functions as a type of veil that marks the separation or transition between two spaces. The noren signals a fluidity and

LISA BEYELER-YVARRA AND DENISE LIM

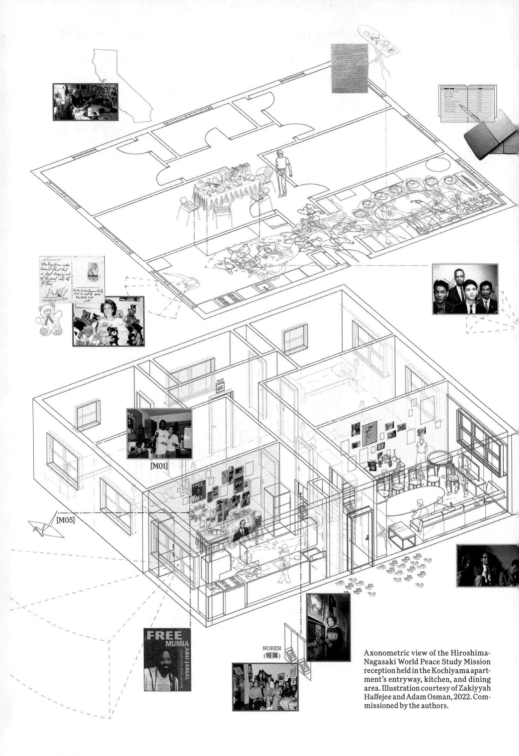

Axonometric view of the Hiroshima-Nagasaki World Peace Study Mission reception held in the Kochiyama apartment's entryway, kitchen, and dining area. Illustration courtesy of Zakiyyah Haffejee and Adam Osman, 2022. Commissioned by the authors.

[M01]

[M05]

FREE MUMIA ABU-JAMAL

NOREN (暖簾)

KEY

● Yuri Kochiyama
● El-Hajj Malik El-Shabazz
● Hibakushas
● Bill Kochiyama

— — — Yuris' Point of View
—·—·— Malcolm X's Movement
——— Domestic Symbols
——— Reception Guests

[Y] Said By/Relating to Yuri
[MX] Relating to Malcolm X
[M] Memory Based Text
[HBK] Relating to Hibakushas

interconnection between the reappropriated functions of the kitchen and living room. Remembering through drawing and looking is a way to ask ourselves what we miss and what we notice when we shift the scale and direction of our attention to the intimate conversations and relations that unfolded in Yuri's apartment across and between specific rooms, objects, and people.

99

Shifting objects, my favorite artifacts of Yuri and El-Hajj Malik's friendship are the postcards that El-Hajj Malik sent during his travels to the Middle East and Africa. Though he is better known as Malcolm X, the reason we refer to his Arabic name is to honor that, between April and May 1964, he completed *Hajj* (حج or "pilgrimage to Mecca"), where he encountered Sunni Islam in a completely different way than he did in the Nation of Islam. One

LISA BEYELER-YVARRA AND DENISE LIM

of my favorite postcards that El-Hajj Malik sent to the Kochiyama family from Kuwait in September 1964 reads: "Still trying to travel and broaden my scope since I've learned what a mess can be made by narrow-minded people. Bro. Malcolm X." I think it's important to acknowledge that both his international travels and intercultural/interracial friendships reflected an expanding worldview that reshaped his definitions of Black nationalism.

After his break from the Nation of Islam, El-Hajj Malik expounded upon his changing definitions in a 1965 interview with *The Young Socialist*.[21] He said that, initially, he defined Black nationalism as "the idea that the Black man should control the economy of his community, the politics of his community."[22] But, after one of his trips to Ghana in May 1964, he met an Algerian ambassador whom he considered revolutionary. When he shared his views on Black nationalism with the ambassador, he responded by asking El-Hajj Malik where he thought the place of revolutionaries in Morocco, Egypt, Iraq, or Mauritania might be within his conception of Black nationalism.

El-Hajj Malik responded: "So, he showed me where I was alienating people who were true revolutionaries dedicated to overturning the system of exploitation that exists on this earth by any means necessary. So, I had to do a lot of thinking and reappraising of my definition of Black nationalism."[23]

21
Denise Lim's colleague at The New School, Dr. Brittnay L. Proctor-Habil, shared this specific quotation with Denise after providing feedback on an earlier draft of this article. The authors express their gratitude to Dr. Proctor-Habil for this citation, which provides important context to El-Hajj Malik El-Shabazz's changing definitions of Black nationalism.

22
Malcolm X, "*The Young Socialist* Interview," in *By Any Means Necessary: Speeches, Interviews, and a Letter*, ed. George Breitman (New York: Pathfinder Press, 1970), 191.

23
Malcolm X, "*The Young Socialist* Interview," 191.

A Typical Mosque in Kuwait

Still trying to travel
and broaden my
scope since I've
learned what a
mess can be made
by narrow-minded
people –
Bro. Malcolm X

Mr. & Mrs. Wm Kochiyama + family
545 West 126th St Apt 3-B
Harlem, New York
USA

Postcard from Kuwait marked as sent from "Bro. Malcolm X" to "Mr. & Mrs. Wm Kochiyama" on September 27, 1964. Courtesy of Yuri and Bill Kochiyama Papers, Malcolm X Scrapbook, Rare Book and Manuscript Library, Columbia University Library.

Later, he pointed out that he'd stopped using the expression "Black nationalism" for several months and was still reassessing how he might describe his overall philosophy on Black liberation. This interview was given a month before his assassination. For me, this interview and El-Hajj Malik's postcard to the Kochiyama family succinctly capture his foray into Black radical internationalism. Racial inequality and injustice were not merely a domestic problem in the United States but moreover a global crisis. He saw value in fighting for, with, and alongside oppressed people all over the world to dismantle Western imperial and colonial structures.

101

LISA BEYELER-YVARRA AND DENISE LIM

LBY: I'm so glad that you bring up these postcards, and the Kuwait postcard in particular, because El-Hajj Malik's postcards are such an important testament to their friendship—especially, to my mind, the simultaneously intimate and public nature of their relationship. Interestingly, El-Hajj Malik sent a nearly identical postcard to Gloria Owens, a Cleveland resident and the sister of Sheikh Al-Hajj Hazziez (born Maceo X Owens), who was the secretary at Muhammad's Temple of Islam No. 7 in Harlem. On a similar postcard of the New Seif Palace, impressed with the same sepia-toned stamp of Kuwait, El-Hajj Malik wrote to Gloria: "Greetings from beautiful Kuwait. Since I've seen what a mess can be made of things by narrow-minded people, I'm still traveling, still trying to broaden my scope – Bro Malcolm X." Now, one might say that these parallel postcards signify a detached or formal association, but I think that the openness that

Postcard from El-Hajj Malik to Gloria Owens from Kuwait in December 1964, with an image caption that reads "New Seif Palace, Kuwait." Courtesy of the *Guardian*.

characterizes postcards as a material object—a postcard is addressed to one person or emplaced group, but its image, message, stamp, and recipients can be intercepted and read by anyone—speaks to the unique kinship that El-Hajj Malik and Yuri shared.

Like the postcard, the most significant moments in their friendship—their initial meeting at a courthouse proceeding following the Downstate Medical Center protests in Brooklyn, El-Hajj Malik's appearance at the Hiroshima-Nagasaki reception in Harlem, and his murder in Washington Heights—were, at once, deeply personal and thoroughly public. Like Yuri's ever-evolving kitchen table, El-Hajj Malik's postcards traveled through space and time, illuminating diasporic adjacencies and shared languages between seemingly distinct people and places. Here, he situates his personal and political transformations within his network of friendships with the Kochiyama and Owens families and connects his awakenings in Kuwait and abroad to communities in Harlem and Cleveland.

DL: The fact that El-Hajj Malik personally visited the Kochiyama family in their home speaks to an intimacy and vulnerability that only deep friendship can provide (see page 98, YM01). When he came to meet and speak with the three *hibakusha* in June 1964, it was just a month after he'd returned from visiting Egypt, Lebanon, Saudi Arabia, Nigeria,

Ghana, Morocco, and Algeria. As El-Hajj Malik drew this connection between the 1945 atomic bombing of Hiroshima and Nagasaki in Japan and the bombs of racism in the US, I thought about how he had avoided the military draft in 1943 by declaring that he wanted to fight for the Japanese. Little did he know back then that it was the same year Yuri and her family were displaced to Japanese internment camps. Yuri and El-Hajj Malik were from disparate cultural backgrounds and social worlds, yet both experienced facets of racialized trauma that connected them twenty years before they first met.

It is also powerful to think about how Yuri showed up for El-Hajj Malik when he was assassinated at the Audubon Ballroom in Harlem on February 21, 1965. Yuri immediately ran to him after he had been shot and held his head in her lap—a moment famously captured and published on the cover of *Life* magazine. Just as good friends often hold space for us, Yuri created and held space for him in a time when he and his family needed it most.

LBY: Denise, your reflections on journeying as a personal and social formation help put into focus the overlapping spatial proximities that we see in Adam and Zakiyyah's speculative drawing of the Hiroshima-Nagasaki reception. Within the elastic limits of the Kochiyama home, this drawing visibilizes the eruptive ecology of movements—the entangled pathways

of *hibakusha* guests, Civil Rights activists, family, friends, Yuri, her husband Bill, and El-Hajj Malik[24] —that characterized the spatial dynamism of the reception, as well as the effervescent placemaking practices of everyday life in the Kochiyama home (see page 98, M06, M07).[25]

In the photographic remnants we have of the reception, we can begin to trace the contours of Yuri and El-Hajj Malik's concurrent journeys through the apartment: from the entryway—the scene of El-Hajj Malik's speech—to the kitchen and living room, where, in a photograph belonging to the Kochiyama family, El-Hajj Malik sits shoulder-to-shoulder with two of the *hibakusha* journalists, his gaze directed upward toward out-of-frame participants (see page 98, MX01).[26] When I view these photographs, I imagine that I am witnessing this event through Yuri's eyes. Yuri is noticeably absent from the reception photographs. So, I began to conceptualize these photographs as a kind of three-dimensional chiasmus: on one side, the physical walls of the Kochiyama home (which, as we've seen, held the physical ephemera of community organizing and was the meeting place for so many movements, from the Harlem Parents Committee to the RAM Black Panther Party in Harlem); on the other, Yuri herself taking photographs of her guests; and encircled within these overlapping modes of hospitality, El-Hajj Malik El-Shabazz and the

24
Kochiyama, discussion. Zakiyyah and Adam's drawings are based on conversations with Akemi Kochiyama and Kochiyama family photographs shared with the authors.

25
Kochiyama, discussion. Akemi noted that Yuri would document every visitor in her home in her guestbook (see page 98, M04). Whether you casually entered the Kochiyama home with a friend or were a special guest for an event, everyone had to sign Yuri's guestbook. Alongside her kitchen table, ironing board, and walls, the guestbook was another dynamic placemaking ritual: a spatial archive of the diverse networks of friendship that coalesced in her home.

26
Akemi Kochiyama, "Reflections on my Grandma Yuri, Malcolm X, and the Past, Present, and Future of Black-Asian Solidarity," *That Which Remains Journal* 1 (2022), https://www.twrjournal.com/nonfiction-akemi-kochiyama.

105

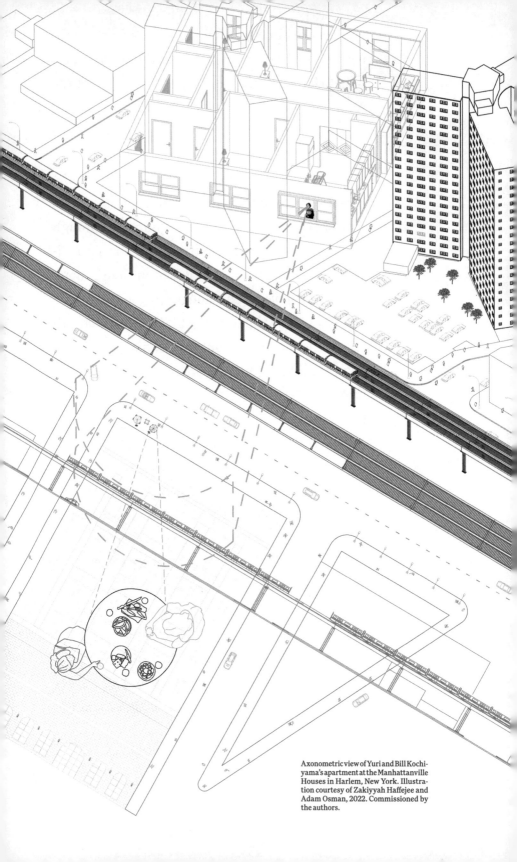

Axonometric view of Yuri and Bill Kochiyama's apartment at the Manhattanville Houses in Harlem, New York. Illustration courtesy of Zakiyyah Haffejee and Adam Osman, 2022. Commissioned by the authors.

27
Kochiyama, discussion. This spatial conjecture was confirmed by Akemi Kochiyama, who explained that Yuri was a prolific photographer and documented many of the events in their home.

hibakusha journalists. It is another image of Yuri "holding space," as you said, for her comrades (see page 98, M02).[27]

DL: That's beautifully put. Yes, I really loved this idea of thinking about this apartment as connecting multiple people, places, and times in one discrete location of space-time. This apartment has such rich memories. Adam and Zakiyyah's idea of depicting intergenerational friendship between the two families is so powerfully illustrated by Yuri looking out from her window, as if she can see across the street to where El-Hajj Malik's daughter Attalah and Yuri's granddaughter Akemi would later meet for dinner in 2016.[28] There is a way in which multiple generations still speak to each other, even after they have passed on.

28
Kochiyama, "Reflections on my Grandma Yuri, Malcolm X, and the Past, Present, and Future of Black-Asian Solidarity."

LBY: Yes, fifty-two years after the Hiroshima-Nagasaki reception, on the night of the 2016 presidential election, Akemi Kochiyama and Attalah Shabazz had dinner at an Italian restaurant across the street from the Manhattanville Houses. "From where I was sitting in the restaurant," Akemi recounts,

> I could see my grandparents' kitchen window, a sight that caused me to envision my favorite image of Malcolm in my grandparents' kitchen that night in 1964, standing alone with a dazzling smile...

107

LISA BEYELER-YVARRA AND DENISE LIM

I thought about our proximity to so much history and beautiful struggle in that kitchen as I... watched Auntie Attalah sitting next to me with that same dazzling smile, holding court.[29]

29
Kochiyama, "Reflections on my Grandma Yuri, Malcolm X, and the Past, Present, and Future of Black-Asian Solidarity."

In Adam and Zakiyyah's second drawing, we see Yuri "holding court" with Akemi and Attallah, linking familial and extrafamilial kinships, as well as divergent timelines, through Akemi and Yuri's reciprocal gazes. Akemi and Attallah are pathbreaking scholars and activists in their own right. Their work takes up the aspirations and visions of Yuri and El-Hajj Malik, reimagining and amplifying their prophetic messages for a new generation.

What fascinated me about the Kochiyama apartment in 2015, and what continues to inspire me today is that, like the kitchen table, it always exceeds the material edges of its architecture to construct ongoing fugitive solidarities[30] that are illegible to the forces of "colonialism, neocolonialism, and imperialism" that they resist.[31] It is an emplaced way of living that enacts collective possibilities of friendship across time and space, overcoming and overturning the structures that work to constrain their undercurrents.

30
See Saidiya Hartman, *Lose Your Mother: A Journey Along the Atlantic Slave Route* (New York: Farrar, Straus and Giroux, 2008); and Hartman, *Wayward Lives, Beautiful Experiments: Intimate Histories of Social Upheaval* (New York: W. W. Norton, 2019). See also Fred Moten, *Stolen Life* (Durham, NC: Duke University Press, 2018); and Fred Moten, *The Undercommons: Fugitive Planning and Black Study* (New York: Minor Compositions, 2013).

31
Fujino Carol, *Heartbeat of a Struggle*, 140.

In 1999, Yuri moved to San Pablo, a hotel-turned-senior-living-facility subsidized by the Oakland Housing Authority in Oakland, California. She brought her unique placemaking traditions to her studio apartment—lining the walls and tabletops with posters, photographs, letters, gifts, notes, and newspaper clippings, and surrounding herself with the same archival assemblage that characterized her home in Harlem. Still from *Mountains That Take Wing—Angela Davis & Yuri Kochiyama: A Conversation on Life, Struggles & Liberation*, 2010, a film by C. A. Griffith and H. L. T. Quan. PHOTO © QUAD Productions 2008.

LISA BEYELER-YVARRA AND DENISE LIM

ARCHIVING T[

A

CONVERSATION

AND

JAIMEE A[

ANSNATIONAL

SOLIDARITY

WITH

AKEMI
KOCHIYAMA

SWIFT

AKEMI KOCHIYAMA is a Harlem-based writer and scholar-activist whose work is focused on community-building, solidarity, and social justice. The granddaughter of Yuri Kochiyama, she is co-director of the Yuri Kochiyama Solidarity Project and co-editor of *Passing It On: A Memoir* by Yuri Kochiyama. A doctoral candidate in cultural anthropology, her dissertation and research is about the impact of Yuri Kochiyama's personal and political practice in support of human rights, radical solidarity, and multicultural community-building on BIPOC activists, educators, and artists working in these areas today.

JAIMEE A. SWIFT is the executive director and founder of Black Women Radicals, a Black feminist advocacy organization dedicated to uplifting and centering Black women and gender-expansive people's radical activism in Africa and in the African diaspora. She is also the creator and founder of The School for Black Feminist Politics, which has a mission of empowering Black feminisms in Black politics by expanding the field through transnational, intersectional, and multidisciplinary perspectives.

NAJHA ZIGBI-JOHNSON (NZJ) Thank you both so much for making space to have this dynamic and necessary conversation around the kinship between Malcolm X and Yuri Kochiyama. Akemi, as a guardian of Yuri Kochiyama's social justice legacy, that is so beautifully reflected in your extensive stewardship of her archive, your community-based scholarship, and commitment to radical institution-building—from Manhattan Country School to the Yuri Kochiyama Solidarity Fund—can you help us situate the relationship between Brother Malcolm and your grandmother, Yuri Kochiyama? Why should we be talking about them together?

AKEMI KOCHIYAMA (AK) Their relationship is an important story of solidarity. It might seem unlikely to people that a second-generation Japanese-American mother of six kids would become a radical Black nationalist and a disciple of Malcolm X. Their relationship points to the importance of history, how we build solidarity and community, and how we understand each other's stories. It is precisely because Malcolm and Yuri were both serious scholars of history that understood their connection to each other, their people, and their experiences in this country as people of color—and as people from parts of the world where imperialism impacted their lives—that they formed such a deep kinship. And, in this moment when people seem to characterize Black-

Asian relationships as hostile and prone to conflict, highlighting the relationship between Malcolm X and Yuri Kochiyama offers a deepened context to the rich history of Black-Asian solidarity.

I just came from California where I went to see Mutulu Shakur, and I'm so glad I got to interview him on my phone, because who knows when I'm going to speak to him again.[1] When I visited, Mutulu was with his friend of over fifty years, Tatsuo Hirano, who is a Japanese-American acupuncturist. Tatsuo actually learned acupuncture from Mutulu, and, together, they created an anti-drug, anti-dope program using acupuncture to heal people back in the sixties and seventies. Tatsuo and Mutulu talked about how their common experiences and their shared commitment to using medicine as liberation brought them together. They had a similar vision, and they learned from each other and maintained that relationship for the thirty-seven years that Mutulu was locked up. Mutulu was moved from prison to prison all over the country quite purposefully, and Tatsuo went to see him wherever he was, regularly. Mutulu explained that they gave each other energy by doing that: they were both sustaining each other through that time. And Mutulu noted how important it is for people to understand the longevity of their relationship and how deep their solidarity was. Mutulu also talked a lot about Yuri and the work she was

1
Mutulu Shakur, brother of political activist Assata Shakur, passed away on July 6, 2023, after this conversation was recorded.

doing and connections she was making that we probably don't even understand today.

NZJ: Yes, thank you for this context. Jaimee, I have the same question for you. It is truly my honor to grow politically alongside you as we uplift the imperative of intergenerational, Black feminist leadership within radical social movements. I have personally learned so much from the range of international voices you bring together around shared visions of healing justice and collective wholeness. It has felt particularly generative to build with you around the legacy of Malcolm X and his wife Dr. Betty Shabazz, given how Black nationalist movements and our understanding of them have not always prioritized the voices and experiences of women, femmes, and gender-expansive people. Through your archival work and politically situated research, both with Black Women Radicals and the Black and Asian Feminist Solidarities, can you help situate the relationship between Yuri Kochiyama and Malcolm X? Why should we be thinking about these two figures together?

JAIMEE A. SWIFT (JS) Every book and every part of scholarship that I've read on radical movement-building always referenced some sort of cross-racial solidarity. I've interviewed Ericka Huggins and Denise Oliver-Velez, and not only did they cite

Malcolm X as an inspiration, but they also cited Yuri Kochiyama. Miss Denise, who was a leader in the Young Lords Party (YLP) and Black Panther Party (BPP), would say that Yuri was someone the YLP looked up to because of how she fought for Puerto Rican liberation alongside the organization. Ericka Huggins, who was also a leading member of the BPP, shared the same thing—that Yuri was always around and always supportive and offering her wisdom. Given the current assaults against Black studies as well as race and ethnic studies, I think now more than ever we need to center the solidarity between Malcolm X and Yuri Kochiyama. There is such a disconnect in the praxis of radical Black politics when talking about cross-racial solidarity. I think it's important at this political juncture that we learn from each other, and not just in a performative way or on social media but in actually doing the nitty gritty work that Yuri and Malcolm did in terms of decolonizing certain politics, changing praxes, and evolving visions of the world. How do we get to that point at this political juncture where everything is so polarized even within radical spaces?

AK: I would add to that the importance of self-education. Malcolm talked about this so much, and I think Yuri really absorbed the importance of self-education from Malcolm.

JS: Yes, you don't have to be an academic to be well-read. And I didn't learn about the relationship between Malcolm and Yuri in grad school or my doctoral program—I learned about their relationship outside of school. I'm in Black politics, and there's this romanticization of heterosexual male leadership in the discipline, which excludes Black women and Queer, trans, and gender-expansive folks. So, while I do think that Yuri and Malcolm's relationship was so important, I also believe Yuri was a scholar, innovator, and organizer in her own right, outside of Malcolm. I want to acknowledge this, because sometimes Yuri is clumped together with Malcolm in a way where we begin to believe that he "made" her. Yuri is a standalone organizer, radical, and intellectual, so I want to contextualize her in that tradition as well.

AK: Thank you for doing that. I just completed a whole timeline for the Yuri Kochiyama website we're working on as part of the Yuri Kochiyama Archives Project. Yuri and her family landed in Harlem in 1960, but they were interested in civil rights before then. Prior to moving to the Manhattanville Projects, Yuri and her family lived in the Amsterdam Projects on the Upper West Side for several years. There they met the Civil Rights activist Daisy Bates. They were so impressed by Daisy and her story that Yuri said something immediately sparked in her head, that

there was some connection between what Daisy Bates was talking about and what had happened to them while being interned during World War II. Yuri said she didn't completely understand the relationship between Japanese internment and the Civil Rights movement at the time but that she became really interested through this connection with Daisy.

And then Yuri and her family moved to Harlem in 1960, when, as Yuri said, "Harlem was on fire." It was in the early sixties that many community-based organizations started—the Harlem Parents Committee and the Harlem Freedom Schools. All this stuff around self-education starts to happen at that time. Yuri and her husband enrolled themselves and all six of their kids in the Harlem Freedom Schools, because they thought, "We should learn this history, because we live in this community. We should have a historical context for understanding the people we live with."

NZJ: Akemi, can you share a little more about this history and help historicize the meaning of your grandmother coming into a historically Black neighborhood in a very heightened political moment? What was it like for them, and how did they move through the neighborhood?

AK: Yuri described it as an exciting and wonderful time. They had just come from the Amsterdam Projects,

where the jazz artist Thelonius Monk was living at the time. And my mother (Yuri's daughter) first met my stepfather—who later became a Black Panther and African American studies professor—when they were children growing up in the Amsterdam Projects. Yuri and her family established very strong relationships there. The Amsterdam Projects, which were predominately Black, are actually located behind Lincoln Center. But Lincoln Center wasn't there when the Amsterdam Projects were built: it came later. They built Lincoln Center in the 1960s and did this whole gentrification thing and transformed the neighborhood.[2] Now people think of that area as a fancy, upper midtown area, but, actually, the Amsterdam Projects are the last physical and architectural legacy of that being a low-income neighborhood. So I think my grandparents had established really strong relationships in the Amsterdam Projects before moving to Manhattanville and felt very comfortable and welcomed living in a Black community, but they hadn't become politicized yet.

I used to think it was an anomaly that my Japanese-American grandparents ended up in public housing, but actually it isn't; it makes sense. They were totally disenfranchised—like most Japanese-American families—and didn't have anything coming out of internment. They were released after having their homes, cars, businesses,

2
Lincoln Center was realized between 1955 and 1969 through the clearing of San Juan Hill, a Black, Afro-Caribbean, and Puerto Rican community displaced and disbanded by Robert Moses' mid-twentieth century urban renewal plans for Manhattan. The Lincoln Square Renewal Project is one of many clearing initiatives undertaken by the city, and its class and racial ramifications persist to this day.

119

AKEMI KOCHIYAMA AND JAIMEE A. SWIFT

money, and everything taken from them. It's like getting out of prison with nothing. So, actually, many Japanese Americans returning to Los Angeles, Chicago, Detroit, San Francisco, and New York ended up in low-income, Black neighborhoods. And it was Black people who, in many ways, offered them mutual aid. I've heard of Japanese-American families who moved into houses owned by Black families who were sympathetic to their re-entry into a very anti-Japanese environment. The Japanese families paid nothing or very little in rent and expenses until they were able to get on their feet. Black people recognized this alienation and discrimination. So my family's story is actually not an anomaly.

Yuri and her family were living in this environment in 1960, and they were so broke when they moved to Manhattanville, during a snowstorm in December, that they couldn't even afford a moving truck. They moved all their stuff by subway, with their six kids. The two parents and their six kids: everybody carried something—even my uncle Tommy, who was two at the time, carried something. They did nine trips back and forth on the 1 train from 66th Street to 125th Street. It's a long walk from the Amsterdam Projects to the 66th Street Station on Broadway. They walked with furniture, everybody holding something, in a snowstorm, went uptown on the train, put things down, and then got back on the train downtown. Just envision this Japanese-

American family moving into Manhattanville in a snowstorm... That's the context.

The way Yuri described it, it was impossible to not get swept up in the excitement of Harlem at that time. On every street corner, there was some political organization—Yorubas, SNCC, the Fruit of Islam. She said, back then, there were so many different political movements, perspectives, and movements within movements happening. She loved to walk across 125th Street and hear these different people, and that's how she encountered Malcolm, on a corner listening to him talk. Initially, she heard him speak on behalf of the Nation of Islam. And she watched him go from doing that to evolving away from the Nation and establishing the Organization of Afro-American Unity—which she later joined and became a card-holding member of!

In 1963, she got an opportunity to meet Malcolm at a courthouse in Brooklyn, and she got the courage to speak to him, and that's how the relationship began. Before that, she had joined the Harlem Parents Committee and participated in the Freedom Schools, so she meets Malcolm right in the midst of this education process.

And she's a crazy note-taker. That's why her archive is so detailed and extensive. She was like an ethnographer. Every single political thing she ever went to, whether she was standing on a street corner or attending a meeting, she saved the flyer, and

she would write all the details—the date, the time, the place, etc. She would even describe, not just the names of the speakers, but how they appeared, what they were wearing, their physical appearance, the feeling in the room. I think she was just really excited, and I think she had an instinct for social justice and connecting to other people and their experiences. I'm not sure this was done consciously, because she had just been through an incredible trauma and was probably trying to work that out for herself. And Malcolm immediately struck her as someone who was saying something different. But I also think what struck her was watching him evolve; that political evolution was very important to her. She talked about that a lot as she got older, that you should evolve in your political philosophy, and you should be growing and changing as you learn more.

NZJ: In hearing about Yuri Kochiyama as an ethnographer and as someone who kept meticulous detailed descriptions of both the spaces she was in and the people she encountered, I'm curious, Jaimee, how do you approach the ethics of archival work as a political historian and founder of Black Women Radicals?

JS: Hearing Akemi talk about how her grandmother took meticulous notes immediately reminded me of Dr. Saidiya Hartman's conceptualization of the

symbolic violence of the archive, which she discusses in her essay, "Venus in Two Acts." In the piece she explores how Black women and girls, and particularly enslaved Black women and girls, suffered this double death.[3] Not only did they experience physical death and the physical trauma of being enslaved and having their culture, politics, everything, even their name stripped away from them, but these people were also rendered in the archives as Venus or Hottentot Venus and given names that were not their own or even simply not named at all. And I think about how Yuri was able to document everything that she experienced. We can see and we know that these archives are coming from her pen, her mind, her hand, and nobody can shift or create a symbolic death for her, because Yuri did that work on her own. And she did that work to preserve her life and her politics and her growth... even parts of her trauma, pain, and sadness.

As someone who is not trained as an archivist but who works with ethnography, who interviews a lot of people, I think it's so important that we are getting back to the root of preserving our stories and embodying a politic of *Sankofa*, which is an Akan word that means that it's not taboo to fetch what is at risk of being left behind. So much of our work as Black women and trans, Queer, and gender-expansive folks has been left behind because of colonization, because of enslavement and imperialism.

3
Saidiya Hartman, "Venus in Two Acts," *Small Axe* 12, no. 2 (June 1, 2008): 1-14.

123

AKEMI KOCHIYAMA AND JAIMEE A. SWIFT

So I approach the work with Black Women Radicals—archiving stories and interviewing and doing story-telling—as a praxis of love—a love of Black women and gender-expansive people, a love for Black people generally, and love for people irrespective of race. I also do it as a politic of care, because a lot of our stories are traumatic, and a lot of people don't feel comfortable telling their stories because of how traumatic they are. So it takes an ethic of care to do the work.

And this work also comes from a politic of community and a politic of futurity—of wanting to cultivate the futurity of our movements. Someone once said to me that we're all walking ancestors. And I think of that in the context of even geographical space; like, we do not know who was walking around in a certain space at a certain time. And sometimes we do, but I think a lot of the land we walk on is very much still a holy, sacred space. I think we should have honor and reverence for that. I think about what it was like for Malcolm to see Yuri Kochiyama on the corner—her walking up to him—and where they were geographically. I think about radical Black women in New York City, like Lorraine Hansberry, Claudia Jones, Audre Lorde, and Shirley Chisholm, and what that New York City landscape possibly looked like for them and how different it is now.

AK: Yes. I recently completed a planning meeting with the Yuri Kochiyama Solidarity Project, and we were

talking about programming for next year. One of the things I want to do is an annual Freedom School in the Manhattanville Projects. It was such a powerful experience to go there a few years ago and work with the kids and teenagers in the community and see their reaction and how empowered they felt by learning about Yuri and Malcolm—learning about who Yuri was and what she did, that she lived right here in this building and that all these important people, including Malcolm X, came to her apartment. They really saw the world differently after they learned this piece of history. I think we should be doing these regular teach-ins or Freedom Schools in the Manhattanville Projects so that, for the kids and the community there, it starts to be part of their story and an oral history that they all know, so that, even if that history wasn't written down, they could still tell people. I feel like that would be really powerful.

NZJ: The Manhattanville Projects is right off the 1 train, and Columbia University's newest Manhattanville campus, which houses the Business School, has popped up across the street and reflects a very visceral form of gentrification. In my eyes, much of the overtone of Harlem is that this university exists not as an educational institution first but as a real estate enterprise. Columbia is the largest landowner in New York City by the number of addresses it manages; the university has completely altered

the landscape of upper Manhattan through its rapacious expansion project all the way from 110th street up to 168th street in Washington Heights. That's the backdrop in which we now understand Harlem, the Manhattanville Projects, and the richness of our neighborhood. Akemi, because you and your family have done tremendous work around stewarding your grandmother's archive and legacy, how do you make sense of the ethical contradictions that Columbia upholds as both an educational institution and an expansionist project?

AK: As a person from Manhattanville, I am angry about the whole situation. I watched them build that campus. It's literally across from where the Kochiyama apartment is. All the windows of the west side of our apartment, 3B, face the elevated train tracks on Broadway. We grew up right there looking out on those tracks. I still live close by, and watching that thing go up has been really hard to me. I've been to art shows at the Forum and always ask the curator of these programs if people from Manhattanville are invited. They always say, "Oh yeah, they can come any time they want; it's free to them." I wonder: How do they know? Does Columbia go to the Manhattanville Community Center? Do they go around distributing flyers? Are they doing workshops and engagement opportunities in Manhattanville to let kids know they can walk into

this building? I'm sure those young people don't know that they can or don't feel that they're welcome in that building. That particular white, glassy construction feels offensive and violent. I grew up right there and can see they have a climbing wall and other facilities for kids. But not kids from Manhattanville. Supposedly kids from Manhattanville can play there, but little is done to ensure that they know that. I keep thinking: What traditions and spaces can we sustain and put in place? How can we make Columbia invest in the education and wellbeing of the Harlem community? How can we do this so they can't possibly change our story?

JS: We need to hold on to something outside of these institutions, because, even as an academic, I know these institutions are so invested in white supremacist fascist interests. I don't know what is to become of our work, what is to become of our futurity at these institutions and the world. We do need to hold onto our artifacts, our archives, our oral storytelling, and our traditions of being griots.

NZJ: What is the necessity of anti-imperialism and of understanding the kinship between Malcolm and Yuri in 2023, in this current moment?

AK: I always really love reading when Yuri writes about Malcolm. Throughout her life, she would write so

4
Yuri Kochiyama, "Malcolm X and the Kochiyamas," in *Passing It On: A Memoir*, ed. Audee Kochiyama-Holman, Akemi Kochiyama-Sardinha, and Marjorie Lee (Los Angeles: UCLA Asian American Studies Center Press, 2004), 67-79.

much about his love of humanity.[4] And all the proof is in his work, his love of humanity, and how much he loved people. Yes, he loved Black people, and he loved humans and knowledge and history. One of the things Yuri used to say a lot in feminist spaces when she was speaking about women (and she always was) is that the most important thing women of color can do is continue to speak their truth. It's a really hard thing to do; people don't want to hear it. But you have to keep saying it.

I think controlling our narrative is so important. Until we can understand and deconstruct white capitalist patriarchy and recognize it everywhere it is, we can't actually overcome or fight it. Yuri decided she was going to make sure people understood Malcolm. No one can deny the overwhelming amount of Yuri's life and energy that was spent connecting people, building community, and helping people educate themselves, empower themselves, and connect to their own humanity. One of my favorite quotes from Malcolm is about how the only way to free ourselves from oppression is to be in solidarity with everyone who is oppressed. And he meant that across the board—race, class, disability, etc.—whatever you're getting oppressed by, that's what he meant. And I think that's why understanding the impacts of anti-imperialism is so important for building solidarity.

JS: I think about this question in the context of one of my favorite speeches by Audre Lorde, titled, "Learning From the 60s."[5] And this was in 1982. In that speech, Lorde contextualizes Malcolm X's assassination and learning from the pitfalls and the mistakes that Black people and Black communities made in regards to not learning across difference. She talks about how Black nationalists were often sexist and how there is rampant homophobia happening in Black women's movements. If we do not learn across difference, and if we do not get coordinated and do our best to really enact freedom and get along in this freedom struggle, then we are going to lose. White supremacists are organizing together; they've always been organizing together across the globe. We can see it in the United States. We saw what happened in Brazil earlier this year, with Bolsonaro's supporters' attack on the capital on January 8th, which was a carbon copy of what happened with the January 6th attempted coup at the US Capitol two years ago. We're seeing migrants, African migrants, being turned away across the Mediterranean. We're seeing all these different movements against Black people, people of color, disabled people, and Queer and trans folks... and, if we are not unified in this regard, we are going to fail and lose each and every time. Because our enemy is surely dedicated to oppressing us.

I understand that, historically and in the contemporary moment, there's been anti-Asian and

5
Audre Lorde, "Learning from the 60s," in *Sister Outsider: Essays and Speeches* (Berkeley: Ten Speed Press, 2007 [1984]), 127-137. Lorde's lecture was given originally at Malcolm X Weekend at Harvard University in February 1982.

129

anti-Black violence, but there are people who are willing to learn and are willing to grow and evolve, like Malcolm X and Yuri Kochiyama did, to really understand that, though we may not see liberation in our lifetime, we will see liberation in the future. So that is why we need to know about Malcolm and Yuri and center their politics and praxis, because they represent what we are trying to achieve, and that is freedom and solidarity.

Malcolm's Greatness—The International Arena

by Yuri Kochiyama

How often We have heard of the "greatness" of Malcolm X. Because the term "greatness" has many connotations, the word, itself, needs clarification. It may be defined categorically in terms of superiority, quantity and size, boundlessness, importance, or reknown.

According to western historians, men such as Alexander, Caesar and Napoleon are considered "great". Their reknown was in the area of military domination—the conquering of lands and people, and bringing subjugation, havoc and destruction. Ghengis Khan also swept his army across continents proclaiming his power. He is listed in the Webster dictionary as "the Mongol Conqueror of land from the Black Sea to the Pacific". In history books he is not listed among the "greats", but as "leading a horde". He also left the same ravaging and crippling of realms and inhabitants.

Malcolm's greatness is derived from a totally different perspective. His objective was never "to conquer" others, and force them under his will; but to free his own people that they could maintain a measure of life through self-reliance, self-determination, and when necessary—through self-defense. He planted seeds of being proud of their Afrikan heritage and encouraged his people to learn the real (and true) history of Afrika's struggle against invaders and transgressors whether called "explorers", "missionaries", "traders" or "slavers". Before he was killed, he warned of "wolves in sheeps' skins"; of the prevalence in Afrika of c.i.a., right-wing journalists, linguists, sociologists, anthropologists, geologists, Afrika researchers, "tourists" and those who find Afrika "fascinating". He also warned of the same kind of "friendly enemies here". At the same time he always wisely and judiciously admonished to "distinguish the trees from the forest".

Malcolm was a teacher, leader, and prophet; never a conqueror; not even to conquer people's minds. His whole objective in life was to "free" people; free their minds, free them from negative thinking and habits; free them from institutions that confined them; from social mores and superficial 'needs' (like drugs) that strangle and warp them; to take off the blinders from their eyes, stuffings from their ears; transform themselves; to transform their own community that one day a transformed people would create their own progressive New Afrikan nation on this hemisphere.

He was the political composite of Geronimo, Patrice Lumumba, Tupac Amaru, Pedro Albizu Campos, Che Guevarra, Ho Chi Minh, Mao Tse Tung and Augusto Sandino—great men who fought against feudalism, foreign aggression, fascism, racism, colonialism, imperialism, and even uncle-tomism. He is interna-

> *"They were curious to know why the powerful amerikkkan government felt so threatened by one Black man..."*

tional because he understands from a world perspective, and thus has become recognized by progressive people around the globe.

In 1985, i met the reknowned Uruguayan playwright, novelist, poet, teacher and christian minister Hiber Conteris. He had recently come out of prison in Uruguay where he was tortured and incarcerated for 8½ years. He was in New York on a speaking tour. I told him that i had heard about him from an Argentinian playwright during the late '60s; that he had written a play about Malcolm around 1966. I asked him how he knew about Malcolm. He said he was in France in 1965 when Malcolm's autobiography first came out. He was so impressed by Malcolm that he went home to Uruguay (before he was imprisoned) and wrote a play which was performed there. I thought that was wonderfully incredible. He then said that Uruguay wasn't the only country that presented the performance about Malcolm. He said it was done in Cuba in 1967; in Chile in 1969, in Czechoslavakia in 1970 and in Poland in '71.

I will also never forget when Malcolm came to our house in June of '64 for a reception for four Japanese hibakusha writers (atom-bomb victims of Hiroshima and Nagasaki). The four Japanese journalists had expressed that they wished to meet Malcolm X more than any other person in amerikkka—if it could possibly be arranged. They were curious to know why the powerful amerikkkan government felt so threatened by one Black man; also why the amerikkkan press vilified him so abusively.

That period (1964) was dangerous for Malcolm. It was only a few months after he left the Nation of Islam. Rumors of threats to his life were rampant. He was also preparing a trip to Afrika and the Middle East.

131

Yuri Kochiyama, "Malcolm's Greatness—The International Arena," undated. Yuri and Bill Kochiyama Papers, Malcolm X Scrapbook, Rare Book and Manuscript Library, Columbia University Library.

AKEMI KOCHIYAMA AND JAIMEE A. SWIFT

SHINING

ALBERT
HICKS IV

AND

PRINCE

MARCUS

WASHINGTON

JR.

AYEM is a collaborative venture between Albert Hicks IV and Marcus Washington Jr. Albert is an art director at *Bloomberg Businessweek,* bringing with him a rich background from *Document Journal,* the Whitney Museum of American Art, and Apple. Marcus is a senior product designer at the New York Public Library. He was a graphic designer at Hood By Air and later became a product designer for tech company Bentobox. Marcus and Albert crossed paths during their studies at Parsons School of Design, and Marcus further expanded his creative horizons at Central Saint Martins.

Ayem extends beyond the conventional boundaries of graphic design, art direction, and user experience. Ayem's personal projects explore tangible elements such as textiles and furniture. Together, Hicks and Washington have undertaken art direction and design for A24, Hulu, the Studio Museum in Harlem, Saint Heron, the Whitney, Nicola Vassal Gallery, and many others. The projects orchestrated by Ayem are fueled by passion, partnership, and purpose.

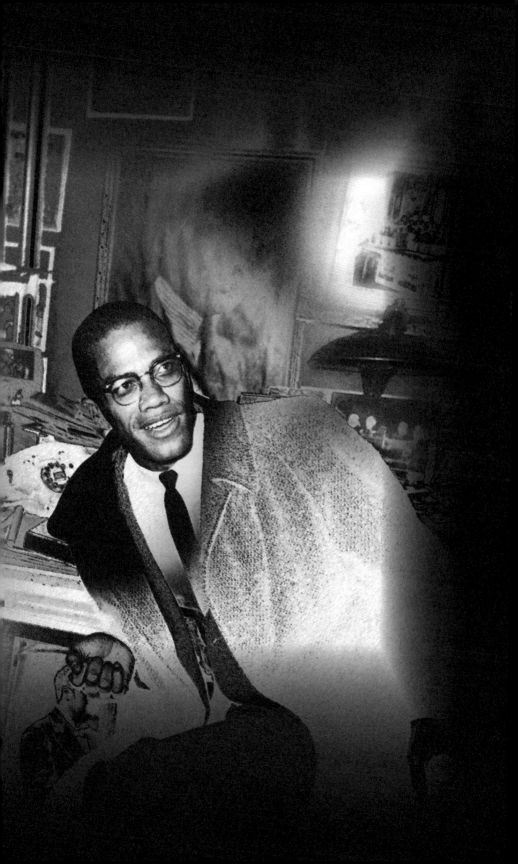

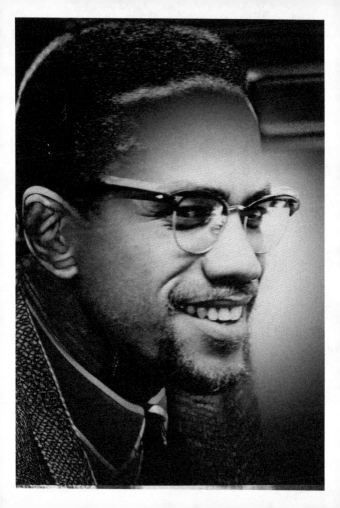

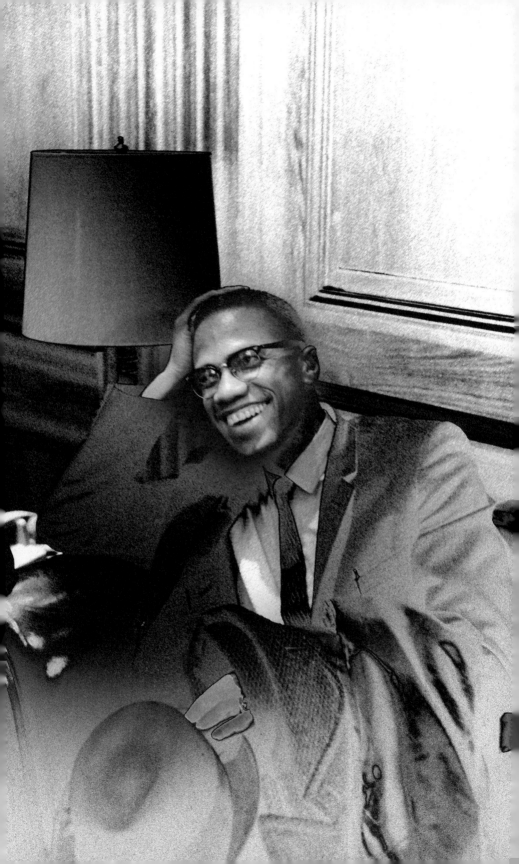

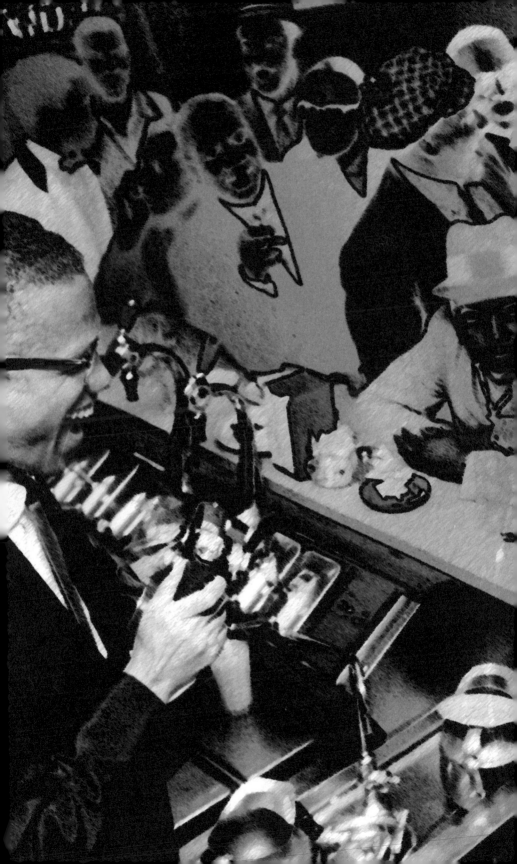

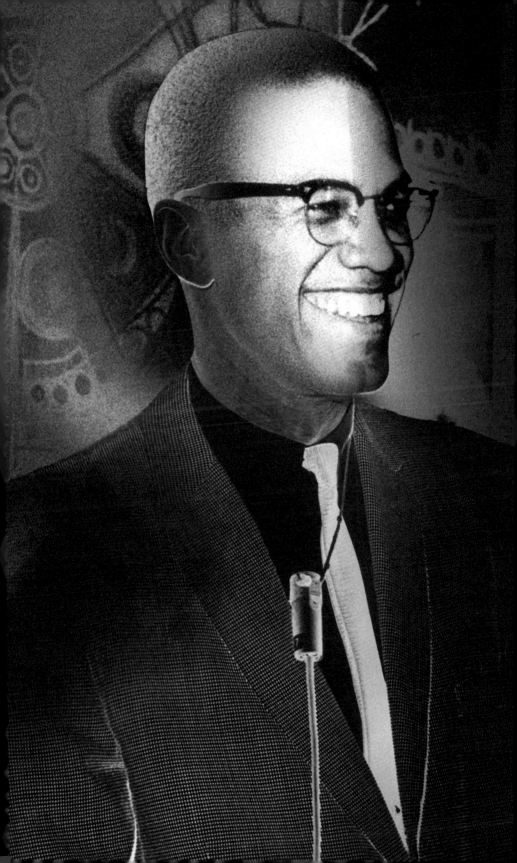

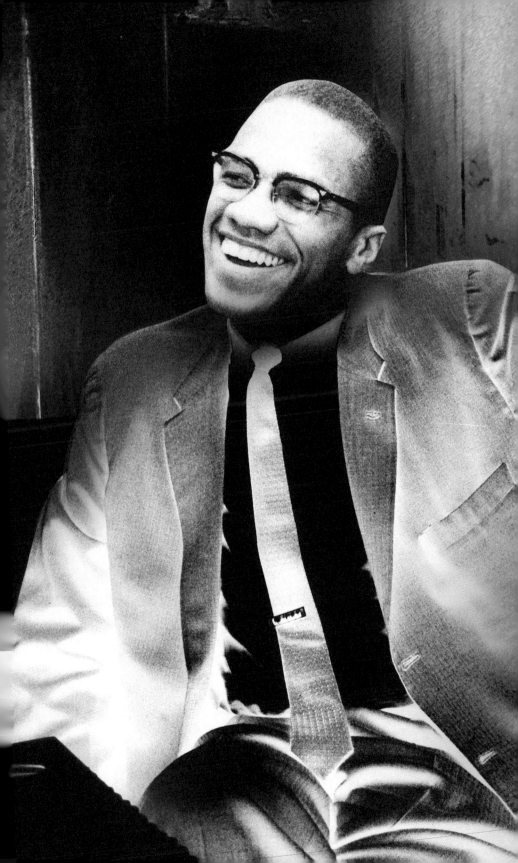

MOVEMENT IN THOUGHT:

AND

MALCOLM X

BLACK
SPACE-TIME

LADI'SASHA
JONES

LADI'SASHA JONES is a writer, designer, and curator pursuing a PhD in the History and Theory of Architecture at Princeton University. Her research explores Black American spatial histories of play, performance, art, and sonics. She has written for *Aperture, The Avery Review, Arts.Black, e-flux Criticism, Gagosian Quarterly,* among others. As an arts administrator, Jones held appointments at The Laundromat Project, Norton Museum of Art, New Museum's IdeasCity platform, and the Schomburg Center for Research in Black Culture.

A politics of Black transnational unity guided the final years of Brother Malcolm's organizing practice and speech acts. Between 1963 and 1965, as the nature of racial power was shifting across the Black world, he worked to transform Black consciousness from paradigms of domestic racial struggle to an international human rights logic connecting the revolutionary forces of all African peoples. Tracing this shift is a spatial exercise, one that

moves us between the enclaves of the Black diaspora as they have mobilized along the avenues of Harlem to the far corners of the States and across the globe. Consistent with the architecture of Black radical thought, Malcolm X's archives and speeches uncover the multi-scalar geography of Black power leadership and collective action. Knowing that he was a prolific community organizer, mapping Malcolm X's geopolitical thought is an endeavor into the internal worlds of the Black prophetic tradition[1] and its socio-spatial vernaculars.

Malcolm X affirmed his investment in connecting Black prophetic ideas with his political practice at a press conference on March 12, 1964, where he delivered what is now referred to as "A Declaration of Independence" from the Nation of Islam (NOI):

> Now that I have more independence of action, I intend to use a more flexible approach toward working with others to get a solution to this problem. I do not believe to be a divine man, but I do believe in divine guidance, divine power, and in the fulfillment of divine prophecy. I am not educated, nor am I an expert in any particular field—but I am sincere, and my sincerity is my credentials.[2]

The address established the future of his philosophical approach to Black nationalism while affirming his religious identification as a Muslim. Through expressions of unity and forgiveness, the statement emphasized the development of a new spiritual base and

154

1
There are several readings, historical and contemporary, on the Black prophetic tradition and the ways in which Brother Malcolm's life and work align with it toward a radical Black theological practice. For one of the central texts on this, see James H. Cone, *Black Theology and Black Power* (New York: Seabury, 1969). See also Jennifer C. James, "Blessed Are the Warmakers: Martin Luther King, Vietnam, and the Black Prophetic Tradition," in *Fighting Words and Images: Representing War Across the Discipline*, ed. Elena V. Baraban, Stephan Jaeger, and Adam Muller (Toronto: University of Toronto Press, 2012), 165–184. Considering Martin Luther King, Jr. and the Vietnam War, Jennifer C. James defines the Black prophetic tradition as follows: "Intimately related to the prophetic tradition in Judaism, Black prophecy envisions the trials of the Jewish people in the Old Testament as parallels to the modern Black historical experience in the West: dispersal, bondage, and the continuing struggle for a fully realized freedom. A deeply eschatological tradition, it is intended to inspire hope for deliverance in the hands of an angry God who will ultimately side with the oppressed." James, "Blessed Are the Warmakers," 165–184.

2
Malcolm X, "A Declaration of Independence," in *Malcolm X Speaks: Selected Speeches and Statements*, ed. George Breitman (New York: Pathfinder, 1989), 35.

constructive practice to address the *common* threat and daily "un-ending hurt" facing Black Americans. At the time of this speech, Malcolm X was still operating within the separatist lens of Black nationalism, asserting that "going back home, to our own African homeland" was the spatial aspiration and antidote to the brutali-ty of the American context. And yet, in his own words, "separation back to Africa is still a long-range program, and while it is yet to materialize, 22 million of our people who are still here in America need better food, clothing, housing, education and jobs *right now.*"[3] Studies of Black spatial practice in this country are entangled with the contextual histories of nationalism, emigra-tion, and the geographical function of movement and building between transatlantic lands. They are a part of the Black radical tradition, which sub-sumes an indelible spatial imaginary. It is a tradi-tion that pushes against the obscurity of Black mobility to make new biopolitical landscapes visible. Malcolm X's political practice is observant of the long and shifting arcs of Black nationalism and, more poignantly, how politics of Black love—for self and communi-ty—can transform site and geography. He understood how conse-quential migration and mobility are for Black folks and the land-scapes they traverse. Beyond nationalism, Black freedom struggles and racial justice are always a spatial matter[4] and a question of land that reorganizes geographical encounters and conceptions of ar-chitectural modernity.

This essay reflects on the spatiality of Malcolm X's work after this March 12th declaration, a mere eleven months before his as-sassination, by exploring the cartographic media of his analytical movements in thought and methods. The archives and generations

[3] Malcolm X, "A Declaration of Indepen-dence," 34.

[4] See Katherine McKittrick's conceptual-ization of geographic domination and the meaning of Black spatialization that affirm, "Black matters are spatial mat-ters." Katherine McKittrick, *Demon-ic Grounds: Black Women and the Carto-graphies of Struggle* (Minneapolis: Univer-sity of Minnesota Press, 2006), xii.

155

LADI'SASHA JONES

of writing on Malcolm X constitute the material base for understanding the religious and spatial intimacies of his radical leadership in Harlem and abroad. They demand an exploration of what Black radical, religious, and organizing traditions mean to architecture—that we readdress the spatiality of Black political movements.

Malcolm X's travels throughout Africa and the Middle East—first in 1959 and then in 1964—advanced the philosophical changes that rippled across his final body of letters, speeches, debates, and interviews. These trips reconfigured his Black nationalist politics to include records of global political power and—paired with his formation of the Muslim Mosque, Inc. (MMI)[5] and of the Organization of Afro-American Unity (OAAU), following his second trip to the region—invite us to consider where we locate ourselves in relation to freedom and bodies of resistance. Questioning the place of freedom and addressing the capacity to build or rebuild this "freedom place" are historical markers of Black liberation in the West. In an account of the Great Migration, as it unfolded in Chicago, historian Wallace Best writes of Black migratory practice: "Blacks have long connected their freedom to the ability to move, to change place or spatial direction, recognizing that, as Ralph Ellison put it, 'geography is fate.'"[6] Black mobility is part of an intra-communal politic wherein land and spatial production are active signs of modernity. "Revolution is always based on land," reminds Malcolm X. "Revolution is never based on begging for an integrated cup of cof-

5
Prior to his "Declaration of Independence," Malcolm X also announced his departure from the NOI at a press conference on March 8, 1964. He signaled the creation of both the OAAU and MMI, the latter of which was a Black Muslim organization with Malcolm X at the helm. According to his FBI records, the MMI was filed for incorporation on March 16, 1964, with New York County, under the Religious Corporation Law of the State of New York, to "work for the imparting of the Islamic Faith and Islamic Religion in accordance with 'accepted Islamic principles.'" The FBI also recorded and monitored their headquarters: "On May 15, 1964, a confidential source advised that the headquarters of the MMI are located in Suite 128, Hotel Theresa, Seventh Avenue, New York City, where they were established on March 16, 1964." The MMI did not continue after Malcolm X was assassinated.

6
Wallace Best, *Passionately Human, No Less Divine: Religion and Culture In Black Chicago, 1915-1952* (Princeton: Princeton University Press, 2005), 4.

fee."[7] Freedom precipitates the development of Black spatial politics and the formation of sociopolitical landscapes.[8]

By forming the MMI and OAAU, Malcolm channeled his political force toward a Black diasporic geography situated alongside the Third World, expanding nationalist strategies around property-buying power toward a consideration of how our freedoms are imagined and strategized across borders and in relationship to each other at the dawn of a postcolonial future. On the evidence of territoriality within Malcolm X's speeches, geographer James A. Tyner writes the following on his geopolitical shifts to dismantle local and global segregationist policies:

> For Malcolm X, the 'Black' revolution, unlike the 'Negro' revolution was global in scope and encompassed the wars of liberation that were sweeping across Asia, Africa, and Latin America. In articulating this connection, Malcolm X situated his revolutionary theory within the territorial-based anti-colonial movements of the Third World... Territoriality may be viewed as the spatial expression of power, an expression that Malcolm X advocated in his writings and speeches.[9]

The final months of Malcolm X's life can be seen as a critical inflection point that redefined his ideologies of race, gender, and Black

7
Malcolm X, "The Black Revolution," in *Malcolm X Speaks: Selected Speeches and Statements*, ed. George Breitman (New York: Pathfinder, 1989), 70. The conclusion of this speech addresses the discussion of land: "Revolutions are fought to get control of land, to remove the absentee landlord and gain control of the land and the institutions that flow from that land. The Black man has been in a very low condition because he has no control whatsoever over any land." See Malcolm X, "The Black Revolution," 78.

8
In his writing on the legacy of Black Power in the aftermath of Malcolm X's assassination, James Boggs writes the following on the spatial politics that have been misinterpreted: "The struggle over 'land,' which Malcolm defined as essential to the 'Black Revolution' as distinguished from the 'Negro Revolution,' has been interpreted to mean an idealized territory rather than the terrain or land of the major cities where Black folks are fast becoming a majority surrounding the centers of political and economic power. Identification with Africa has come to mean identification with anybody or anything African rather than an identification with those revolutionary forces in Africa which are carrying on a war to unite and liberate the entire continent from colonialism and neo-colonialism." James Boggs, "The Influence of Malcolm X on the Political Consciousness of Black Americans," in *Malcolm X: The Man and His Times*, ed. John Henrik Clarke (Toronto: Macmillan, 1969), 52.

9
James A. Tyner, "Territoriality, Social Justice and Gendered Revolutions in the Speeches of Malcolm X," *Transactions of the Institute of British Geographers* 29, no. 3 (2004): 336. On Malcolm's racial analysis after his 1964 travels, Tyner asserts, "Following his *Hajj*, Malcolm X reinterpreted the causes of oppression among Third World peoples. Oppression was no longer reducible to skin-colour, but rather a synthesis of racism, capitalism, colonialism and, belatedly, sexism." See Tyner, "Territoriality, Social Justice and Gendered Revolutions in the Speeches of Malcolm X," 335.

157

LADI'SASHA JONES

nationalism.[10] Although not as widely traced as the OAAU, his formation of the MMI marks a conceptual change within his theological practice as it relates to the continuation of his local community organizing in Harlem. Malcolm X framed the MMI within Black nationalism when he introduced it during the press conference marking his independence from the NOI:

> I am going to organize and head a new mosque in New York City, known as the Muslim Mosque, Inc. This gives us a religious base, and the spiritual force necessary to rid our people of the vices that destroy the moral fiber of our community. Our political philosophy will be Black nationalism. Our economic and social philosophy will be Black nationalism. Our cultural emphasis will be Black nationalism. Many of our people aren't religiously inclined, so the Muslim Mosque, Inc., will be organized in such manner to provide for the active participation of all Negroes in our political, economic, and social program, despite their religious or non-religious beliefs.[11]

10
See Farah Jasmin Griffin, "'Ironies of the Saint': Malcolm X, Black Women and the Price of Protection," in *Sisters in the Struggle: African American Women in the Civil Rights-Black Power Movement*, ed. Bettye Collier-Thomas and V.P. Franklin (New York: New York University Press, 2011), 214–229; Patricia Hill Collins, "Learning to Think for Ourselves: Malcolm X's Black Nationalism Reconsidered," in *Malcolm X: In Our Own Image*, ed. Joe Wood (New York: St. Martin's Press, 1992): 67–74; Patricia Robinson, "Malcolm X, Our Revolutionary Son and Brother," in *Malcolm X: The Man and His Times*, ed. John Henrik Clarke (Toronto: Macmillan, 1969), 56–63; and bell hooks, "Spike Lee's *Malcolm X*," *Artforum* 31 no. 6 (February 1993).

11
Malcolm X, "A Declaration of Independence," 34.

Through his reassessment of the Black Muslim movement, Malcolm X was determined to uphold and thread new roles for Islam and Black nationalism within the everyday lives and mobilization practices of Black folks in Harlem across religious ideologies. His call for Black liberation acknowledged the fundamental need for cooperative alliances to unite Black communities. Of his final meeting with Malcolm X in January 1965, Amiri Baraka writes that he stressed

the need for a united front in the US, stemming from an expanded political dimension of Black nationalism and self-determination:

> He insisted that we must move the whole people into a live revolutionary unity. This is the opposite of the religious sectarianism of the Nation of Islam. It is an admission that Islam is not the only road to revolutionary consciousness and that Muslims, Christians, Nationalists, and Socialists can be joined together as an anti-imperialist force in the US. Malcolm had made the connection between Black struggle for democracy and self-determination, between white supremacy and its political economic base, imperialism.[12]

As we understand the politics of unity-building within this period of his public work, it is critical to underline how Islam produced and sustained a deeply personal idea of relationality within Malcolm X's political practices. "The Islamic view of social action as being inseparable from ethical and religious beliefs was not lost upon Malcolm," writes Abdelwahab M. Elmessiri.[13] In fact, Elmessiri continues, Malcolm accepted and embodied many characteristics of orthodox Islamic ethical traditions, particularly that of communitarianism through a technological "commitment to his community and his desire to bring salvation to it." On his journey of spiritual awakening, which is embedded in his political work, bell hooks writes that Malcolm X gave his life freely to the people, "that we would know in our hearts the meaning of spiritual and political commitment, the union of love that he felt between religious aspiration and progressive political struggle, the passionate longing for Black liberation."[14]

159

12
Amiri Baraka, "Malcolm as Ideology," in *Malcolm X: In Our Own Image*, ed. Joe Wood (New York: St. Martin's Press, 1992), 29.

13
Abdelwahab M. Elmessiri, "Islam as a Pastoral in the Life of Malcolm X," in *Malcolm X: The Man and His Times*, ed. John Henrik Clarke (Toronto: Macmillan, 1969), 77.

14
bell hooks, "Sitting at the Feet of the Messenger: Remembering Malcolm X," in *Yearning: Race, Gender and Cultural Politics* (New York: Routledge, 2015), 87.

LADI'SASHA JONES

Organizing across national and international lines, borders, and scales, all the while maintaining a hyper-local commitment to Harlem, was a strategic vision of Malcolm X's leadership. A date book from circa 1961 features several entries for scheduled meetings and engagements that placed Malcolm in conversation with a range of Black cultural and political figures. There are entries for a meeting with James Baldwin in Lower Manhattan on May 14th at 81 Horatio Street and with Jean Blackwell Hutson later that week, on his birthday, at the Schomburg Center. Also listed is an August 27th visit to John Oliver Killens' Brooklyn home at 1392 Union Street, and two speaking engagements in November: one for the radio station WBAI on the 17th and an appearance at Hunter College with Bayard Rustin on the 21st. Malcolm X ends the year with a trip to Atlanta, where meetings were scheduled with Dorothy Cotton on December 7th at 1321 Sharon St. NW, and with Lonnie Cross at Atlanta University on the following day.[15] Recording meetings with librarians, Queer writers, Civil Rights educators, and women organizers, this date book offers a mere glimpse at the scope of Malcolm's engagements. By interpreting Malcolm's travels at the geographic and social level using the material conditions of his archives, it becomes possible to trace what it means to build and take part in communal discourses of political dissent during this time.

What Angela Y. Davis refers to as Malcolm X's political travels illustrate an ongoing investment in a dialogical organizing practice that was about community exchange and deep listening across borders. Traversing domestic enclaves and global nation-states was a practice of social transformation and resistance. His political mobility was in steady circulation, even as it remained captured within

14
bell hooks, "Sitting at the Feet of the Messenger: Remembering Malcolm X," in *Yearning: Race, Gender and Cultural Politics* (New York: Routledge, 2015), 87.

15
"Date Book, 1961?," The Malcolm X Collection: Papers, Sc Micro R-6270, Box 1, Folder 3, Schomburg Center for Research in Black Culture, Manuscripts, Archives and Rare Books Division, New York Public Library.

the confines of one empire to another. This tension courses through his speeches and conversations throughout 1964, particularly after his *Hajj*. Many have traced the bending and disappearance of some of his more popular rhetorical nationalist devices in the final months as evidence of this philosophical movement.[16] One of the texts firmly planted in public memory as marking this ideological splinter is "The Ballot or the Bullet," delivered ahead of his return to Africa in the spring of 1964 at two Midwestern churches, first in Cleveland on April 3rd and then in Detroit on April 12th. Theologian scholar James H. Cone builds on the reading of this speech as one that jointly shepherds in new ideas and tends to Malcolm X's oratorical past:

> "The Ballot or the Bullet" speech was Malcolm's initial attempt to develop a political vision that was continuous with his Black nationalist, Muslim past, while also showing the new directions in his thinking that would enable him to enter and expand the Civil Rights movement. The "bullet" in the phrase represented the continuity in Malcolm's perspective. It accented his militancy. It referred to his firm belief that no people can be recognized and respected as human beings if they are not prepared to defend their humanity against those who violate their God-given rights.[17]

16 In addition to Angela Y. Davis's and James H. Cone's work, the essay that comes to mind in relation to this point is Patricia Hill Collins, "Learning to Think for Ourselves: Malcolm X's Black Nationalism Reconsidered," in *Malcolm X: In Our Own Image*, ed. Joe Wood (New York: St. Martin's Press, 1992), 59–85.

17 James H. Cone, "Malcolm and Martin and America: A Dream or a Nightmare," in *A Malcolm X Reader: Perspectives on the Man and the Myths*, ed. David Gallen (New York: Carroll and Graf, 1994), 170.

In a similar vein, Davis writes about Malcolm X's ideological adherence to Black nationalism and the evolution in his metaphorical expressions of Black imprisonment in her reflective essay "Meditations on the Legacy of Malcolm X."

While the thematic content of his speeches retained previous invocations of Black imprisonment—the dialectics of social and psychological incarceration—what was different about his approach two years later was a more flexible construction of the unity he proposed as a strategy for escape. At what was no doubt a tentative moment in the process of questioning his previous philosophy, a moment never fully developed because of his premature death, Malcolm appeared to be seeking an approach that would allow him to preserve the practice of Black Unity—his organization was called the Organization for Afro-American Unity—while simultaneously moving beyond the geopolitical borders of Africa and the African diaspora.[18]

18
Angela Y. Davis, "Meditations on the Legacy of Malcolm X," in *Malcolm X: In Our Own Image*, ed. Joe Wood (New York: St. Martin's Press, 1992), 39.

His push for a human rights approach to Black struggle remains a critical signifier of his philosophic legacy. In a speech titled "The Black Revolution," given on April 8, 1964, in New York City for the Militant Labor Forum at Palm Gardens, Malcolm X situates 1964 within a global landscape of racial unrest:

Any kind of racial explosion that takes place in this country today, in 1964, is not a racial explosion that can be confined to the shores of America. It is a racial explosion that can ignite the racial powder keg that exists all over the planet that we call earth. I think that nobody would disagree that the dark masses of Africa and Asia and Latin America are already seething with bitterness, animosity, hostility, unrest, and impatience with the racial intoler-

ance that they themselves have experienced at the hands of the white West.[19]

The speech expressed an expansive move from targeting the racialized oppression of state power to organizing against the colonial and imperial projects of the US and European nations, reconstructing the margins of injustice by charging them with crimes against humanity. In an outline for the petition to the United Nations, Malcolm X annotated a series of violations against the 1948 Universal Declaration of Human Rights, charging the US with genocidal acts as defined by the Draft Convention on the Prevention and Punishment of the Crime of Genocide. His notes include sections on economic genocide, mental harm, the conspiracy and complicity to commit genocide, and more items making historical references to the American constitution, the Reconstruction period, foreign terrorism, and the constitutional background of Civil Rights legislation.[20] The movement from Black nationalism to a hemispheric framework generated a diasporic geography of continuity across cities and empirical powers.

19
Malcolm X, "The Black Revolution," 06.

20
Malcolm X, "Outline for Petition to the United Nations Charging Genocide Against 22 Million Black Americans," in *A Malcolm X Reader: Perspectives on the Man and the Myths*, ed. David Gallen (New York: Carroll and Graf, 1994), 343–351.

163

Malcolm X's reconceptualization of Black nationalism was beginning to reflect a border-defying remapping of the world. It was not a modernist project of Black utopianism. Instead, he called for the coalition of all oppressed peoples, tending to the sacrality of human life in the company of all who shared this vision. He expressed as much during a student-organized debate at Oxford University on December 3, 1964, wherein he gestures toward a faint call of allyship to the largely white European student body in attendance:

LADI'SASHA JONES

And in my opinion the young generation of whites, Blacks, Browns, whatever else there is—you're living at a time of extremism, a time of revolution, a time when there's got to be a change. People in power have misused it, and now there has to be a change and a better world has to be built, and the only way it's going to be built is with extreme methods. And I for one will join in with anyone, I don't care what color you are, as long as you want to change this miserable condition that exists on this earth.[21]

On his political position around building coalitions after the *Hajj*, Betty Shabazz writes,

The Methodists, or the Baptists, or the Democrats or whatever all looked at the problem from their particular eye. They would help those who belonged to their group, but no one joined for the sake of humanity—forgetting about politics or religion—to solve the problem of all oppressed people. Malcolm's feeling was that if a group has an answer to the problems of Black people, then they should help solve the problem without having all Black people join that group. In this sense, his scope had been broadened.[22]

21
Malcolm X, "Any Means Necessary to Bring about Freedom," in *Malcolm X Talks to Young People: Speeches in the U.S., Britain, and Africa*, ed. Steve Clark (New York: Pathfinder, 1991), 25-26.

22
Betty Shabazz, "Malcolm X as a Husband and Father," in *Malcolm X: The Man and His Times*, ed. John Henrik Clarke (Toronto: Macmillan, 1969), 141.

The wages of human life weighed heavy on Malcolm's tongue. A broadened Black political consciousness began to take a new form in the OAAU. Developed in the image of the Organization of African Unity (OAU) that was established the year prior in Ethiopia, the OAAU not only called for the unification of all peoples of African de-

scent in the Western Hemisphere but also was founded on the logic of tethering the fates of decolonial and migratory movements across the Black world together. "Our problem is your problem. It is not a Negro problem, nor an American problem. This is a world problem; a problem for humanity. It is not a problem of civil rights but a problem of human rights," states Malcolm in an address during the OAU's First Assembly of Heads of State and Governments on July 17, 1964, in Cairo.[23] More than solidarity, Malcolm's OAAU, based in Harlem's Hotel Theresa, implored the urgency of political mutuality. This politic is illustrated clearly in the nearly page-length map foregrounding the OAAU's six-page charter, which, attempting to represent a new configuration of Black world unity, features the outline of the African continent with a speckled drawing of North and South America within it. As a political design object, this map forges the supergraphics of Black Atlantic geography.[24]

The graphic is reminiscent of the spatial rendering of "the distribution of the Negro race" in the opening plate to W.E.B. Du Bois's *The Georgia Negro: A Social Study*, presented as a part of the Negro Exhibit at the Parisian "Exposition Universelle" in 1900. In Du Bois's map, the globe is divided in two, with lines delineating the "routes of the African slave trade" stretching from the African continent to South America, the Caribbean, and North America. Architectural scholar Mabel O. Wilson explores the cartography of this map as a visual empirical narrative of the Atlantic slave trade through information design:

> When Du Bois rendered a geographic history of the African slave trade and mapped present conditions in Georgia,

[23] "OAAU Cairo Speech," Organization of Afro-American Unity (OAAU) Collection, Sc MG 752, Box 1, Folder 5, Schomburg Center for Research in Black Culture, Manuscripts, Archives and Rare Books Division, New York Public Library.

[24] Here, I am referencing the iconography of Black movements of the time, like SNCC's famed "Together, We Shall Overcome" logo with a white hand and Black hand clasped in solidarity, as well as the circulation of protest messaging across the diaspora as evidenced in the "Solidarity with American Civil Rights Movement" protest held in Notting Hill, London, on September 3, 1963, with slogans like "Caribbean Unity Against Yankee Fascism," "Jim Crow Must Go," and "Legislate Against Racialism." The messaging of the OAAU's design graphic of a Black globe is situated within a continuum of politicized media production of utility, including the popularized "All Power to the People" closed fist emblem of the Black Panther Party.

165

he sutured the two together and illustrated through evidence—
black lines on white pages—how centuries of racial oppression
and exploitation, not a lack of natural aptitude,
had shaped the current abysmal conditions of
Black life worldwide.[25]

25
Mabel O. Wilson, "The Cartography of the Color Line," in *W.E.B. Du Bois's Data Portraits Visualizing America: The Color Line at the Turn of the Twentieth Century*, ed. Whitney Battle-Baptiste and Britt Rusert (New York: Princeton Architectural Press, 2018), 48.

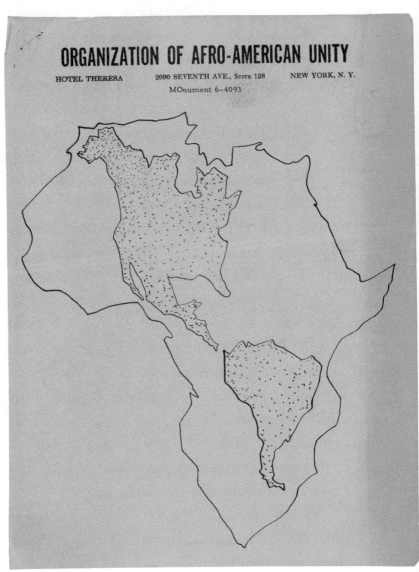

Organization of Afro-American Unity Collection, Sc MG 752, Box 1, Folder 6, Schomburg Center for Research in Black Culture, Manuscripts, Archives and Rare Books Division, The New York Public Library. Courtesy of the Estate of Malcolm X.

Du Bois's color line is alive and active in Malcolm's unifying cartography more than half a century later. Both maps represent a field of Black diasporic spatial iconography. However, the OAAU map is also a speculative design product of its time, responding to Cold War geopolitics, the spatial and temporal climates of decolonial movements, and the rise of African state leaders. What is visually represented here is the resolution to a global study of anti-Blackness, wherein borders are blurred, and contours of the local are stretched—extending the localization and geographic orientation of freedom from one's backyard to emerging nation-states abroad.

Looking at these maps, we might ask: In what ways is mapping the geographic reality of Black sociopolitical thought perceptible beyond ephemeral abstraction? Just as Black nationalism presents a conceptual spatiality of separatist living and economic flows, so does bridging the Black Atlantic and folding its global borders into the African continent speculate on unifying struggles of colonial independence and human rights. Lest we forget, a free Ghana in 1957 became a vital twentieth-century spatial marker that greatly shaped the Black radical imagination. And it is in Ghana that the first international chapter of the OAAU develops. On the impact and legacy of the OAAU, historian John Henrik Clarke writes,

> The formation of the Organization of Afro-American Unity
> and the establishment of an official connection with Africa
> was one of the most important acts of the twentieth century.
> For this act gave the Afro-Americans an official link with
> the new emerging power emanating from both Africa and
> Asia. Thus, Malcolm X succeeded where Marcus Garvey
> and others had failed. Thus, doing this, Malcolm projected

the cause of Afro-American freedom into the international arena of power. When he internationalized the problem, by rising it from the level of civil rights to that of human rights and by linking up with Africa, Malcolm X threw himself into the crossfire of that invisible, international cartel of power and finance which deposes presidents and prime ministers, dissolves parliaments, if they refuse to do their bidding. It was this force, I believe, that killed Malcolm X [United States], that killed Lumumba [Democratic Republic of the Congo], that killed Hammarskjold [Sweden].[26]

26
John Henrik Clarke, foreword to *Malcolm X: The Man and His Times*, ed. John Henrik Clarke (Toronto: Macmillan, 1969), xxiii–xxiv.

Malcolm X communicated the stakes of bridging the Third World to Lenox Avenue across his final speeches. In a series of Sunday night OAAU convenings at the Audubon Ballroom beginning in late 1964, Malcolm X explored this sightline of shared borders with his growing audience. In an address on December 20, 1964, with Fannie Lou Hamer in attendance, he dove into the economic wages of African industrialization and its threat to the European markets and systems of living, in addition to the spatial possibilities it opened up for the Black world.[27] Malcolm X intuited the power and "force," to use Clarke's word, of a growing internationalist, anti-imperialist worldview:

Today, power is international, real power is international; today, real power is not local. The only kind of power that can help you and me is international power, not local power... You have to have a power base among brothers and sisters. You have to have your power base among people who have something in common with you.[28]

27
Malcolm X, "At the Audubon," in *Malcolm X Speaks: Selected Speeches and Statements*, ed. George Breitman (New York: Pathfinder, 1989), 156.

28
Malcolm X, "At the Audubon," 158.

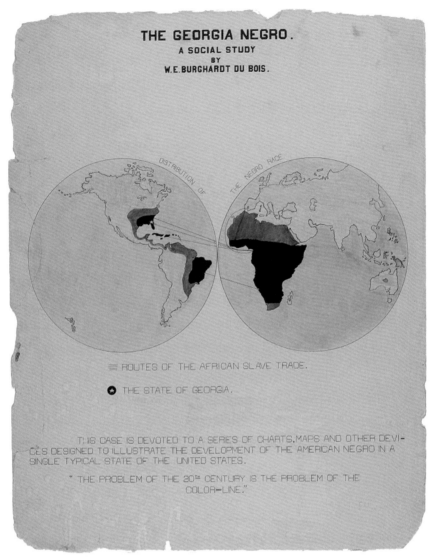

THE GEORGIA NEGRO.
A SOCIAL STUDY
BY
W.E.BURGHARDT DU BOIS.

DISTRIBUTION OF THE NEGRO RACE

≡ ROUTES OF THE AFRICAN SLAVE TRADE.

⊛ THE STATE OF GEORGIA.

THIS CASE IS DEVOTED TO A SERIES OF CHARTS, MAPS AND OTHER DEVI-
CES DESIGNED TO ILLUSTRATE THE DEVELOPMENT OF THE AMERICAN NEGRO IN A
SINGLE TYPICAL STATE OF THE UNITED STATES.

" THE PROBLEM OF THE 20ᵗʰ CENTURY IS THE PROBLEM OF THE
COLOR-LINE."

169

W.E.B. Du Bois, *The Georgia Negro: A
Social Study*, 1900. Courtesy of the
Library of Congress, Prints and Photo-
graphs Division [LOT 11931, no. 1].

In the same speech, Malcolm X drew a line between Mississippi
and the Congo by stating, "You can't understand what is going on
in Mississippi if you don't understand what is going on in the Congo.

LADI'SASHA JONES

And you can't really be interested in what's going on in Mississippi if you're not also interested in what's going on in the Congo. They're both the same. The same interests are at stake."[29] During the final months of his life, Malcolm X articulated this epistemology through a Black spatial grammar of unity and power. His sky was full.

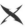

Through their "chocolate maps" framework, Marcus Anthony Hunter and Zandria F. Robinson render Black cultural production as a vital source of change in the twentieth century—one that reshaped rural and urban regions alike across the US. Offering "a perceptual, political, geographic tool" to develop a new Black geography, Hunter and Robinson mapped the enduring conditions of the South as it has been multiplied and disseminated within the US through The Great Migration. Recontextualizing the country, in its entirety, as regions of the South, their maps highlight the dissonance of Black spatial lifeways through an expanded articulation of the Southern racial context: "The South is not merely the common geographic location below the Mason-Dixon Line. It is, rather, America—the broader cultural, economic, and political soil on which Black communities and neighborhoods have been planted and supplanted, the soil on which they have grown, persisted and evolved."[30]

Tracing the movement of the Black population alongside cultural and political figures like Malcolm X, their maps pull our attention to the domestic and material conditions that are also written into his political speech. Brother Malcolm was at *home* in Harlem. Harlem was a spatial subject and site that Malcolm X returned to over and

29
Malcolm X, "At the Audubon," 153–154.

30
Marcus Anthony Hunter and Zandria F. Robinson, *Chocolate Cities: The Black Map of American Life* (Oakland: University of California Press, 2018), 43. In many ways, their maps also argue that racialization in the US is inherently geographic and that there is no region or place in the country that is untouched by racial production.

over again, the place at the center of his religious and political life, where his organizations took root, and where his growing community of Muslim followers were mobilized. Akin to Lansing, Harlem was where he organized the futurity of his personal being, where he practiced radical Black love as a father, husband, sibling, friend, and community member. From this political homeplace, Malcolm X worked to produce a new sociality for the Black world. His teachings produced a Black atlas of the future—one that envisioned the possibilities of a global human rights struggle and pulled the migratory nature of Black nationalism into the foreground.

Malcolm X's archival tracks reflect a practice of exchange, political dissemination, oratorical action, and global base-building. The architectural memory of his leadership is held within the public sphere, from the building sites of auditorium stages, community halls, hotel rooms, and religious sanctuaries to the street corners and public squares of present or the ephemeral markings of those that have been demolished. Black and Muslim enclaves across much of the transatlantic world have embedded markers of remembrance for Brother Malcolm within their built environment. If ever mapped alongside one another, Malcolm X's global spatial markers, an incalculable index of the roads his words have traveled, will form a surreal diagram of reconstructive presence. His own mapping work of Black and oppressed worlds, of unified and migratory freedom lands, was cut short, eclipsed, by the inhabitants of anti-Blackness in possession of empirical power. We have been refused the development of his organizational practice and the spatial imaginaries they attempted to project into the world. Still, Malcolm X's evolving analyses of Black nationalism and human rights, liberation from environmental subjugation, continue to be recovered over a half-century later.

171

UMMAH

AND

MAYTHA ALHASSEN

"HUMAN RIGHTS"

MAYTHA ALHASSEN is a historian, journalist, engaged artist, and mending practitioner. She received her PhD in American Studies and Ethnicity from USC, with an emphasis on race, class, gender, religion, and social movements. As a journalist, Alhassen has appeared as a co-host on *Al Jazeera English* and *The Young Turks* and has written for *CNN*, *Huffington Post*, *Boston Review*, *LA Review of Books*, and *The Baffler*, among others. Following the 2011 uprisings, she co-edited *Demanding Dignity: Young Voices from the Front Lines of the Arab Revolutions*. Alhassen has served as a co-executive producer on Golden Globe– and Peabody-winning Hulu series *Ramy*, an executive producer for the upcoming docuseries *American Muslims: A History Revealed*, and a producer for upcoming film *Edgware Road*. She was also a researcher for Columbia University's Malcolm X Project.

The very essence of the Islam religion in teaching the
Oneness of God, gives the Believer genuine, voluntary
obligations toward his fellow man (all of whom are One
human family, brothers and sisters to each other)... and
because the true believer recognizes the Oneness of all
humanity the suffering of others is as if he himself were
suffering, and the deprivation of the human rights of others
is as if his own human rights (right to be a human being)
were being deprived.

1
Malcolm X Diary, April 26, 1964, reel
9, Malcolm X Collection, Schomburg
Center for Research in Black Culture,
Manuscripts, Archives and Rare Books
Division, The New York Public Library.
—Malcolm X, April 26, 1964[1]

The Islamic conceptualization of *ummah*, which
can be described as "a community of believers,"
offers a powerful framework to think through
the possibilities of unity marked by an interde-
pendent difference. The metaphoric connection
of *tawhid*, of God's oneness, to the "ummic body"
of mankind, reflected in the brother-, sister-, and
family-hood of man, is lucidly described in the
following Qur'anic verse 5:32: "Unless in retalia-
tion for the killing of another person or in punish-
ment for spreading evil, whoever kills a person

175

MAYTHA ALHASSEN

has killed the whole of humanity; and whoever gives life to a person has done so to the whole of humanity."[2] Islamic scholar Isma'il Faruqi emphasizes that the ontological assertion emanating from this *ayah*, or verse—that "to be born is to have the right to be"—obligates a Muslim to recognize the sanctity of human life.[3] It makes the active practice of preserving a part of the ummic body a moral imperative,[4] with honoring difference being one of the most fundamental ways to safeguard community. Verse 49:13 of the Qur'an states: "... We have made you from peoples and tribes, so that you may come to know one another."[5] In this sense, difference is the foundation for generating and sustaining social intimacies, for "knowing one another."

How, then, is this community—bound not by a geographic territory but by a shared sense of human rights, suffering, deprivation, liberation—mapped and membered, especially for someone like Malcolm X emerging from his *Hajj* experience alongside *communities* of believers in 1964? What constitutes this "ummic body," and how does it reconstitute and remake our world? Looking to Malcolm's personal travel accounts and reading between and beyond his biographic projects evinces how his development of an ummic praxis propelled his interventions into American racism, global Indigeneity, and coloniality in his final years of life.

While some scholars have written about Malcolm X's encounters with political figures across pan-Arab and global Islamic networks, few have probed the impact of these travels and friendships on his spiritual consciousness after leaving the Nation of Islam (NOI) and the development of his internationalist, Third Worldist, and Black

2
Qur'an 5:32 مَنْ قَتَلَ نَفْسًا بِغَيْرِ نَفْسٍ أَوْ فَسَادٍ فِي الْأَرْضِ فَكَأَنَّمَا قَتَلَ النَّاسَ جَمِيعًا وَمَنْ أَحْيَاهَا فَكَأَنَّمَا أَحْيَا النَّاسَ جَمِيعًا

3
Tafsir, or philosophical analysis, of the Qur'anic verse 5:32 by Islamic scholar Isma'il al-Faruqi in "Islam and Human Rights," Isma'il Faruqi, accessed December 7, 2023, https://ismailfaruqi.com/articles/islam-and-human-rights.

4
As further evidence of emphasis on human rights and "right-doing," it is also stated in the Qur'anic verse 3:104: "Let there be of you an *ummah* which calls to the good, which enjoins the acts of righteousness, prohibits the acts of injustice and evil. Such are the felicitous." وَلْتَكُنْ مِنْكُمْ أُمَّةٌ يَدْعُونَ إِلَى الْخَيْرِ وَيَأْمُرُونَ بِالْمَعْرُوفِ وَيَنْهَوْنَ عَنِ الْمُنكَرِ ۚ وَأُولَٰئِكَ هُمُ الْمُفْلِحُونَ

5
Qur'an 49:13 وَجَعَلْنَاكُمْ شُعُوبًا وَقَبَائِلَ لِتَعَارَفُوا

176

American political projects. These relations underscored for Malcolm a shared "spirit of brotherhood," one he leveraged in his promotion of Islam as the antidote for curing the "cancer of racism" in the United States. In a letter from Mecca to his post-Nation spiritual confidant, Dr. Mahmoud Shawarbi, Malcolm reflects on performing *Hajj* in April 1964. "Witnessing this *Hajj*," he writes, "has opened my eyes to the real brotherhood created by Islam among people of all colors. I am convinced that Islam will remove the cancer of racism from the heart of all Americans who accept it."[6] What emboldened Malcolm to make such a prescriptive assertion, one originally written in his diary and later published worldwide from the *New York Times* to Uganda's *Uganda Argus* (July 24, 1964) as an "Open Letter"? [7]

In an early diary entry, Malcolm sketched how Islam's commitment to human rights distinguished itself from the Christian commitment to civil rights—offering a conceptual list of terms that connected faith and political advocacy:

1. Islam offers FJE [Freedom, Justice, Equality], human dignity, Brohood
2. Christianity offers civil rights
3. Islam offers human rights[8]

This assessment ultimately provided the groundwork for his elevation of Islam above Christianity as a political and social project.[9] In his April 3, 1964, "The Ballot or the Bullet" speech at Cory United Methodist Church in Cleveland, right before his *Hajj* trip, Malcolm introduced his human rights framework for Black liberation. Malcolm distinguished

6
In the notes, toward the end of his first travel diary, next to a transliteration of the *sujud*. Malcolm X Diary, 1964, Malcolm X Collection, Schomburg Center for Research in Black Culture, Manuscripts, Archives and Rare Books Division, The New York Public Library.

7
M.S. Handler, "Malcolm X Pleased By Whites' Attitude On Trip to Mecca," *The New York Times*, May 8, 1964, https://www.nytimes.com/1964/05/08/archives/malcolm-x-pleased-by-whites-attitude-on-trip-to-mecca.html; "An Open Letter from Malcolm X," *Uganda Argus* (Kampala), July 28, 1964, box 1, page 2, Aliya Hassen Papers, Bentley Historical Library, University of Michigan.

8
Malcolm X Diary, undated, 18, Malcolm X Collection, Schomburg Center for Research in Black Culture, Manuscripts, Archives and Rare Books Division, The New York Public Library.

9
Malcolm X Diary, undated, reel 9, Malcolm X Collection.

177

this fight for human rights from the fight for civil rights, which he believed was circumscribed by the aims of white liberals in a "so-called democracy [which] has failed the Negro."[10] Malcolm elaborates:

> We need to expand the civil rights struggle to a higher level—to the level of human rights. Whenever you are in a civil rights struggle, whether you know it or not, you are confining yourself to the jurisdiction of Uncle Sam. No one from the outside world can speak out in your behalf as long as your struggle is a civil rights struggle... All of your African brothers and our Asian brothers and our Latin-American brothers cannot open their mouths and interfere in the domestic affairs of the United States... When you expand the civil-rights struggle to the level of human rights, you can take the case of the Black man in this country before the nations in the UN. You can take it before the General Assembly. You can take Uncle Sam before a world court, but the only level you can do it on is the level of human rights. Civil rights keeps you under his restrictions, under his jurisdiction. Civil rights keeps you in his pocket.[11]

Speaking a few months later to African heads of state at an Organization of African Unity conference on July 17, 1964, Malcolm insisted: "Our problem is your problem. It is not a Negro problem, not an American problem. This is a world problem; a problem for humanity. It is not a problem of civil rights but a problem of human rights... And if South African racism is not a domestic issue, then American racism also is not a domestic issue."[12] He con-

10
Malcolm X, "The Ballot or the Bullet," in *Malcolm X Speaks: Selected Speeches and Statements*, ed. George Breitman (New York: Grove Press, 1990), 31.

11
Malcolm X, "The Ballot or the Bullet," 34–35.

12
Malcolm X, "Appeal to African Heads of State," in *Malcolm X Speaks*, ed. George Breitman (New York: Grove Press, 1990), 75.

cluded the address by calling on "independent African states" to recommend an investigation of "our problem" by the United Nations Commission on Human Rights.[13] For Malcolm, removing this "cancer" required "barking up the human rights tree," as racism was responsible for the greatest crime in Malcolm's eyes: judging man based on skin color.[14] In other words, civil rights denials were symptoms of the cancer; human rights denials were the cancer itself.

This period of Malcolm's life, less than a year before his gruesome public execution at the Audubon Ballroom on February 21, 1965, marked not only an expansion of his understanding of Islam but also an expansion of his application of Islam, putting a primacy on praxis. Faith solely rooted in principles, in "armchair philosophizing," stood no match to the actual application of faith. For Malcolm, Islam was not just a religion that spoke of a worldwide *ummah* but, as evidenced in his writings, a religion that actively practiced and extended a generosity of spirit in defiance of social and spatial norms.

In compiling *The Autobiography of Malcolm X*, co-author Alex Haley emphasizes the transformational power of Sunni Orthodox Islam on Malcolm's sociopolitical, cultural, and spiritual orientations. Although rightly articulated, its representations almost fall into the realm of fantasy and caricature. And while the *Autobiography* includes Malcolm's statement on the *Hajj* that "The brotherhood! The people of all races, colors, from all over the world coming together as one! It has proved to me the power of the One God," and even draws comments from Malcolm's diary that people "ate and slept as one," he neglects to note his observation that "birds of the same color stay primarily together."[15] For as much as Haley exclusively relies on his *Hajj* as the reason or

13
Malcolm X, "Appeal to African Heads of State," 37.

14
As Malcolm explains in one of his final speeches at the Ford Auditorium in Detroit, "The yardstick used by another Muslim to measure is not a man's color, the man's deeds, the man's conscious behavior, the man's intention, and when you use that as a standard for measurement or judgment, you never go wrong. But when you judge a man by the color of his skin you are committing a crime, because that is the worst kind of judgment." See Malcolm X, *February 1965: The Final Speeches*, ed. Steve Clark (New York: Pathfinder Press, 1992).

179

MAYTHA ALHASSEN

the climatic shift in Malcolm's move away from a "racist ideology," in reality, the contents of this shift included many more experiences of ummic brotherhood. To sift through the personal notes, diary entries, speech transcripts, and longform biographic writings that comprise Malcolm's textual legacy is to read across the various genres he himself used to articulate his beliefs. Undertakings like Haley's, when referred to independent of the rest, emphasize the insufficiency of any one form of these writings in communicating a faithful account of Malcolm's values in their entirety.

15
Malcolm X and Alex Haley, *Autobiography of Malcolm X* (New York: Ballantine Books, 1964), 345; and Malcolm X Diary, April 19, 1964, reel 9, Malcolm X Collection, Schomburg Center for Research in Black Culture, Manuscripts, Archives and Rare Books Division, The New York Public Library.

Malcolm's diaries are replete with encounters and anecdotes that never made it into more "authoritative" texts like Haley's *Autobiography.* For example, Malcolm zealously writes about a particularly influential moment in Egypt during the summer of 1964 that embodied the Islamic tenet of *ummah* and that "impressed" him even more than his trip to Mecca. In an entry dated August 2, 1964, he details the happenings of a speaking engagement attended by a group of 800 Muslim youth (representing seventy-three of seventy-four different countries) at a camp in Alexandria for the Abu Bedr El Sadiq Conference. Honored by the invitation to speak at *Shuban Al-Muslimin* (Young Men's Muslim Association) on *Saidina* (the Prophet Muhammad's birthday), Malcolm describes the experience of giving the speech and its reception in detail. Beyond the initial, warm welcome from the audience who shouted, "Welcome Malcolm," as he entered, Malcolm was impressed by the diversity of attendees. He made a side note that three of the youth who spoke represented the "Arab-African-Asian" formula he later cited often in his speeches. Witnessing a multi-colored sea of believers at *Hajj* was trumped by seeing a smaller group of polycultural youth interacting together

For Malcolm, this tangible example of an *ummah*, disengaged from what he believed to be "America's poison" of racial conflict, was a further testament to the strength of Islam as a platform for championing human rights: "Youth from everywhere, face of every complexion, representing every race and every culture... all shouting the glory of Islam, filled with a militant, revolutionary spirit and zeal" was the greatest evidence that Islam was the panacea for many of the world's ills.[16]

16
Malcolm X Diary, August 2, 1964, Malcolm X Collection, Schomburg Center for Research in Black Culture, Manuscripts, Archives and Rare Books Division, The New York Public Library.

And yet, this moment did not make it into the *Autobiography*, even though Malcolm described it as a more transformative and moving experience than his time in Mecca. Such an omission was likely made because it did not fit the neat, linear narrative constructed by Haley: framing the potency of Malcolm's spiritual awakening in Mecca as the defining moment that altered his views on race relations. In reality, it was the Islamic spirit of brotherhood in practice at different times and in different places that profoundly shaped Malcolm personally and politically. Though the reason for his transformation was reduced to what he witnessed in Mecca and Medina while on *Hajj*, it appears Malcolm was more inspired by his personal interactions with Muslims who challenged the US-based racial and class-based caste system by demonstrating friendships rooted in this "spirit of brotherhood" and nourished with "sincere hospitality."

181

SAUDI ARABIA 1964:
APRIL 17-28; SEPTEMBER 18-24

Travel broadens one's scope. Any time you do any travel, your scope will be broadened.

MAYTHA ALHASSEN

It doesn't mean you change—you broaden. No religion will ever make me forget the condition of our people in this country. No religion will ever make me forget the continued fighting with dogs against our people in this country. No religion will make me forget the police clubs that come up 'side our heads. No God, no religion, no nothing will make me forget it until it stops, until it's finished, until it's eliminated. I want to make that point clear...

17
Malcolm's answer to a question about his "Hajj letter" at the Militant Labor Forum of New York's symposium "What's Behind the 'Hate-Gang' Scare?" in Malcolm X, *Malcolm X Speaks: Selected Speeches and Statements*, ed. George Breitman (New York: Grove Press, 1990), 70.

— Malcolm X, May 1964[17]

While in a tent on Mount Arafat, Malcolm was asked what impressed him the most about his *Hajj* experience. While we know part of his answer from his *Autobiography*—again, the refrain, "The brotherhood, people of all races, colors, from all over the world coming together as one, which proved to me the power of the One God," all-too-frequently narrated as one of "Sunni triumphalism,"[18] as a supposed post-race transformation—we miss his relentless commitment to combating the weaponization of race, as articulated in the next line in his diary entry: "This also gave me an opening to preach to them a quick sermon on American racism and its evils... I could tell its impact upon them, and from then on they were aware of the yardstick I was using to measure everything. For me the earth's most explosive evil is racism, the inability of God's creatures to live as One, especially in the West."[19] The deepening of Malcolm's training in the Islam of Sunni Orthodoxy deepened Malcolm's analysis of American racism.

18
Michael Muhammad Knight invoked "Sunni triumphalism" at Duke University's "Forum for Scholars and Publics: Malcolm X Now" (minute 48:00) to explain a popular argument that describes Malcolm's post-*Hajj* views as his "coming to Jesus" moment: "Malcolm's pre-NOI life gets erased and his post-NOI life gets really oversimplified. And we just look at the *Hajj* and that is the entirety of his post-NOI story." https://fsp.trinity.duke.edu/projects/malcolm-x-now.

19
Malcolm X Diary, April 25, 1964, reel 9, Malcolm X Collection, Schomburg Center for Research in Black Culture, Manuscripts, Archives and Rare Books Division, The New York Public Library.

white supremacy, and Islam. Racism was the greatest assault to Islam's governing principle of *tawhid*, of Oneness.[20]

Thus, post-*Hajj* Malcolm proposed instrumentalizing Islam in the Black Freedom movement not to transcend race but to think of it as a methodology capable of condemning American racism and dismantling American constructions of whiteness, not Blackness. It was whiteness that needed to be transcended, and Islam was best suited, in Malcolm's estimation, to rid the US of the disease of race and white supremacy. In April 25, 1964, Malcolm wrote a letter from Mecca, Saudi Arabia, describing the role he sees Islam (and *tawhid*) playing in undoing and resisting certain cognitive presets of race:

I could look into their blue eyes and see that they regarded me as the same (Brothers), because their faith in One God (Allah) had actually removed "white" from their mind, which automatically changed their attitude and their behavior (toward) people of other colors. Their beliefs in the Oneness has made them so different from American whites that their colors played no part in my mind in my dealing with them.[21]

In the "After the Bombing" speech on February 13, 1965, in Detroit, Malcolm famously made the distinction between "white" as a term of power deployed by Americans and "white" as used as an adjective by Muslims in Asia, the Arab world, and Africa. Explaining the

20
Some other diary entries of note on "brohood," *tawhid*, and "unity in difference": "I remember when about 20 of us were sitting in the huge tent on Mount Arafat and they asked me what about the *Hajj* thus far had impressed me the most. My answer was not the one they expected but it drove home the point: 'The brotherhood, people of all races, colors, from all over the world coming together as one, which proved to me the power of the One God.' This also gave me an opening to preach to them a quick sermon on American racism and its evils," On the violation of *tawhid* as "The world's most explosive evil," Malcolm writes: "I could tell its impact upon them, and from then on they were aware of the yardstick I was using to measure everything. For me the earth's most explosive evil racism, the inability of God's creatures to live as One, especially in the West. The *Hajj* makes one out of everyone, even the king, the rich, the priest loses his identity (rank) on the *Hajj*—everyone forgets self and turns to God and out of this submission to the One God comes a brotherhood in which all are equal," Malcolm X Diary, April 25, 1964.

21
Malcolm X, "Mecca, Saudi Arabia—April 25, 1964," *Hajj* letter. Accessed from "The Most Remarkable Revelatory Letter Ever Written by Malcolm X," *Moments in Time*, http://momentsintime.com/the-most-remarkable-revelatory-letter-ever-written-by-malcolm-x/#.WDImTJMrLiw.

183

American use, Malcolm states, "when he says he's white, he means he's the boss."[22] In the same letter, Malcolm extends his analysis of Islam "erasing" whiteness from the "minds" of white people, more pointedly an erasure of white consciousness, to what this means for Black Americans:

> If white Americans could accept the religion of Islam, if they could accept Oneness of God (Allah) they too could then sincerely accept the Oneness of Men, and cease to measure others always in terms of their "difference in color." And with racism now plaguing America like an incurable cancer all thinking Americans should be more receptive to Islam as an already proven solution to the race problem. The American Negro could never be blamed for these racial "animosities" because his only reaction or defense mechanism which is subconscious intelligence has forced him to react against the conscious racism practiced (initiated against Negroes in America) by American whites. But as America's insane obsession with racism leads her up the suicidal path, nearer to the precipice that leads to the bottomless pits below, I do believe that whites of the younger generation, in the colleges and universities, through their own young, less hampered intellects will see the "Handwriting on the Wall" and turn for spiritual salvation to the religion of Islam, and force the older generation to turn with them—This is the only way white America can warn off the inevitable disaster that racism always leads to, and Hitler's Nazi Germany was best proof of this.[23]

184

22
Malcolm X, "After the Bombing," in *Malcolm X Speaks*, ed. George Breitman (New York: Grove Press, 1990), 163.

23
Malcolm X, *Hajj* letter.

Curiously, the *Autobiography* reprints these observations but eliminates Malcolm's phrasing of "Hitler's Nazi," adds "Christian" before "American whites," and uses words like "color-blindness" to describe Malcolm's assessment of play and performance of race in the "Muslim world's religious society" and the "Muslim world's human society."[24] Since it was designed as a collaboration between Malcolm X and Alex Haley, we can never truly know how much of this is Malcolm and how much of this is Haley.[25] This letter is a clear generative artifact of Malcolm's engaged witnessing, of the testimony he gathered on behalf of Black Americans throughout travels that both affirmed and complicated his conceptions of race and FJE (freedom, justice, equality). It insists on our understanding that it is not "difference of color" that is at the heart of racism but the power attached to hierarchies of difference rooted in racial logic. For, as Malcolm had observed in the ummic praxis of brotherhood, a "difference in color" could be treated as a "difference in unity," in the way of Brent Hayes Edwards's notion of *décalage*. That is, to "know one another."

24
For instances in the *Autobiography* of "color-blindness" (author's emphasis), see Malcolm X and Haley, *Autobiography*, 345, 347–348. Most of Malcolm's letters from Jeddah use the phrases "all colors," "people of all colors," and "all colors and races" and explain what he saw as a divergent relationship to difference than his experience in the US. See Malcolm X, "Letters from Abroad," in *Malcolm X Speaks*, ed. George Breitman (New York: Grove Press, 1990), 58–61.

25
See Garrett A. Felber, "'A Writer Is What I Want, Not an Interpreter': Alex Haley and Malcolm X—Conceiving the Autobiographical Self and the Struggle for Authorship," *Souls: A Critical Journal of Black Politics, Culture, and Society* 12, no. 1 (2010): 33–53: "The tension between the two authors' conceptions of the autobiographical self differed dramatically—Malcolm's as communal, shifting, and fluid; Haley's as individual, personal, and departing from a fully conceived point arrived at through a series of transformative epiphanies." Malcolm's terse statement to Haley at the project's beginning, with which Haley ultimately ends: "A writer is what I want, not an interpreter."
In an August 1963 letter to Oliver Swan, of Paul Reynolds's office, Haley asked that the book be amended to read "as told to" rather than "co-authored by," noting that "'co-authoring' with Malcolm X. [sic] would, to me, imply sharing his views—when mine are almost a complete antithesis of his."

185

What is curious is why and how Malcolm chalks up anti-racism to the practice of Sunni Islam—which he did not necessarily experience with the Sunni Orthodox followers with whom he frequently quarreled in Harlem and in the rest of the Nation—and why he did not attribute this to race and colorism constructed differently outside of the West. Later, Malcolm's conversations with Arab Muslims did complicate his understanding of race and colorism outside of the geography and history of the States, of American racial logic. And

MAYTHA ALHASSEN

he would eventually indict Western coloniality or "Twentieth Century Dollarism" (Western neocolonialism and neoimperialism) as the culprit of systemic racism on a global scale.

In addition to evidencing and broadcasting anti-racist ummic practices back to his American constituents, the other direction of Malcolm's "two-way" engaged witness involved "preaching" about the plight of 22 million Black Americans to new friends and acquaintances from the Arab world, Asia, and Africa. During his travels across *mashriq* and Africa, Malcolm applied his engaged witness of American apartheid/racism as a feature and form of testimony in conversations. On April 26, 1964, Malcolm dined with Muhammad Abdul Azziz Maged, the Deputy Chief of Protocol for Prince Faisal.[26] They discussed James Baldwin, other Black American writers, and John Howard Griffin's 1961 *Black Like Me.* Malcolm noted his reply to Maged in his diary: "'If that was a frightening experience to him, and he was only a pseudo-Negro for 60 days, think what it has been for the real Negroes for 400 years.' And again I preach."[27] Malcolm, as a witness of state-sanctioned violence directed toward Black Americans, makes frequent references to his acts of testimony to Arabs and Africans abroad, usually explained in his diaries as "preaching": "I have not bitten my tongue once, nor passed a single opportunity in my travels to tell the truth about the real plight of our people in America. It shocks these people. They knew it was 'bad,' but never dreamt it was as inhuman (psychologically castrating) as any uncompromising projection of it pictures it to them."[28] It is worth noting that directly after his "*Hajj* revelation," Malcolm deployed the

26
Malcolm X and Haley, *Autobiography*, 342.

27
Malcolm X Diary, April 26, 1964. Also mentioned in the *Autobiography*, "Two American authors, best-sellers in the Holy Land, had helped to spread and intensify the concern for the American Black man. James Baldwin's books, translated, had made a tremendous impact, as had the book *Black Like Me* by John Griffin. If you're unfamiliar with that book, it tells how the white man Griffin blackened his skin and spent two months traveling as a Negro about America; then Griffin wrote of the experiences that he met. 'A frightening experience!' I heard exclaimed many times by people in the Holy World who had read the popular book. But I never heard it without opening their thinking further: 'Well, if it was a frightening experience for him as nothing but a make-believe Negro for sixty days—then you think about what *real* Negroes in America have gone through for four hundred years.'" Malcolm X and Haley, *Autobiography*, 353–354.

28
Malcolm X Diary, April 26, 1964.

term "our people" to signify Black Americans—a form of affective kinship and a way of establishing connections between peoples otherwise divided by racial, classist, and financial constructs.

Describing another encounter with two Arabs in the Jeddah marketplace on April 26, Malcolm recounted that when he "really preached" to them about Blackness in the US, they requested Malcolm abstain from using the word "Negro." "If a word must be used, they preferred 'Black,'" he wrote.[29] One wonders if this Arab resistance to the term "Negro" could have also been a complicated analysis of their Arabness in a framework of Afro-Arab diasporic consciousness. Malcolm racialized Saudi Arabians within the American racial cosmology as Black, acknowledging the ways that they would surely be subjected to anti-Black racism and segregation in the US.[30] Malcolm first raised this observation five years prior, when he returned from his first trip to the region, stating in an article in the *Pittsburgh Courier* on August 15, 1959, that, "99 percent" of "the people of Arabia," who he characterized as "regal black and rich brown," "would be Jim-Crowed in the United States of America." Malcolm extends this notion of a "color kinship," by reporting back from his travels to Saudi Arabia, Sudan, and Egypt that, "in fact, the darkest Arabs I have yet seen are right here on the Arabian Peninsula. Most of these people would be right at home in Harlem. And all of them refer warmly to our people in America as their brothers of color."[31] It is through affirmations like these that Malcolm established continuities across ostensibly disparate geographies. His traveling between these many sites and his analogizing of the many ways in which they might be familiar fortified his ummic commitments in ways that helped him feel right at home just about anywhere.

187

29
Malcolm X Diary, April 26, 1964.

30
"They were shocked when I told them all of them would be segregated in America," Malcolm X Diary, April 23, 1964, reel 9, Malcolm X Collection, Schomburg Center for Research in Black Culture, Manuscripts, Archives and Rare Books Division, The New York Public Library.

31
Malcolm X, "Arabs Send Warm Greetings to 'Our Brothers' of Color in U.S.A.," *Pittsburgh Courier*, August 15, 1959.

MAYTHA ALHASSEN

Malcolm's understanding of the brotherhood underpinning um-mic praxis accounts for his persistent "preaching" as a delegate on behalf of Black America. The care he exercised toward his "brothers of color" are embodied by the ethnographic observations and theorizations made during his 1964 trip:

> These people have a tender heart for the unfortunates, and very sensitive feelings for truth and justice. The very essence of the Islam religion in teaching the Oneness of God gives the believer genuine voluntary obligations toward his fellow men (all of whom are one family, brothers, sisters to each other)... and because the True Believer recognizes the Oneness of all humanity, suffering of others is as if he himself were suffering, and deprivation of the human rights of others is as if his own human rights (right to be a human being) were being deprived.[32]

By seeing the "oneness of all humanity," Malcolm was able to tie Black liberation to both Black nationalism and Islam: "Our success in America will involve two circles: Black nationalism and Islam—it will take BN to make our people conscious of doing for self and then Islam will provide the spiritual guidance. BN will link us to Africa and Islam will link up spiritually to Africa, Arabia, and Asia."[33]

This passage demonstrates that Malcolm, even while lauding the preaching of an "Oneness of all humanity," racially coded Islam as part of a "dark world" geography that could link to the project of inducting Black Americans into an African diasporic consciousness, a Black globality with spiritual and sociopolitical dimensions. It also illustrates the persistence of his NOI training to see the "Asiatic

[32] Malcolm X Diary, April 26, 1964.

[33] Malcolm X Diary, April 26, 1964.

Blackman" (linking Africa, Arabia, and Asia as part of an "Original Man" geography) and Islam as metaphysically intertwined. Furthermore, it helps us understand how this retention of the NOI cosmology around the Asiatic Blackman could lead to Malcolm's embrace of the Third Worldist politics, aligned with the discursive tradition, started by Egyptian president Gamal Abdel Nasser, of referring to Arab, African, and Islamic identities as cohesive "three circles."[34]

Malcolm's testimonies to a burgeoning friendship network in Saudi Arabia and the two-way cross-cultural exchange, constitutive components of engaged witnessing, continue to be preserved in community histories and collective memories multiple generations down the line. It is through these exchanges and engagements that Malcolm created connections, stitching the geographies of our world anew through the *ummah* that is our collective imagination.

[34] Maytha Alhassen, "The "Three Circles" Construction: Reading Black Atlantic Islam through Malcolm X's Words and Friendships," *Journal of Africana Studies* 3, no. 1 (2015): 1-17.

189

INTRODUCING

BROTHER

MALCOLM

DARIEN
ALEXANDER
WILLIAMS

DARIEN ALEXANDER WILLIAMS is an assistant professor in the Macro Practice Department at Boston University, with a focus on climate and environmental justice. His research broadly engages Black and Muslim urban planning history, hurricane disaster recovery, and community organizing, and more specifically examines methods of counter-institution-building developed by the Nation of Islam as it grappled with segregation and land clearance in urban neighborhoods across the twentieth century. He is currently an organizer for the Queer Muslims of Boston, a grassroots organization that builds social and spiritual space for LGBTQ Muslims across New England.

A glimpse at an old surveillance film reel sitting in the New York Police Department archives draws the eye across time and space. It's 1963: we're in Harlem on Lenox Avenue between 112th and 115th Street. The air is uncharacteristically cool for mid-July. A breeze blows between the brick, red-hued high-rise Stephen C. Foster Houses, washing over a crowded street of women and men in pressed dresses and suits, capped with light sun hats.[1] Stephen C. Foster, the white

loyd A. Green, "In The Beginning," *Endless Perceptions*, February 19, 2021, http://ndlessperceptions.com/in-the-begining.html; and Newark Liberty International Airport, "New York City 1963 ast Weather (New York, United States)," Weather Spark, https://weatherspark.om/h/y/23912/1963/Historical-Weathr-during-1963-in-New-York-City-New-'ork-United-States.

DARIEN ALEXANDER WILLIAMS

man whose name the New York City Housing Authority bestowed on the expansive Harlem public housing development in 1952, has been named "the father of American music" by white scholarship.[2] A more apt name could not have been given, for Foster's legacy, which was built on Civil War–era minstrel performance, was absorbed into the bedrock of an "American" music tradition, just as the practice of urban planning has inscribed anti-Black racial hierarchies into the landscape. These buildings, like many monuments of American infrastructure renamed after Black public figures in place of more substantive, transformative intervention to divest them of their collusion with white supremacy, would later be renamed the Martin Luther King, Jr. Towers.[3] Somewhere across the street from the housing complex, concealed in plain sight, the steady hand of a New York Police Department (NYPD) surveillance officer tracks the barrel and eye of a film camera across the faces of onlookers in the street.

A stage is set up where the sidewalk meets the asphalt, but the buzzing crowd is so large and tightly packed that hardly any ground can be seen. The NYPD camera locks onto a man in a black suit with a sign reading, "THERE IS NO GOD BUT ALLAH." He moves through the crowd while a man sells the Nation of Islam's *Muhammad Speaks* newspaper to passersby. Several thousand people, including onlookers perched on nearby windowsills, wait in anticipation for an electric speech by a thirty-eight-year-old Minister Malcolm X. Breaking the gentle hum of the crowd, a group of ten takes the stage and the mic. They sway left and right, tapping drums, shaking percussion instruments, and moving their bodies from side to side in ecstatic dance

[2] Ken Emerson, ed., *Stephen Foster & Co.: Lyrics of the First Great American Songwriters* (New York: Library of America, 2010); JoAnne O'Connell, *The Life and Songs of Stephen Foster: A Revealing Portrait of the Forgotten Man Behind "Swanee River," "Beautiful Dreamer," and "My Old Kentucky Home"* (Lanham, MD: Rowman & Littlefield, 2016), 3; Linda Jo Scott, "Stephen Foster Was Rightly called 'Father of American Music,'" *Battle Creek Enquirer*, May 21, 2015, https://www.battlecreekenquirer.com/story/opinion/columnists/2015/05/21/scott-stephen-foster-rightly-called-father-american-music/27728723.

[3] Matthew Shaftel, "Singing a New Song: Stephen Foster and the New American Minstrelsy," *Music and Politics* 1, no. 2 (Summer 2007), https://doi.org/10.3998/mp.9460447.0001.203.

194

The camera zooms in, and percussionist Nana Yao Opare Dinizulu and his band of "African dancers and drummers" come into view, each draped in brilliantly colored West African fabrics flapping in the Harlem breeze.[4] After the group performs, Malcolm X comes on stage, greets the crowd, and begins his speech. In a few swift clicks, the cameraperson exits the scene, cutting the footage short.[5]

This scene, shot by an Officer "Kane," was not uncommon in the 1960s, across New York, Chicago, Boston, or Los Angeles.[6] The Nation of Islam employed music during public rallies and speeches organized across the United States to reach a broad Black constituency. Alongside the group's leading public faces, including Malcolm X and Louis Farrakahn (Louis X), were equally vibrant figures with past lives in the unfolding world of jazz, soul, calypso, and West African performance.[7] These organizers were musicians, performers, promoters, venue owners, dealers, and managers in Jazz-Age communities across the US, who, even prior to being in the Nation, informed the cultural and political foundation of Black freedom movements in the early twentieth century. For these reasons, the sonic landscapes of Black America, the Caribbean, and continental Africa are inextricably linked to the internationalist politics of the Nation of Islam and Malcolm X himself. These musical connections did not evaporate for members upon joining the Nation. Rather, relationships between musicians and organizers were central to the spread of Islam across Black American communities in major cities such as New York and Boston.[8]

4
"Nana Yao Opare Dinizulu I: Founder of the Akan Culture in America," Dinizulu Cultural Arts Institute, March 30, 2020, https://dinizuluarts.org/nyod.

5
Muslim Meeting New Area, 115th and Lenox Avenue, East, No Incidents, Nation of Islam and Malcolm X (July 13, 1963); New York Police Department surveillance films, 1960–1980; REC 0063; nypd_f_0050_1; Municipal Archives, City of New York, https://nycma.lunaimaging.com/luna/servlet/detail/NYCMA~3~3~38~1233505:Muslim-Meeting-New-Area,-115th-and-.

6
Muslim Meeting New Area, 115th and Lenox Avenue, East, No Incidents, Nation of Islam and Malcolm X.

7
E. U. Essien-Udom, *Black Nationalism: A Search for an Identity in America* (New York: Dell, 1965); Ula Yvette Taylor, *The Promise of Patriarchy: Women and the Nation of Islam* (Chapel Hill: University of North Carolina Press, 2017); and Garret Felber, *Those Who Know Don't Say: The Nation of Islam, the Black Freedom Movement, and the Carceral State* (Chapel Hill: University of North Carolina Press, 2020).

8
Fatimah Fanusie, "Ahmadi, Beboppers, Veterans, and Migrants: African American Islam in Boston, 1948-1963," in *The African Diaspora and the Study of Religion*, ed. T. L. Trost (New York: Palgrave Macmillan, 2007), 49–69.

195

DARIEN ALEXANDER WILLIAMS

Film snippets of the opening acts for Malcolm's Harlem speeches have been made accessible because of the invasive surveillance campaign launched by the NYPD and FBI to destabilize and undermine Black liberation projects and social movement work.[9] This relationship is perverse, as some of the only detailed film records of the group in action during the height of its organizing activity are due to the animus of local and federal law enforcement. The quality and accuracy of written reports generated by these entities can and should be contested. These were records maintained by agencies determined to disrupt and disband the Nation ever since they labeled the organization the result of "Foreign-Inspired Agitation among the American Negroes" during World War II.[10] Film records, however, allow a narrow and limited but direct visual understanding of the Nation's tactics in action in the street.

If one were to thumb through a copy of *Muhammad Speaks* on October 5, 1963, they might notice an ad for a rally with "special guest speaker Minister Malcolm X," accompanied by "music by Richard 'Groove' Holmes and his trio (featuring Thornel Schwartz)." *Muhammad Speaks*, the official newspaper for the Nation of Islam between 1960 and 1975, was founded by Herbert Jabir Herbert Muhammad and Malcolm X in a room in a Harlem office building, eventually finding a home at 153 Lenox Avenue. The paper ran for almost fifteen years and published over 642 issues, amounting to over 20,000 pages of newsprint.[11] It was a cultural catalyst, showcasing political art, social commentary, and regular reports on the anticolonial resistance movements sweeping across Africa, Latin America, and Asia in the 1960s.[12] Advertisements throughout

9
Federal Bureau of Investigation, *Nation of Islam*, 1964, https://vault.fbi.gov/Nation%20of%20Islam; Felber, *Those Who Know Don't Say*; and *Muslim Meeting New Area, 115th and Lenox Avenue, East, No Incidents, Nation of Islam and Malcolm X.*

10
Felber, *Those Who Know Don't Say*.

11
Khuram Hussain, "Something of Our Own: 'Muhammad Speaks' in the Cause of Black Agency in School Reform, 1961–1975" (Phd diss., Syracuse University, 2010); and Darien Alexander Williams, "Let's Build Our Own House: Political Art and the Making of Black and Muslim Worlds," *Southern Cultures* 29, no. 2 (Summer 2023): 48–67.

12
Williams, "Let's Build Our Own House."

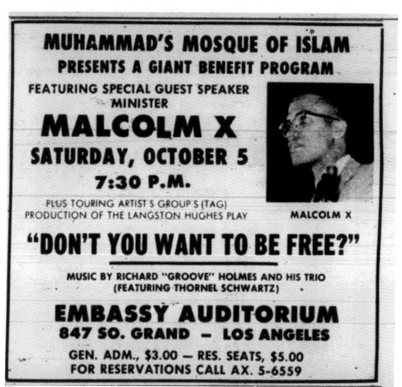

Muhammad Speaks 3, no. 2, October 11, 1963, 17.

the paper typically featured information for political rallies or locally organized African and Asian bazaars, where speakers and entertainers raised the profile of businesses associated with the Nation. Advertised speaking events by Malcolm X frequently promised a performance by a popular singer, dancer, or musician.

 Music from across the Black world was central to the Nation's work in constructing a politically unified diaspora. In a *Muhammad Speaks* advertisement titled, "the MUSLIMS present... an african bazaar" [sic], the words, "Starring Oscar Brown, Jr., Max Roach and his 17 Voice Chorus, The Walt Dickerson Quartet, and Olatunji and his African Dancers & Drummers," are featured even more prominently than the name "Malcolm X."[13]

197

13
Babatunde Olatunji and Robert Atkinson, *The Beat of My Drum: An Autobiography* (Philadelphia: Temple University Press, 2005).

DARIEN ALEXANDER WILLIAMS

the *MUSLIMS present . . .*

an
african
bazaar

SATURDAY, NOVEMBER 30th

AT THE **369th ARMORY**, 142nd ST. AND 5th AVE.,
NEW YORK, N.Y.

Starring **OSCAR BROWN, JR.**

MAX ROACH and his 17 Voice Chorus
THE WALT DICKERSON QUARTET
OLATUNJI and his African Dancers & Drummers
FEATURED SPEAKER: MALCOLM X

EXHIBITS ★ ARTS ★ CRAFTS ★ DISPLAYS SUBSCRIPTION (Advance:) $2.00—(At Door:) $2.50
FOR TICKET AND BOOTH INFORMATION CALL:

| SHABAZZ RESTAURANT 113 Lenox Avenue New York City AC 2-4559 | NILE RESTAURANT 342 Tompkins Ave. Brooklyn, New York ST 3-8918 | SHABAZZ RESTAURANT 105-05 Northern Blvd. Corona, L.I., N. Y. TW 9-9633 | MUHAMMAD SPEAKS NEWSPAPER OFFICE 153 Lenox Avenue New York, N.Y. AC 2-6322 | WILL'S RECORD SHOP 147 West 125th St. New York, N. Y. MO 6-1417 |

Muhammad Speaks 3, no. 6, December 6, 1963, 6.

Each performer—Brown (the Chicago-born musical vocalist), Roach (the famed North Carolina–born jazz drummer), Dickerson (the vibraphone player from Philadelphia), and Olatunji (the Nigerian

drummer born in Lagos under British colonization)—was talent-
ed in their own right, but together they demonstrated a diasporic
Black cultural virtuosity. Such an event, held at the 396th Armory
in Harlem, featured numerous establishments owned by members
of the Nation of Islam. There were additionally non-Muslim African-
owned businesses and non-Black Muslim–owned businesses as part
of the cultivated ecosystem of enterprises. In the midst of Harlem, a
hotspot for the Nation's activities but also for cultural and political
production across many Black spheres of existence, these events,
in tandem with the explicit speech and written text produced by
the Nation, culminated in an exhibition of internationalist cooper-
ation, a model of the organization's ideal political project. Historian
Fatimah Fanusie explores the musical geographies of a similarly
prominent Nation of Islam outpost, Boston's Muhammad's Temple
No. 11. Founded by Louis X and Malcolm X in the late 1950s, as the
Nation of Islam grew in reach and prominence, Temple No. 11's
nascent success was due in large part to a local community of mu-
sicians and artists.[14] Charles X, a jazz drummer who was religious-
ly and politically inspired by his friendship with Malcolm X during
their incarceration at the Massachusetts Correctional Institute at
Norfolk, mobilized a cadre of residents in the then largely Ahmadi
Black American Muslim community in Boston to eventually form
"the structural backbone of the NOI's Temple No.
11 in Boston... dubbed the 'Musicians Five' for a set
of five local jazz artists who performed in venues
in the city's South End neighborhood."[16] Fanusie
writes that "jazz artists by this time were exper-
imenting with Baha'ism, Islam, Hinduism, and
other Eastern and alternative religious practices'"

199

14
Fanusie, "Ahmadi, Beboppers, Veter-
ans, and Migrants."

15
The Ahmadiyya movement was found-
ed in Punjab in the latter half of the nine-
teenth century by Mirza Ghulam Ahmad
around a set of messianic concepts. Ah-
madi Muslims have historically been
very transitory as a result of ostraciza-
tion and oppression from larger Sunni
movements. Eventually, Ahmadi com-
munity organizing found success in Bos-
ton's early Muslim history.

16
Fanusie, "Ahmadi, Beboppers, Veterans,
and Migrants," 56.

DARIEN ALEXANDER WILLIAMS

and that "residents were eventually transformed by the new Islamic identity introduced by musicians who embraced Islam as taught by Ahmadiyya and NOI representatives."[17] She writes further:

> Ahmadiyya missionaries were active in the United States, notably among supporters of Marcus Garvey's Universal Negro Improvement Association (UNIA) and also among African American musicians... [Religious scholar] Amina [sic] McCloud observes that Ahmadiyya converts to Islam drew heavily from jazz musicians and created a distinctly Islamic culture that was highly visible in African American urban centers between 1917 and 1960... [and] "these musicians were major propagators of Islam in the world of jazz even though the subject of music was often a source of debate with the subcontinent Ahmadis. Some even developed a distinct jargon—a unique blend of bebop and Arabic."[18]

The success of this religious organizing drew on the robust infrastructure of the jazz scene that stretched between Boston's South End, where the Nation had its beginnings in the area, and Roxbury, where the Boston community of the Nation of Islam would gain a geographic foothold that remains to this day. Both Ahmadi and Nation organizers utilized newspapers (the *Moslem Sunrise* for Ahmadiyya, and *Muhammad Speaks* for the NOI) as a means to reach a wider Jazz-Age American public.[19]

Like many complex social movements, the Nation of Islam wrestled with a deep set of contradictions over what members of the organization expected of themselves and each other, as

17
Fanusie, "Ahmadi, Beboppers, Veterans, and Migrants," 50-51.

18
Fanusie, "Ahmadi, Beboppers, Veterans, and Migrants," 52, quoting Aminah Beverly McCloud, *African-American Islam* (New York: Routledge, 1995), 20-21.

19
Roger House, *South End Shout: Boston's Forgotten Music Scene in the Jazz Age* (Ann Arbor: Lever Press, 2023); and Hisham Aidi, *Rebel Music: Race, Empire, and the New Muslim Youth Culture* (New York: Knopf Doubleday Publishing Group, 2014).

well as how they were asking people to participate. Despite Elijah Muhammad's explicit call against secular musical performance, Malcolm X and Louis X engaged in public collaborations with jazz and soul artists, and *Muhammad Speaks* published editorial columns by famed jazz percussionist Max Roach, detailing the genre as "one of the greatest art forms" and critiquing the profitability of white record companies.[20] Before joining the Nation of Islam, the then-named Malcolm Little was immersed in the vibrant Harlem jazz scene. In his autobiography, Malcolm fondly reflects on venues such as Small's Paradise, Cotton Club, and the Savoy Ballroom and names Duke Ellington, Ethel Waters, Cab Calloway, and Jelly Roll Morton, among others, as jazz musicians who shaped the vibrant musical and cultural scene of the 1940s and 1950s.[21] Undoubtedly, Malcolm maintained many of his conections to soul and jazz artists even after rising to prominence as a religious and political leader, including his time both within and outside the Nation (post 1964). Malcolm traveled on *Hajj* and across the Muslim world, to places such as Egypt, Saudi Arabia, Nigeria, Ghana, Iran, and Syria. Connections between Malcolm's legacy, the projects of the Nation of Islam, and new bonds formed with Muslims in the Arab world gener-

ated discourses about the role of music in liberation movements.[22] Similarly immersed in the mid-1950s diasporic music world was then-named Louis Eugene Walcott, the "charismatic Calypso singer," who was brought into the Nation of Islam through a friendship with Rodney X of Boston.[23] Walcott, later Farrakhan, had recorded numerous calypso records, with hits such as "Brown Skin Gal," "Is She Is or She Ain't," and "Trinidad Road March."[24] As

20
Edward E. Curtis, *Muslim American Politics and the Future of US Democracy* (New York: New York University Press, 2019); and Edward E. Curtis, *Black Muslim Religion in the Nation of Islam, 1960–1975* (Chapel Hill: University of North Carolina Press, 2006).

21
Malcolm X and Alex Haley, *The Autobiography of Malcolm X* (New York: Random House Publishing Group, 1965), 82–83.

22
Aidi, *Rebel Music*.

23
Panusie, "Ahmadi, Beboppers, Veterans, and Migrants," 62.

24
Louis Farrakhan, *Louis Farrakhan is the Charmer: Calypso Favorites 1953-1954*, Botrox Records 9908, 1999, compact disc.

DARIEN ALEXANDER WILLIAMS

Max Roach On JAZZ

How Whites Made $Billions From Negro Art Form

By MAX ROACH
America's Greatest Drummer

"A kind of music, generally improvised but sometimes arranged, achieving its effects by syncopation, heavily accented rhythms; dissonance, melodic variation and particular tonal qualities of the saxophone, trumpet clarinet and other instruments. It was originated by New Orleans Negro musicians..."

Encyclopedia Britannica Dictionary

This definition of jazz, taken from the Encyclopedia Britannica, is, at best, just a surface explanation of this many-spectrumed terminology.

Jazz actually was founded in African chants and songs. It began as an expression of the pain and suffering endured by chained, innocent, black men, women and children deep in the dark, damp, filthy holes of slave ships crossing the Atlantic. It is a reflecting f the humiliations experience by these black human beings as they were auctioned off like cattle or produce.

Jazz mirrors the pain of the whip, the assulter, the procurer, the "driva man," the patrol wagons, the kidnapper, and the sun up-to-sundown slave field and plantation.

IT IS AN expression of the black man who thought he had been "freed," but found—upon venturing out into the "free" world of opportunity and wealth that he was still in shackles, again to be assaulted, whipped, raped and murdered.

It is all this, and yet, something more than this. It is a profound, dazzling glimpse into the beauty, wonder, hope, confidence and courage which black men and women have infused into their lives for generations.

It is a common denominator of the "soul," of the glory and joy of life to which men and women in Tokyo, Moscow, Burma, Paris, Stockholm, Berlin, Iceland can instantly recognize and respond. Its creators have shared deeply the most moving and acute experiences of mankind.

Jazz, although originated here by and brought to its ascendency by the poor and oppressed black man and wo-

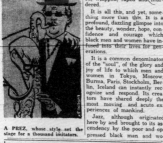

A PREZ, whose style set the stage for a thousand imitators.

The Negro's Portrait Of His Hopes And Hells

NOW ONE OF THE greatest of art forms, jazz is the sophisticated outgrowth of the expressions of man, has a unique quality possessed onl; by the greatest art.

That quality is its ability to communicate emotionally with mankind on any part of the planet.

The white man in America liked and admired the music and has made billions of dollars out of it. He now claims to be its co-originator and best exponent.

There are, however, those white musicians who have approached the music with respect and sympathy. Within the bounds of their emotional ability to indentify with their black brothers and humanity, they elaborate on the music.

MUSICAL instruments and theories on harmony preceded the black man to this country, but it is his hell on earth which he sublimates (and is sublimating) into the beauty that makes for the esthetic musical contribution, "jazz."

In its emotional intensity, brilliance, drive and extended harmonic and rhythmic frontiers, the music is indicative of

pain and suffering endured by slaves, plus the wonder, hope and courage of the "free" black American.

A DUKE, whose music through the years has made others rich.

where the Negro came from and to, and foretells where he might go one day.

Though the connotation of "jazz" has gained stature in the eyes of the world, and its original spelling — "jazz" — abandoned, its original emotional and social content has not changed very little. The music is being misrepresented, distorted, misconstrued and capitalized on by others than its authors.

The white musician, if he

(Continued on page 21)

Muhammad Speaks 2, no. 6, December 15, 1962, 20.

an eventual minister, Louis Farrakhan collaborated with men and women of the Nation "in writing and performing plays, recording

albums, and promoting independent thought and cultural expression."[25] Initially, these collaborations would explicitly focus on the conditions faced by Black women and men in the United States. As he would go on to resurrect and lead the organization after several decades of rapid transformation, Farrakhan very publicly developed relationships with hip-hop artists in an effort to develop cultural and political appeal with a new generation of Black youth. [26]

25
Fanusie, "Ahmadi, Beboppers, Veterans, and Migrants," 62.

26
Andre E. Johnson et al., *Urban God Talk: Constructing a Hip-Hop Spirituality* (Lanham, MD: Lexington Books, 2015).

The playlist that follows offers a "set list," or compilation, comprised of artists who opened for various Malcolm X speeches and associated events during his time as a minister in the Nation of Islam. I constructed this playlist through the names of artists and event locations advertised in the Nation's newspaper, *Muhammad Speaks,* largely in the 1960s. Several other tracks have been added to further contextualize the project, with explanatory notes listed beneath the song titles. As a sonic reconstruction, it meets the ears of the listener-reader as an echo of the cultural and political project of the Nation during the 1960s. The Nation set out to establish an economically self-sufficient unity among African and African diasporic people globally, prioritizing the plight of Black Americans in tandem with solidarity forged among and alongside other colonized peoples in Asia and Latin America. One means of inviting nonpoliticized people into the project was by appealing to self-pride—affirming the dignity in Black arts, from musical traditions hailing from the African continent to innovative sonic forms that emerged from the Caribbean and the US South. My ability to build out this playlist is a testament to the Nation's project—which, alongside

203

DARIEN ALEXANDER WILLIAMS

theological, economic, and political rhetoric, made its vision accessible to Black American Muslims in the 1960s through culture. This playlist should be read (or listened to) with a sensitivity to this broad goal, rather than with an emphasis on the individual details of songs or artists chosen. Many artists and public figures are associated with the Nation of Islam without being members themselves, largely due to their general belief in the cause or their strategic use of the prominent and growing Black counterpublic platform.

The playlist begins with Max Roach, whose contribution is followed by Dinizulu and His Africans (of North Carolina and New York, respectively, though the latter is a descendant of the Akan people). It continues with Abbey Lincoln's "Afro-Blue," a song originally composed by Mongo Santamaría, a Black percussionist hailing from Cuba (whose revolution Malcolm supported).[27] Next are pieces from Chicago-born singer-songwriter and activist Oscar Brown, Jr., and New Jersey's jazz organist Richard "Groove" Holmes.

The playlist continues with a contribution from Missouri-born and Harlem Renaissance–famed Langston Hughes, whose poetry and plays were read at numerous Nation of Islam events and were advertised in *Muhammad Speaks* in anticipation of his performances. Nigerian drummer Olatunji's song "Someday," about Black fatherhood, follows (also included is his upbeat and cinematic "African Waltz"), as does "Everywhere," by saxophonists Clifford Jordan (of Chicago) and John Gilmore (of Mississippi), who, like the Nation itself, both rose to prominence with early careers in Chicago before animating the Harlem jazz scene in the 1960s. Included midway through the playlist is a speech by Bronx-born Louis X himself, "White Man's Heaven Is a Black Man's Hell," a record

27
Malcolm's support for Cuban revolutionaries culminated in his 1960 meeting with Fidel Castro at the Hotel Theresa in Harlem. See Curtis, *Black Muslim Religion in the Nation of Islam*; Curtis, *Muslim American Politics and the Future of US Democracy*; and Harlem World, "Fidel Castro And Malcolm X At The Hotel Theresa, 1960," *Harlem World Magazine* (blog), June 9, 2020, https://www.harlemworldmagazine.com/fidel-castro-and-malcolm-x-at-the-hotel-theresa-1960.

that was pressed in 1960 before being distributed and adapted by numerous artists thereafter. Despite internal admonishments of participation in music, the brandishing "A Moslem Sings" on the label features Farrakhan's voice backed by gentle piano, guitars, bongos, and bass played by fellow members of the Nation.[28] The record was sold at various mosques and temples, as well as played at events.

The track is followed by Max Roach's "Tears for Johannesburg," an emblem of Black American solidarity with other communities across the diaspora, and the SNCC Freedom Singers' "Ain't Gonna Let Nobody Turn Me Around." The quartet drew on Southern Baptist gospel singing and protest chants and originally featured Rutha Mae Harris, Bernice Johnson Reagon, Cordell Reagon, and Charles Neblett, all of whom met at Albany State College in Georgia.[29] Then comes "Seesaw" by Lonnie Liston Smith, a pianist and singer who moved to New York from Richmond, Virginia, in 1963, followed by Bana Kadori, a Kenyan band, singing about the late Jaramogi Oginga Odinga, a revered Kenyan revolutionary leader who was often invoked at Nation of Islam rallies and in *Muhammad Speaks*. Walter Davis, Jr., a Virginia-born bebop pianist is included as the final "opener" for the speech I have chosen to include by Malcolm X, "The Ballot or the Bullet." Delivered in 1964 following his departure from the Nation, this speech is included because of its accessibility across music streaming platforms at the time of writing, as well as the sense of finality it evokes as a development toward the end of Malcolm's political transformation. Finally, the playlist closes with New York–based vocalist Jimmy Randolph, who reportedly sang "I Believe" at Malcolm X's *janazah*, or funeral.

205

28
Louis X, *A Moslem Sings: A White Man's Heaven Is a Black Man's Hell*, recorded at 113 Lenox Ave, New York, NY, distributed by Muhammad's Temple of Islam Inc., Salaam SPC-101, 1960, 45 rpm.

29
Edward Hatfield, "Freedom Singers," in *New Georgia Encyclopedia*, ed. John C. Inscoe, Edward Hatfield, and Anna Forrester, last modified Aug 14, 2020, https://www.georgiaencyclopedia.org/articles/arts-culture/freedom-singers.

DARIEN ALEXANDER WILLIAMS

Working through this playlist emphasizes the Nation's embrace of music as an organizing tactic, despite the group's changing relationship with the artform itself, and positions music as integral to their internationalist project. A small sample of these efforts can be engaged through this sonic tapestry that reflects musical lineages from Black America, the Caribbean, and continental Africa. In the turbulent 1960s, amidst state surveillance and rapidly developing new political forms and artforms alike, the Nation of Islam and Malcolm X were able to harness the power of music to forge relationships and build global consciousness across the African diaspora.

1

MAX ROACH
Freedom Day[30]

30
Muhammad Speaks 3, no. 5, 1963, 22.

"An African Bazaar"

Saturday, November 30, 1963

369th Armory at 142nd Street and 5th Avenue

New York, NY

2

DINIZULU AND HIS AFRICANS
Dinizulu[31]

31
Muhammad Speaks 2, no. 24, 1963, 16

Artist performed several times, including:

"Unity Party and Show Benefit"

Tuesday, January 28, 1964

El Sid's Trianon at 62nd Street and Cottage Grove Avenue

Chicago, IL

"African Asian Bazaar"

Saturday, August 17, 1963

Matthews Arena at 238 Saint Botolph Street

Boston, MA

3

207

WALT DICKERSON QUARTET DINIZULU
Arrival at Auda's Camp[32]

32
Muhammad Speaks 3, no. 5, 1963, 22.

"An African Bazaar"

Saturday, November 30, 1963

369th Armory at 142nd Street and 5th Avenue

New York, NY

DARIEN ALEXANDER WILLIAMS

4

ABBEY LINCOLN
Afro-Blue[33]

Artist performed several times, including:

Sunday, February 24, 1963

Roberts Show Lounge at 66th Street and South Park

Chicago, IL

NOI Town Hall[34]

Tuesday, September 8, 1964

123 West 43rd Street

New York, NY

[33] *Muhammad Speaks* 2, no. 10, 1963, 12.

[34] The Nation of Islam had planned this large program months in advance but ended up not having a speaker. The event was advertised in *Muhammad Speaks* using the exact ad and layout of an event that previously featured Malcolm X as a speaker, in addition to the usual musical guests preceding Malcolm's speeches. For these reasons, there is speculation about whether Malcolm would have spoken here had he not departed from the Nation of Islam earlier in 1964.

5

OSCAR BROWN, JR.
The Tree and Me[35]

"An African Bazaar"

Saturday, November 30, 1963

369th Armory at 142nd Street and 5th Avenue

New York, NY

[35] *Muhammad Speaks* 3, no. 5, 1963, 22.

6

RICHARD "GROOVE" HOLMES
Everything Must Change[36]

"Giant Benefit Program:
Don't You Want to be Free?"

Saturday, October 5, 1963

Embassy Auditorium, 847 South Grand Avenue

Los Angeles, CA

[36] *Muhammad Speaks* 3, no. 2, 1963, 17.

7

LANGSTON HUGHES
The Negro Speaks of Rivers[37]

"Giant Benefit Program:
Don't You Want to be Free?"

Saturday, October 5, 1963

Embassy Auditorium, 847 South Grand Avenue

Los Angeles, CA

[37] *Muhammad Speaks* 3, no. 2, 1963, 17.

8 OLATUNJI AND HIS DRUMS OF PASSION
Someday[38]

"An African Bazaar"

Saturday, November 30, 1963

369th Armory at 142nd Street and 5th Avenue

New York, NY

38
Muhammad Speaks 3, no. 5, 1963, 22.

9 CLIFFORD JORDAN & JOHN GILMORE
Everywhere[39]

NOI Town Hall

Tuesday, September 8, 1964

123 West 43rd Street

New York, NY

39
Muhammad Speaks 3, no. 26, 1964, 17.

10 LOUIS X[40]
White Man's Heaven Is a Black Man's Hell[41]

A Moslem Sings

Produced by the Nation of Islam in 1960

113 Lenox Avenue

New York, NY

40
A *Muhammad Speaks* issue published in March 1963 features an ad for the song, naming it "America's No. 1 Record Hit."

41
Despite stepping away from music upon entering religious leadership, Louis X would lean on knowledge of the record industry to distribute his speeches via vinyl records. He would later give speeches after musical interludes at rallies, as noted in *Muhammad Speaks* in October 1974.

11 MAX ROACH
Tears for Johannesburg[42]

"An African Bazaar"

Saturday, November 30, 1963

369th Armory at 142nd Street and 5th Avenue

New York, NY

42
Muhammad Speaks 3, no. 5, 1963, 22. Additionally, Roach wrote a column about jazz and the impact of Black art for *Muhammad Speaks*. His column appears in *Muhammad Speaks* 2, no. 6, December 15, 1962.

DARIEN ALEXANDER WILLIAMS

12

OLATUNJI AND HIS DRUMS OF PASSION
African Waltz[43]

"African Asian Bazaar"

43
Muhammad Speaks 2, no. 24, 1963, 16. This artist performed numerous times for the NOI and other Black freedom movements, the first instance advertised being at the aforementioned show.

Saturday, August 17, 1963
Matthews Arena at 238 Saint Botolph Street
Boston, MA

13

THE SNCC FREEDOM SINGERS[44]
Ain't Gonna Let Nobody Turn Me Around

Lest We Forget, Vol. 3: Sing For Freedom

44
Malcolm repeatedly interfaced with leaders from the Student Nonviolent Coordination Committee (SNCC), a group active from 1960 to 1970. The Freedom Singers were frequently found alongside members of the Nation at rallies protesting the Vietnam War.

Performed in 1963

14

LONNIE LISTON SMITH[45]
Seesaw[46]

NOI Town Hall

45
Lonnie Smith himself was a member of the Nation of Islam active in the DC-Maryland-Virginia region of the organization's 1960s expansion, before moving to New York in 1963 and collaborating frequently with Max Roach, another regular performer at NOI programs.

Tuesday, September 8, 1964
123 West 43rd Street
New York, NY

46
Muhammad Speaks 3, no. 26, 1964, 17.

15

BANA KADORI
The Late Jaramogi Oginga Odinga

Intercooler
Equator Heritage Sounds
January 1, 2002
New York, NY

16 WALTER DAVIS, JR.
Rhumba Nhumba[47]

NOI Town Hall
47
Muhammad Speaks 3, no. 26, 1964, 17. Tuesday, September 8, 1964
123 West 43rd Street
New York, NY

17 MALCOLM X
The Ballot or the Bullet

Malcolm delivered this speech twice:
Friday, April 3, 1964
Cory United Methodist Church at 1117 East 105th Street
Cleveland, OH

Sunday, April 12, 1964
King Solomon Baptist Church at 6100 14th Street
Detroit, MI

18 JIMMY RANDOLPH
There's No More Beautiful Days

Malcolm X's *janazah*
Saturday, February 27, 1965
The Faith Temple Church of Christ at 206 Malcolm X Boulevard
New York, NY

211

ASSEMBLING

A

CONVERSATION

WITH

SACRED SPACE

NSENGA KNIGHT

NSENGA KNIGHT is an Afro-Caribbean American Muslim artist from Brooklyn, New York. Knight has exhibited her work at many prestigious galleries and museums across the United States and internationally, in venues such as the Drawing Center, New York; Project Rowhouses, Houston; Berman Art Museum; Contemporary Art Museum, Houston; MoMA PS1; the Contemporary Image Collective in Cairo; New Museum for Contemporary Art, New York; and the Museum of Contemporary African Diasporan Art, Brooklyn. She is the recipient of numerous awards, grants, and fellowships, including the 2022–2024 In Situ Artist Fellowship at the Queens Museum in New York, the Pollock-Krasner Foundation Grant, and a Southern Constellations Fellowship. She has held many artist residencies, including at BRIC House in Brooklyn, the Drawing Center in New York, and Elsewhere Museum in North Carolina. Knight earned an MFA at the University of Pennsylvania and a BA in film production at Howard University.

NAJHA ZIGBI-JOHNSON (NZJ) I'm interested in your personal experiences growing up. Where did you find community, and how was it assembled?

NSENGA KNIGHT (NK) The word "community" is big for me. I feel very strongly that I belong to a community, whether it's the Brooklyn-based Muslim community, the Black Muslim community, or the worldwide Muslim community, what we call the *ummah*. My community has many layers. Masjid Abdul Muhsi Khalifah, formerly known as Temple No. 7C, has been around since the late fifties/early sixties and was established by Malcolm X in Bed-Stuy, Brooklyn. Most of the elders from that community were in the Nation of Islam (NOI), and many of them were companions of Malcolm X and followed him when he left the NOI. Then there is also Masjid At-Taqwa, which is also in Bed-Stuy, three blocks away from Masjid Muhsi Khalifah. They are both very Black, very Muslim mosques, although Masjid Muhsi Khalifah attracts a particularly Afro-Caribbean population—Malcolm X remarked as much in his autobiography. My parents themselves emigrated to the United States in the late sixties and early seventies from the Caribbean. So these are also my family's roots.

Growing up in the eighties like I did, to be Muslim was to be a part of something bigger—to be connected and part of activities, Black Muslim-

215

owned businesses, and events at the mosque. To be Muslim is to feel connected to one another. Community meant that you could be trusted. To be Muslim, for me, means that other people are safe around you, that I am safe with them. Their property is safe with me and mine with them. We will protect each other, and not just Muslims, but others too—you know that, if you're around a Muslim, you're safe.

We know so much about Harlem, because it was the "Mecca" of Black cultural life, and that's also where the major "temple," as they called it in the NOI, was. Malcolm X spent a lot of time in Harlem, but, as a Muslim minister, his primary role was to establish temples across New York City. We can trace his geographic imprint in the temples he established throughout Harlem and Brooklyn.

NZJ: Thank you for contextualizing Malcolm in Brooklyn. Beyond Harlem, Malcolm's work as a lead minister in the NOI meant he helped to shape the Black religious community and geographic space across the Northeast through the establishment of mosques. Like Harlem, Bed-Stuy is still one of the Blackest and most historically rich neighborhoods in New York City, and it is also being rapidly and relentlessly gentrified.

In addition to mapping particular neighborhoods shaped by the NOI's presence, can you share how sacred space is assembled within your project

Last Rite? I'm thinking about how Malcolm X's *janazah* prayer happened at a Christian church, how he was moved to his final resting place at the Ferncliff Cemetery in Westchester, New York, and how those particular rites, rituals, and processions were part of the process to ensure that Malcolm X could be granted the highest place in *Jannah*, in Heaven.

> NK: Again, the mosque is a place where people take care of each other. When a person dies, that care includes the community's responsibility to ensure that a proper Islamic burial is carried out for them. This begins with people from within the community (of their same gender or close family members) gently washing the body of the deceased, perfuming it, and then, finally, shrouding it. Prayers follow. It is actually similar to what the ancient Egyptians did. My husband pointed this out when we lived in Egypt—that Muslims have carried forth this ancient tradition.
>
> Because of Malcolm's break from the NOI and because Elijah Muhammad was still its leader, there was massive tension around his death. The NOI was not going to give Malcolm X a burial. His wife, Betty Shabazz, put out a call along the lines of, "He is Muslim; it is his right to be taken care of," "care" being the key word here. Back then, the Muslim immigrant community was still small, and so many were unwilling to get involved in anything so politically charged. There was also tension with a local Sunni

219

Muslim leader, Sheik Daoud Ahmed Faisal, head of the Black Sunni Muslim community in Brooklyn. He, too, didn't really believe that Malcolm X was a proper Muslim and so was unwilling to carry out his burial.

As it happens, though, there was a sizable community of Sunni Muslims in New Jersey willing to assist. What you see in this image is Sheikh Heshaam Jaaber leading Malcolm's burial rites. Sheikh Heshaam was the leader of a group of Black Muslims who established a community there in the 1920s. They were very different: they wore Saudi regalia; they spoke Arabic. These were Black scholars who traveled to study Islam. They weren't a huge community, but they had a network. Sheikh Heshaam always admired Malcolm X, though he didn't know him personally. He was watching the situation very closely, and, when Betty Shabazz made the call, he reached out to her to take care of Malcolm X. He embodied that sense of brotherhood, that understanding that, "This is my Muslim brother. And, even if I don't know him personally, I will take care of him." This, in essence, is what you see in my *Last Rite* series, and this is part of what I'm interested in thinking about in terms of assembling sacred space across the Black Muslim diasporic community.

Once Sheikh Heshaam and his fellow leaders had extended that kindness, their community brought Malcolm's casket around to different houses of worship, different mosques, all of which rejected

him. There was, however, a minister from a church in Harlem who accepted Malcolm X. His *janazah* finally took place at a church in Harlem, which is very uncharacteristic for Muslim ritual. Regardless, it shows that Malcolm X was somebody who was loved. There were a lot of people who felt a sense of legacy and attachment to Malcolm X—he belongs to a lot of people. I always find it very interesting to think about his *janazah*, because you can see Islamic ritual being undertaken across rows and rows of church pews. That, to me, represents the beauty of Black religion—that a lot of Black people value spirituality—and also speaks to the strength of the Black community.

NZJ: I really appreciate this context and your point around Christian and secular Black Americans working alongside the Black American and global Muslim communities to ensure Malcolm's proper burial. I think this sense of collectivism speaks to that particular political moment—that amidst all of the racial violence and terror that came along with the sixties and seventies, there was a concerted effort to ensure that, at least in death, Black people were taken care of and were sent out with celebration and love. There is this understanding amongst Black folks that white supremacy may dictate our exterior lives, but that Black folks hold a sense of ownership over our spiritual lives. I think this is something ubiquitous to the Black experience. The story of Black Christian and

223

Muslim people coming together to bury Malcolm
reminds me of this fact. Malcolm really was every-
one's "shining Black prince."

NK: Definitely. Sheikh Heshaam embodied a clarity
around the *janazah* ritual and affirmed that this
Islamic ritual would be done no matter what anyone
thought about Malcolm being Muslim, about wheth-
er he was Sunni, or a part of the Nation. Malcolm's
janazah prayer and Muslim burial put a seal on his
religious identity.

NZJ: On this religious identity, can you share why you
believe Black folks, and particularly Black women,
were turning to Islam in the sixties and seventies?
How did the political and cultural moment of the
Civil Rights and Black Power movements inform
this turn to Islam?

226

NK: Yes, these were some of the main questions explored
in my project *As the Veil Turns*, through conversa-
tions with Black women who converted to Islam pri-
or to 1975 and who were a part of the Brooklyn Mus-
lim community that I grew up in. There was a real
curiosity at the height of Black consciousness. When
you think about the NOI, which started in the 1930s,
it was comprised of folks who were the children and

grandchildren of enslaved people and sharecroppers. I think people were looking for change. It was very revolutionary that Black folks could choose their own beliefs and communities. Alberta, one of the women I interviewed for *As the Veil Turns*, was the first person in her family to leave sharecropping in the forties. She had the courage to leave South Carolina, move to Pittsburgh, and then to New York, where she met the brothers from the Nation of Islam who recruited her.

Alberta shared a story with me about the first time she went to the temple in New York. She recalled a line that NOI ministers, particularly Malcolm X, would say when showing a picture of a man being lynched in the South. He was strung up on a tree, and this image was juxtaposed with a picture of the NOI's flag. This was done to introduce the idea around who would win the war of Armageddon, what is believed to be the last fight between good and evil prior to Judgement Day. It emphasized the idea of a strong Nation, the Nation of Islam, and Black people, all of whom sought to rally strength in the face of lynching. Alberta experienced so much of this growing up in South Carolina. She recalled to me the mental process of juxtaposing those two images and feeling so incredibly moved that she leapt straight out of her chair. "I don't even know who picked me up," she told me. "It's like something just lifted me up, and

all I could say was, 'Sign me up!'" At that time, the NOI was the opposite of white supremacy. Black folks saw the NOI as a liberatory space. Islam is global and affirms that we are all human and are all connected through *ummah*. I think people really wanted to break free from the boundaries holding them back, and Islam allowed for this.

NZJ: That is really powerful. I've also been thinking a lot about the ways in which Malcolm learned from the various women in his life, be it his mother Louise, his sister Ella, his wife Dr. Betty Shabazz, or many others. I am interested in how you think about the women in Malcolm's life and how they may have informed his political evolution.

NK: Ever since I first picked up Malcolm's autobiography in the fifth grade, Ella's role in Malcolm's life always stood out to me. I want to do a whole project on Ella. Malcolm spoke about his sister Ella as an independent woman who was wealthy and owned real estate. And his family, including Ella, all joined and left the NOI before Malcolm did. His family told him, "You need to clean up your life, Malcolm. That's not what we do." Malcolm X came from a good stock of people. After leaving the NOI, Ella started her own Islamic school in Boston. She had teachers coming from Sudan and other parts of Africa to teach Arabic and Islam. Ella paid for Malcolm to make

229

Hajj when he left the NOI. She also became the leader of the Organization of Afro-American Unity when Malcolm passed, so Ella was deeply instrumental in supporting Malcolm in so many ways.

A lot of times when you listen to the portions of Malcolm X's speeches that talk about women, he emphasizes the importance of protecting Black women. I think, in a lot of ways, there is a certain duality around protecting Black women, which, in a modern context, some may understand as rooted in a type of patriarchy. But being protected doesn't make us weak: it is very much in line with the particular reality and circumstances created by white supremacist violence. Malcolm understood the power of Black women, but he also affirmed the importance of protecting and honoring Black women in the same breath.

NZJ: Thank you for that context. I really appreciate it. I think it's helpful to understand the duality of being strong and needing protection. These two things can exist at once. I'm not trying to ascribe a type of feminism onto Malcolm but rather understand Malcolm as a realist who understood the reality of violence and how structural white supremacy operates in this world.

Before we close, can you share what you see as the role of art and culture within the Black American Muslim tradition?

NK: I think that, even though I am an artist, art is still something that holds a lot of mystery for me. I believe art is a type of internal spiritual work—it is bringing something from the unseen world into the seen world. As people are seeking nearness to Allah and seek inspiration and awe as spiritually grounded people, it is important that we make it more feasible to traverse from the unseen into the seen world.

As an artist, many of my projects, like *As the Veil Turns* or my more socially engaged and collaborative projects *X Speaks* and *Muhammad School of Language and Martial Arts*, are an opportunity to involve more people in the artmaking process. Even though I'm interviewing and photographing women in *As the Veil Turns*, I am also a part of their community, so the work becomes like an auto-ethnography of sorts. I am also somebody that those women want to pass information down to, because it has meaning in their own lives and in mine. The impetus for making *As the Veil Turns* was many of these women asking me, "Do you know how to film? Do you know photography? Did you study this? We need you to do this." My artmaking is also something that allows me to be useful to my community.

In my work, I choose to highlight people who embody and can testify to the story of the Black community based on their own lived experiences. In fact, with the *As the Veil Turns* project, I was highlighting women who people might not necessarily

231

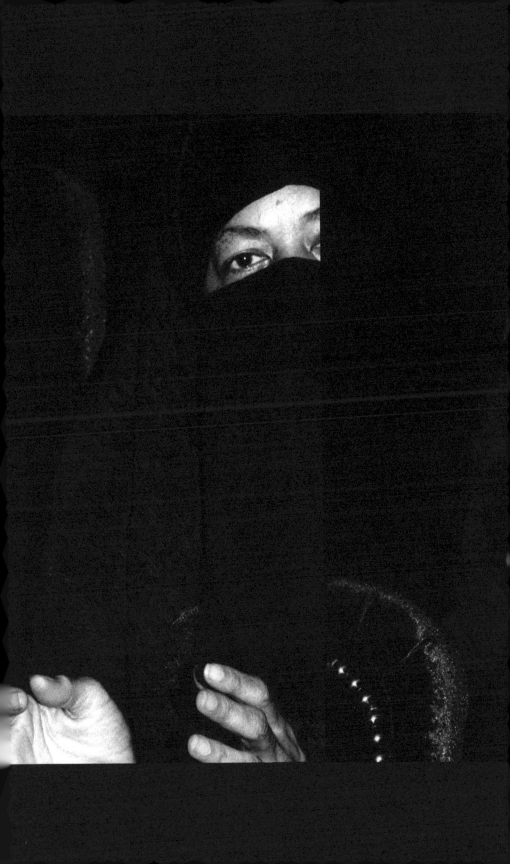

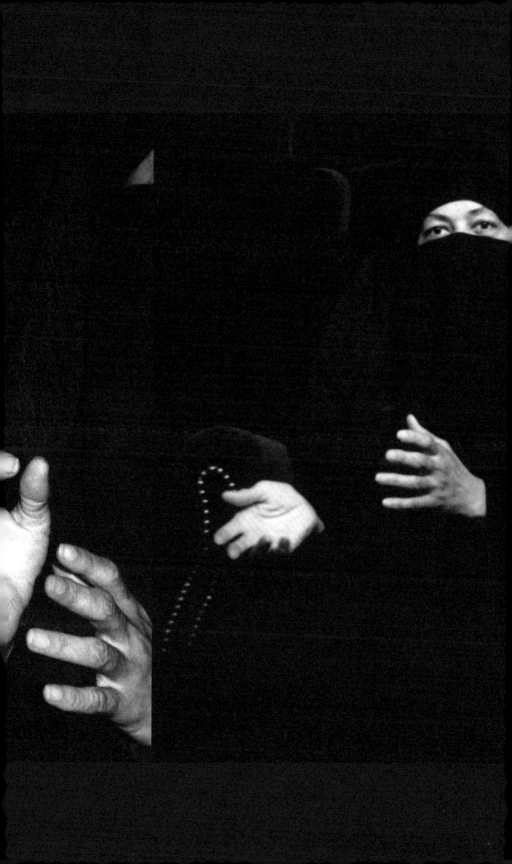

think of as "public leaders." They aren't the *imams* of our communities; these are everyday women. But, as an artist, they are participants who hold history. They carry stories and bear witness to our everyday. In that sense, artmaking, for me, is also an opportunity to create something in response to our lack of representation in the archives. I don't see myself in most of the archives, and my work responds to the fact that I am not present. We have to write ourselves into history, and that's also what my work does—it writes us into history so that we are preserving ourselves, speaking for ourselves, and declaring to others who we are.

NZJ: This is so wondeful and informative. That is exactly what *Mapping Malcolm*, the project, is trying to do. I think a lot about the work of Saidiya Hartman and others and often reflect on this history of material dispossession. As Black folks in the Atlantic world, so much of our archive has been taken or stolen from us. So, hopefully, *Mapping Malcolm* becomes part of this new archive, alongside the work of other historians, archivists, organizers, griots, and artists who are working to maintain, collect, and write our histories.

In many ways, I'm just trying to create this context to understand what is happening in my own community. So I really appreciate everything you've shared. Thank you.

234

EULOGY

OSSIE DAVIS

FOR

MALCOLM X

WITH

GUY DAVIS

OSSIE DAVIS (1917–2005) was an American actor, director, writer, social activist, and Civil Rights leader. He was the recipient of numerous awards and accolades alongside his artistic partner and wife, Ruby Dee, with whom he was jointly awarded the National Medal of Arts in 1995 and a Kennedy Center Honor in 2004.

GUY DAVIS is a two-time Grammy nominee for Best Traditional Blues and a musician, actor, author, and songwriter. Davis uses a blend of roots, blues, folk, rock, rap, spoken word, and world music to address the frustrations of social injustice, touching on historical events and common life struggles. Davis won the "Keeping the Blues Alive" Award and was nominated by The Blues Foundation for Best Acoustic Album of the Year, Best Acoustic Artist of the Year, and Best Instrumentalist.

My name is Guy Davis. I am seventy-one years of age. I was twelve when Malcolm X was murdered.

My father, Ossie Davis, introduced me to Malcolm X when I was a very little boy. It was in a ballroom on 155th Street in Harlem, not far from the Polo Grounds, where Joe Louis used to fight. I remember raising my eyes and reaching up to shake the hand of this smiling man who seemed to be treetop tall.

OSSIE DAVIS WITH GUY DAVIS

My mom Ruby Dee's brother, Uncle Tommy, was one of Malcolm X's bodyguards. His daughters used to babysit Malcolm and Betty's kids. I remember getting a ride home from college once from Dr. Betty Shabazz. Over the years, I got to know her and some of Malcolm's daughters.

Philosophically, my dad was a link in the Civil Rights struggle, who could speak alongside Martin Luther King, Jr., Stokely Carmichael, the Black Panthers, Paul Robeson, and pretty much all others. The breadth of his understanding was that we could all work together, because the various factions had way more things in common than things that separated them. People tended to trust Dad. He was steady, dependable, strong and clear, but not brash.

Dad was a creature of habit. He was up every morning before 5:00 am writing at the dining room table. On the table were two yellow legal pads, several #2 pencils, scotch tape, paper clips, and scissors. This is likely where he composed these words.

The day Malcolm was assassinated, my sisters and I were just blocks away from the Audubon Ballroom, at our grandmother's apartment on St. Nicholas Avenue. A night or two later, I remember playing with a toy car on the kitchen floor of our New Rochelle home, hearing my father on the phone at the kitchen table, discussing something about Malcolm's funeral. I don't remember if he was writing down details, or if he was in the midst of writing and editing the actual eulogy

As a schoolboy, I once tried to forge my father's signature on a test that I flunked. I discovered that such activities lead to destruction. The act of me handwriting this eulogy has no intrinsic value. It is merely an honorific. My copying these words is meant to demonstrate what my parents taught me: that it is important to elevate our heroes, and that the human race can be a family if you let it.

Malcolm X Eulogy

Here - at this final hour, in this quiet place -
Harlem has come to bid farewell to one of
its brightest hopes - extinguished now, and
gone from us forever.

For Harlem is where he worked and where
he struggled and fought - his home of homes,
where his heart was, and where his people are -
and it is, therefore, most fitting that we meet
once again - in Harlem - to share these last
moments with him.

For Harlem has ever been gracious to those
who have loved her, have fought for her, and
have defended her honor even to the death. It
is not in the memory of man that this be-
leaguered, unfortunate but none the less proud
community has found a braver, more gallant
young champion than this Afro-American
who lies before us - unconquered still.

I say the word again, as he would want me
to: Afro-American - Afro-American Malcolm,
who was a master, was most meticulous

in his words. Nobody knew better than
he, the power words have over the minds
of men. Malcolm had stopped being a 'Negro'
years ago. It had become too small, too puny,
too weak a word for him. Malcolm was
bigger than that. Malcolm had become an
Afro-American and he wanted - so desperate -
ly - that we, that all his people, would become
Afro-American too.

There are those who will consider it their duty,
as friends of the Negro People, to tell us to
revile him, to flee even from the presence
of his memory, to save ourselves by writing
him out of the history of our turbulent times.

Many will ask what Harlem finds to honor
in this stormy, controversial and bold young
captain - and we will smile. Many will
say turn away - away from this man, for
he is not a man but a demon, a monster,
a subverter and an enemy of the black man -
and we will smile.

They will say that he is of hate - a fanatic, a
racist - who can only bring evil to the cause
for which you struggle!

And we will answer and say unto them:
Did you ever talk to brother Malcolm?
Did you ever touch him or have him smile
at you? Did you ever really listen to him?
Did he ever do a mean thing? Was he ever him-
self associated with violence or any public
disturbance? For if you did, you would know
him. And if you knew him you would know
why we must honor him: Malcolm was our
manhood, our living black manhood! This
was his meaning to his people. And in honor-
ing him we honor the best in ourselves.

Last year, from Africa, he wrote these words
to a friend: "My journey" he says, "is almost
ended, and I have a much broader scope than
when I started out, which I believe will add new
life and dimension to our struggle for
freedom and honor and dignity in the States. I
am writing these things so that you will know
for a fact the tremendous sympathy and support
we have among the African States for our
Human rights struggle. The main thing is that
we keep a United Front wherein our most
valuable time and energy will not be wasted
fighting each other."

However much we may have differed with him—
or with each other about him and his value as
a man — let his going from us serve only to bring
us together now. Consigning these mortal
remains to earth, the common mother of all,
secure in the knowledge that what we place
in the ground is no more now a man — but a seed —
which, after the winter of discontent, will come
forth again to meet us. And we will know him
then for what he was and is — a Prince — our
own black shining Prince! — who didn't
hesitate to die, because he loved us so.

I WISH

GIVE YOU

 TURNER;

I COULD

THIS FEELING;

QUE!?

JERRELL GIBBS

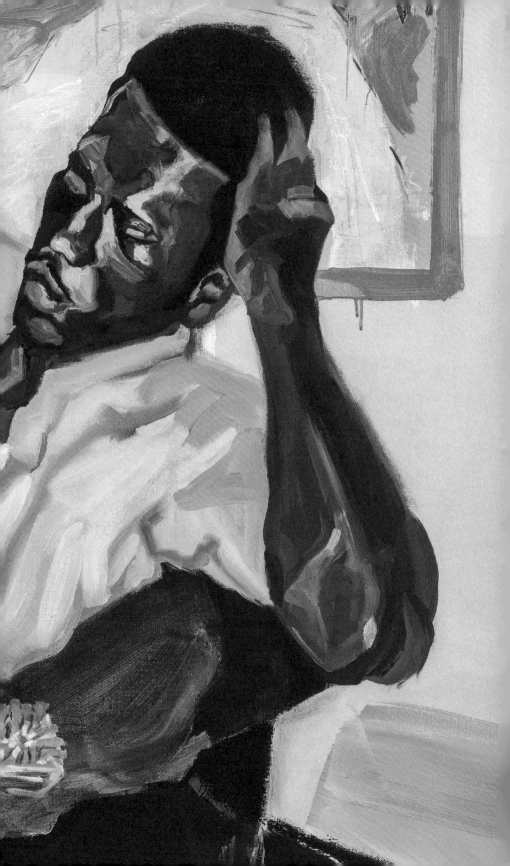

JERRELL GIBBS opposes deceptive perceptions of Black men by questioning master narratives and their connection to a muted visual history. His paintings are acts of resistance, asserting power over visual stereotypes. He paints the Black male figure with adornments, such as flowers, and contextualizes them in moments of peace, rest, and solitude. These gestures function to dismantle the visual misrepresentation of violence, trauma, and pain.

Gibbs is committed to creating paintings that are both authentic and truthful, and he reveals Black men as God-fearing husbands, fathers, brothers, and sons. His paintings highlight joy, beauty, and the mundane, all components within the vastness of Black life. The compositions, which are often taken from his family archive, focus on placement, size, proportion, as much as they do on mark-making and painterly gestures. His assertions of legacy highlight the performative nature of heritage and displaces an audience unaccustomed to more extensive and wide-ranging portrayals of Black life.

Gibbs graduated with an MFA from the Maryland Institute College of Art, Baltimore, in 2020. His work is in the permanent collection of the Brandywine Museum of Art, Baltimore Museum of Art, Columbus Museum of Art, the Los Angeles County Museum of Art, the CC Foundation, and the X Museum Beijing.

255

BEAN PIE SA7TEIN!

THE POETICS

CHRISTOPHER JOSHUA BENTON

OF EATING IN

THE NATION
OF ISLAM

1
Literally translated as "two healths," Sa7tein
or صحتين is a colloquial blessing used
during mealtimes that imparts wishes
for "good eating."

A version of this text was originally pub-
lished in *Thresholds* 51: Heat, edited by
Hampton Smith and Zachariah DeGiulio.
Christopher Joshua Benton, "Beyond Bow
Ties & Bean Pies: A Material Analytic Ap-
proach to Eating & Meaning-Making in the
Nation of Islam," *Thresholds*, no. 51 (Spring
2023): 204–213.

CHRISTOPHER JOSHUA BENTON is an American artist based in the UAE working in artistic research and installation. His art practice produces alternative archives that platform the narratives of diasporic people. His exhibitions have been presented at museums, biennials, and art fairs around the world, including the Fikra Graphic Design Biennial (Sharjah, UAE); Abu Dhabi Art's Beyond Emerging Artists (59th Venice Biennale); and Dubai Design Week among others. Supported by the Salama Bint Hamdan Al Nahyan Foundation, Benton has a master's degree in Art, Culture, and Technology from MIT, where he earned the Obermayer Prize and the Harold and Arlene Schnitzer Prize.

I grew up in the Church—my grandfather and his grandfather were both pastors. Most Sundays were spent at Sunday school, but not on weekends with my dad. Those Sundays would end at the intersection of Brambleton and Tidewater, steps aways from the Calvert Square housing projects and its dull red bricks, next to the buzzing HBCU where my mom and dad went to college, and across from the infamous whites-only high school that the state of Virginia closed rather than desegregated back in the 1960s. This is where

CHRISTOPHER JOSHUA BENTON

Dad and I would go to pick up fresh slices of bean pie from Muslims selling them on the street. And what of the freeway and the railroad track, which conspired to sequester this tiny plot of land from the rest of downtown Norfolk? Or the two boulevards as wide as highways that carved the land so callously it could barely hold the well-dressed men darting back and forth between crabgrass and pavement and cars to ask us: "Bean pie, my brother?" Of course, as a child, this was just the place with yummy pie, the place that helped me relate to my father's recent conversion to Islam.

The Supreme Bean Pie is made of just a few essential ingredients: navy beans, sugar, butter, cinnamon, pie crust, and, most importantly, grit[2]—that jagged grain of blues and resilience that has textured Black American history from the outset. Perhaps more than any other signifier, the bean pie has become representative of the Nation of Islam (NOI), a Black religious and political organization that at one time was America's largest Muslim cohort. Of course, food is never just food: what we eat represents a complex entanglement of ideas, customs, histories, and relationships.

The bean pie is an important product of Black American and American Muslim culture that continues to influence family histories, politics, culinary traditions, music, and business. Its precise origins remain elusive. As popular legend goes, Lana Shabazz, Muhammad Ali's private chef, invented the bean pie. However, others claim that NOI founder W.D. Fard created the recipe himself.[3] Eating the bean pie has no explicit ritualistic pur-

[2]
Ameenah Muhammad-Diggins, *Bashirah and the Amazing Bean Pie: A Celebration of African American Muslim Culture* (Scotts Valley, CA: CreateSpace Independent Publishing, 2018).

[3]
Mike Sula, "Bean Pie, My Brother?" *Chicago Reader*, November 18, 2013, https://chicagoreader.com/food-drink/bean-pie-my-brother.

pose in the Nation of Islam, and yet the dish has symbolic and practical potency as a cultural artifact unique to the religion.[4] As a fusion of foodways from the Islamic diaspora and the Great Migration, the bean pie is an edible piece of material culture. Tracing the bean pie's production and circulation reframes the dish as an anti-slavery tool, a radical marker of a new Black identity, and a practical instrument for economic independence.

4
Asad El-Malik, *Bismillah & Bean Pies* (New Orleans: Muslim Fresh Publishing, 2016), 15.

My dad Rafiq's bean pie recipe.
Courtesy of the author.

261

CHRISTOPHER JOSHUA BENTON

While the Nation of Islam was founded by W.D. Fard in 1930 in Detroit, MI, it wasn't until its second leader, Elijah Muhammad, that the organization reached its height, with over 500,000 members and seventy-five mosques across the United States.[5] By the 1960s, the NOI was running hundreds of businesses that employed over 11,000 Black people.[6] Many of the organization's beliefs and gestures can be understood as resistance to white oppression and Black American orthodoxy. For the Nation of Islam, every facet of the Black American project was to be rethought and remade. Each mainstream Black call to action—which of course, was typically rooted in the Black Christian church—had its own opposite in the Nation of Islam. If your equality was a fight for *integration* into normatively "white" systems, the NOI's idea of equality was a separatist desire for a new, totally Black system.[7] If your civil rights called for peaceful non-violence, then the NOI demanded action "by any means necessary."[8] It is not surprising, then, that this position could even be imposed onto food: If the Black status quo cooked black-eyed peas, the NOI cooked navy beans. If most Black folks ate sweet potato pie (a staple of the Black American "soul food" diet), the NOI baked and sold bean pie.[9] In fact, the entire NOI enterprise rejected what Elijah Muhammad saw as vestiges of slavery in the Black psyche and body.[10] It is not incidental that one of the first things a NOI convert does is "restore" their Muslim name from their "slave name"[11]—

5
Edward E. Curtis, *Black Muslim Religion in the Nation of Islam, 1960–1975* (Chapel Hill: University of North Carolina Press, 2006), 2.

6
Nafeesa Muhammad, "The Nation of Islam's Economic Program, 1934–1975," *BlackPast*, April 1, 2020, https://www.blackpast.org/african-american-history/the-nation-of-islams-economic-program-1934-1975.

7
The Hate That Hate Produced, produced by Louis Lomax and Mike Wallace of *NewsBeat*, aired July 13–17, 1959 (New York: WNTA-TV), five half-hour installments. In the infamous TV program, Elijah Muhammad even called for the government to give Black Muslims their own State in the western part of the country.

8
Malcolm X, "By Any Means Necessary Speech," New York City, June 28, 1964, 7:36, available on YouTube, https://youtu.be/WBS416EZsKM. Transcript available on *BlackPast*, published October 15, 2007, https://www.blackpast.org/african-american-history/speeches-african-american-history/1964-malcolm-x-s-speech-founding-rally-organization-afro-american-unity.

9
El-Malik, *Bismillah & Bean Pies*, 16.

10
Curtis, *Black Muslim Religion in the Nation of Islam*, 98.

11
Ayman Ismail, "This Pie Tells One of the Most Essential Stories About Muslims in America. And It's Delicious," July 22, 2018, in *Who's Afraid of Aymann Ismail?*, produced by *Slate* magazine, 7:56, https://youtu.be/yWjDBWXzBLQ.

perhaps most popularly exemplified in the refashioning of Cassius Clay as Muhammad Ali.[12]

Whether it be Christian names, recipes, or sweet potato pies, the provenance and practice of everyday things were to be inspected, reconsidered, and recrafted in the Nation. The oldest-known published recipe for sweet potato pie appears in *A Domestic Cookbook: Containing a Careful Selection of Useful Recipes for the Kitchen*, written in 1866 by Melinda Russell.[13] A similar recipe was published in *What Mrs. Fisher Knows about Old Southern Cooking*, written in 1886 by Abby Fisher, a formerly enslaved person.[14] It was the proximity of the sweet potato to the plantation that bothered Elijah Muhammad the most. Sweet potatoes were considered "very cheaply raised," "used to feed slaves," and "unfit for human consumption."[15] The context of these two cookbooks helps illuminate the milieu in which the bean pie was produced. The Great Migration diffused traditionally Southern recipes to new audiences northward, transmitting Black American food from oral traditions passed between families to private homes, bakeries, and, finally, cookbook audiences. The bean pie would follow a similar trajectory of exchange fifty years later.

Some of the first widely circulated texts recording the NOI's beliefs about food were published in *Message to the Blackman*, written by Elijah Muhammad in 1965. Food is first addressed near the beginning of the book, as Muhammad writes about the teachings of W.D. Fard, who he considered "God in the Flesh":

He taught us that the slave-masters had taught us to eat the wrong food and that this wrong food is the cause of

12
Victor Mather, "In the Ring He Was Ali, but in the Newspapers He Was Still Clay," *New York Times*, June 9, 2016, https://www.nytimes.com/2016/06/10/sports/muhammad-ali-name-cassius-clay-newspapers.html.

13
Melinda Russell, *A Domestic Cookbook: Containing a Careful Selection of Useful Recipes for the Kitchen* (Ann Arbor, MI: William L. Clements Library, 2007), 23.

14
Abby Fisher, *What Mrs. Fisher Knows about Old Southern Cooking* (Bedford, MA: Applewood Books, 1995), 26.

15
Elijah Muhammad, *How to Eat to Live: Book 2* (Atlanta: Messenger Elijah Muhammad Propagation Society, 1972).

263

CHRISTOPHER JOSHUA BENTON

our sickness and short span of life. He declared that he would heal us and set us in heaven at once, if we would submit to Him. Otherwise He would chastise us with a severe chastisement until we did submit. And that He was able to force the whole world into submission to his will. He said that he loved us (the so-called Negroes), his lost and found, so well that he would eat rattlesnakes to free us if necessary for he has power over all things.[16]

For Muhammad, how one eats is a life-or-death enterprise, one marked by a dualism in which Fard is God and slave-masters are the Devil. Of course, food and the body are important sites of spirituality in various other traditions of Islam too. Specific dietary rules keep the body healthy, while fasting enables space for gratitude, cleansing, and contemplation. In *An Introduction to Islamic Cosmological Doctrines*, Seyyed Hossein Nasr makes the claim that language in the Qur'an provides an ontological "hierarchy of the universe" that designates "good foods" from "bad foods."[17] According to this cosmology, eating good foods makes a good human, while eating bad foods makes a bad one. Food therefore affects the character of the soul, as the body becomes a battleground wherein eating comprises an ethical reckoning between the self and the divine. And yet, in this cosmic-scale war on health, are Southern food traditions the "cause of sickness" (as Muhammad posits)—or are food systems? Diabetes and hypertension might overwhelmingly wrack the Black community, but the root cause extends beyond what grandmother serves in her casserole: it extends to the food policy that brings her recipes to the crockpot. What about the food deserts that isolate Black communi-

16
Elijah Muhammad, *Message to the Blackman in America* (Goodyear, AZ: Secretarius MEMPS Publications, 1973), 17.

17
Seyyed Hossein Nasr, *An Introduction to Islamic Cosmological Doctrines* (Albany: State University of New York Press, 1993), 70.

ties from fresh fruit and vegetables? What about the oppressive labor systems that make healthy food unaffordable, or the precarity that limits access to self-care? What of the corporate food systems that separate us from the land and the agricultural, hunting, and fishing traditions that are our birthright? And what of the crisis of care: the medical negligence, the limited access to insurance, and the daily pang of stress and worry that embeds in the body over a lifetime of racist abuse?

In 1967, Elijah Muhammad published the seminal text *How to Eat to Live*, a dietary guide that drew on his decades-long proclamations about food. Five years later, in 1972, he released *Book 2* of the series. The title's double infinitive of "to eat" and "to live" posits that to eat well is not just a matter of survival but a type of freedom, a freedom that brought hope to millions, including my father, who for most of my life ate vegetarian and fasted—both things he first encountered in Muhammad's book. "Have you ever spent a day *not* eating?" he would sometimes ask me on his fasting days. The answer was always "no": the proposition of not eating for an entire day was baffling—even if it was healthy, or contemplative, or a way to practice gratitude. In telegraphing Muhammad's book, Dad's follow-up was always the same: "Don't live to eat; eat to live."

How to Eat to Live reads like a sermon. Delivered in compact sentences and frequent shifts into all-caps, the text is exuberantly punctuated with exclamation marks, as if transcribed from the radio broadcasts that made Muhammad a household name. It is in this jeremiad that Muhammad makes his case for navy beans, which are mentioned seven times in *Book 2*, at one point asserting: "[God] said that a diet of navy beans would give us a life span of one hundred and forty years. Yet we cannot live one-half that length

265

3
uhammad, *How to Eat to Live: Book 2*,
9.

CHRISTOPHER JOSHUA BENTON

of time eating everything that the Christian table has set for us."[18] While certainly overstated, it is scientifically proven that navy beans—the primary ingredient of the bean pie—are one of the healthiest beans on the planet. In addition to being rich in ferulic acid and vitamin B, they are the greatest non-meat source of phosphatidylserine, which is associated with good memory, cognition, health function, and stress release.[19] While the health credentials of this "superfood" certainly inform the Nation of Islam's ideas of a purified Muslim body, to assert one's health isn't just a matter of wellness and longevity: it's also a form of resistance—a means of fighting back against a world seemingly designed to kill you.

So-called "bad" foods—pork, catfish, lima beans, and black-eyed peas—are painstakingly described in *How to Eat to Live*. They are inscribed with special meaning in the Black community. It's "soul food": that decidedly Black vernacular of adding pork fat to cornbread, collard greens, and other Southern dishes "that'll make you smack your mama," as my mom likes to say. Poet Amiri Baraka coined the term "soul food" in an essay of the same name in 1962, calling it "good grease,"[20] but, just a few years later, he would launch the Marxist organization Committee for Unified Newark (CFUN), teaching the same vegetarian and anti–soul food diet of Black nationalists such as the NOI.[21] Indeed, for Black revolutionaries of the sixties and seventies, to change how you eat to live became a rite of passage, locating oneself in a new understanding of Blackness. In his autobiography, Malcolm X describes the exact moment he gave up pig, as it was served on a platter in prison: "I hesitated, with the platter in mid air; then I passed it along to the inmate waiting next to me. He be

19
Michael J. Glade and Kyl Smith, "Phosphatidylserine and the Human Brain," *Nutrition* 31, no. 6 (2015): 781–786.

20
LeRoi Jones, "Soul Food," *Home: Social Essays* (New York: Akashic Books, 1961).

21
Jennifer Jensen Wallach, "How to Eat to Live: Black Nationalism and the post-1946 Culinary Turn," *Study the South* (Oxford, MS: Center for the Study of Southern Culture, University of Mississippi, 2014), https://southernstudies.olemiss.edu/study-the-south/how-to-eat-to-live.

gan serving himself; abruptly he stopped. I remember him turning, looking surprised at me. I said to him, 'I don't eat pork.'"[22] These are the same culinary ethics espoused in *How to Eat to Live*, which uses food to image a new type of Black American: one interested in lower-cholesterol, lower-fat foods like fish, bean soup, fresh vegetables, and bean pie—all in a quest for greater health autonomy. In *New World A-Coming*, historian Judith Weisenfeld summarizes the aims of Muhammad's dietary stricture:

> The NOI's dietary practices were intended to restore individuals to their original state as Asiatics, heal and fortify them to withstand the hardships of life under the devil's rule, prepare them for the coming judgment and destruction of the devil's society, and make them worthy of life in the paradise that would follow.[23]

Organizations like the NOI, according to Weisenfeld, offered new narratives that could "relocate" adherents by "rejecting the prevailing American system of categorization in which [followers] were Negroes at the bottom of a hierarchy."[24] In other words, diet could destabilize the social order. Muhammad's food restrictions (to fast, to eat once a day, and to reject the so-called "white man's diet") were strategic, re-orienting and separating Black personhood away from and above whites in American society— if not yet economically, at least dietarily.

The bean pie also served up its own aesthetic that has become one of its main signatures: the distinctive bow ties of the men who sell them. While the NOI's version of Islam may have been practiced

22
Malcolm X and Alex Haley, *The Autobiography of Malcolm X* (New York: Ballantine Books, 1965).

23
Judith Weisenfeld, *New World A-Coming*, (New York: New York University Press, 2016), 147. Note that the NOI believes that the Black Man is from Asia, therefore "Asiatic."

24
Weisenfeld, *New World A-Coming*, 87.

Black Muslims learning about diet. Gordon Parks, *Untitled*, Chicago, Illinois, 1963. Courtesy of and © The Gordon Parks Foundation.

chiefly in the sequestered space of the home, the mosque, or in converted shopfronts, the familiar image of the bean pie being sold and distributed on street corners helped make the religion visible in the public sphere. The NOI's dress codes were rooted in the respectability politics of the time: as much related to ideas of moderation, self-love, and self-respect as it was about setting Black Muslims apart. Each man wore what we call "Sunday's Best" in the Black Church but dressed that way every day. "They look clean, Jack!" as my grandma likes to say. You can see this immortalized in *Life* magazine photographs by Gordon Parks: men in crisp suits, sunglasses, and ties, and women in long dresses and headscarves.[25]

Often featuring large groups in similar dress, Park's photos enact a sense of repetition and vastness that approximate the infinitude one *feels* in Islamic geometric art and architecture. So, while Park's photographs record the NOI as an essential vision of Harlem life in the sixties, smaller-scale renderings of this new Black life were also being staged throughout Chocolate Cities in America,[26] even in Southern towns like my home in downtown Norfolk. It's the singular figure of the sharply dressed NOI man, stationed at busy intersections and selling the bean pies, that captured my imagination as a child and became an important visual identifier for the group at large.[27]

The history of the bow tie in the Nation of Islam is not well studied, but some believe that its endurance in the organization stems from the bow ties that Elijah Muhammad wears in photographs. The bow tie is also part of the uniform of the Fruit of Islam, the all-male security force of the Nation. It is often constructed out of red fabric, echoing the NOI flag. The fashion flourish—and male fashion in the NOI more broadly—is perhaps best understood through the history of Black dandyism: that special Black passion of dressing meticulously to assert one's presence in a white supremacist culture. Curator Ekow Eshun describes the double bind of Black masculinity as "simultaneously hypervisible and invisible to white society."[28] In this context, the NOI's clothing becomes a political act of self-imaging that exists within and outside the white gaze. Inside the Nation, moderate clothing encourages adherents to act in adherence to the Qur'an. Outside the Nation, suiting and bow ties become a way to fight stereotypes around the Black body, while also functioning as a recruitment tool for the group to grow.[29]

25
Gordon Parks, "What Their Cry Means to Me—A Negro's Own Evaluation," *Life*, May 31, 1963, 22–33.

26
Coined by the band Parliament Funkadelic, "Chocolate Cities" refers to the cities and towns where Black culture is created, performed, and preserved.

27
Asad El-Malik, *Bismillah & Bean Pies*, 107.

28
Ekow Eshun, "The Subversive Power of the Black Dandy," *The Guardian*, July 4, 2016, https://www.theguardian.com/artanddesign/2016/jul/04/the-subversive-power-of-the-black-dandy.

29
Kayla Renée Wheeler, "Bow Ties, Beards, and Boubous," *The Revealer*, September 2, 2020, https://therevealer.org/bow-ties-beards-and-boubous-black-muslim-mens-fashion-in-the-united-states.

CHRISTOPHER JOSHUA BENTON

Beyond the body, the remediation of the bean pie through music and culture further gives way to what critic David Morgan calls "cultural work"—in this case, providing an important new model for Black identity in America.[30] In her book *Racial Indigestion*, Kyla Wazana Tompkins argues that eating was a "trope and technology of racial formation during the first 130 years of the US republic."[31] Elijah Muhammad used the power of food and eating to cement his vision for the new Black American family. It is not an overstatement to say that the bean pie has come to symbolize the Nation of Islam, while also subsuming itself into the greater cultural apparatus of the African American community and beyond. Just look to hip-hop for proof. The website Genius, a lyrics aggregator for popular music, lists 119 rap songs that include a reference to the "bean pie." Some of the earliest song mentions come in 1993. In "You Better Ask Somebody," MC Yo-Yo raps, "I can get mad as a mean guy / And on the other hand be sweet as a bean pie."[32] Similarly, in Queen Latifah's hit song "Just Another Day," the performer recounts an average day in the neighborhood by paying homage to her own NOI roots: "Stomach ache, head to Steak-N-Take for a bean pie / Get a *Final Call* from the brother in the bow tie."[33] Many of these songs rely on similar imagery to the NOI-owned *Final Call* newspaper and the bow ties that NOI men typically wear, attesting to the shared visual and cultural memory of the bean pie in urban areas. Perhaps most of all, these musical citations prove the bean pie's ability to disseminate a distinctive style and identity for Black Muslims while further serving as a conduit for creative expression and a new paradigm for American Blackness.

30
Tim Hutchings and Joanne McKenzie, *Materiality and the Study of Religion: The Stuff of the Sacred* (New York: Routledge, 2017), 23.

31
Kyla Wazana Tompkins, *Racial Indigestion* (New York: New York University Press, 2016), 22.

32
Yo-Yo, "You Better Ask Somebody," 1993, track 6 on *You Better Ask Somebody*, EastWest Records America 4-92252, cassette.

33
Queen Latifah, "Just Another Day," 1993, track 11 on *Black Reign*, Motown 37463 6370-4, cassette.

"Do for self," is a familiar refrain for Nation of Islam members. Elijah Muhammad's infamous motto is not just a statement of intent but a clarion call for total independence through economic empowerment.[34] This model of economic self-reliance could be applied to the scale of both the individual and the group. In this way, each member's personal drive for entrepreneurship could be fulfilled while also galvanizing collective action to support the greater organization. The bean pie is a near-perfect metaphor for these two scales of financial autonomy.

In 1964, Elijah Muhammad launched a three-year economic plan, also known as the National Savings Plan.[35] Members were encouraged to donate 10 to 30 percent of their income to the Nation of Islam and live modestly for three years. The commitment was not dissimilar from the Christian practice of tithing, which encourages congregants to give 10 percent of their income to the church. However, in the NOI, proceeds were used to start various types of businesses operated by the organization. Controversially, donations would also enrich Elijah Muhammad and his family. As the historian Nafeesa Muhammad writes, "In Chicago alone, the NOI organized fifteen different businesses including Your Supermarket, Shabazz Grocery, Chicago Lamb Packers, Shabazz Bakery, Good Foods, Shabazz Restaurant and Salaam Restaurant, Shabazz Barber Shop, and a clothing factory."[36] These businesses laid the groundwork for the NOI's unrealized dream of a fully separate economic system for Black people, powered by completely vertically integrated companies. For instance, the food produced at NOI-owned farms

34
Muhammad, *Message to the Blackman in America.*

35
Muhammad, "The Nation of Islam's Economic Program."

36
Muhammad, "The Nation of Islam's Economic Program."

in Alabama, Michigan, and Georgia was delivered via NOI-owned trucks and NOI-owned airplanes to be sold at NOI-owned supermarkets.[37] This collective capital-building is also present in the bean pie. Streetside bean pie salesmen did not keep the proceeds from their bean pies; instead, they donated them to the mosque. In this way, the bean pie is a potent symbol for the type of cooperative service and enterprising spirit embedded into the ethos of the NOI. The bean pie, therefore, is not only about eating but also about giving, perpetuating a gift economy of charitable works that maintained and circulated an invisible, selfless spirit among buyers and sellers.[38] Of course, charity and generosity are foundational practices in Islam at large. *Sadikah* (voluntary giving) and *zakat* (the mandatory giving of 2.5 percent of one's yearly savings) are mentioned several times in the Qur'an, although the NOI's sense of giving was much more gumptious.

The bean pie also represents the individual entrepreneurial spirit of Nation of Islam families and businesspeople. While members operated their own dry cleaners, barbershops, and clothing stores during the organization's height in the 1960s, the most common NOI businesses in American cities were bakeries whose star product was the bean pie.[39] Several decades after Marcus Garvey inspired millions with his Buy Black Movement and its unofficial motto "Be Black, Buy Black, Think Black, and all else will take care of itself!" the NOI developed similar large-scale plans to concentrate Black wealth into its member-owned businesses. It is not an overstatement to say that the bean pie epitomized the NOI's value system, shared sense of community, and successful program in building its own world through business.

37
Muhammad, "The Nation of Islam's Economic Program."

38
Jessica Harris, *High on the Hog: A Culinary Journey from Africa to America* (New York: Bloomsbury, 2011), 214. This spirit of giving wherein the body becomes a site or conduit of generosity loosely recalls other Black American practices like "pinning," a Black Cajun practice where a pin is placed on the lapel for others to clip on money for one's birthday. It also echoes other rent parties in Harlem, where guests would donate money to benefit the rent of their neighbors.

39
Jennifer Wallach, *Every Nation Has Its Dish* (Chapel Hill: University of North Carolina Press, 2019), 180.

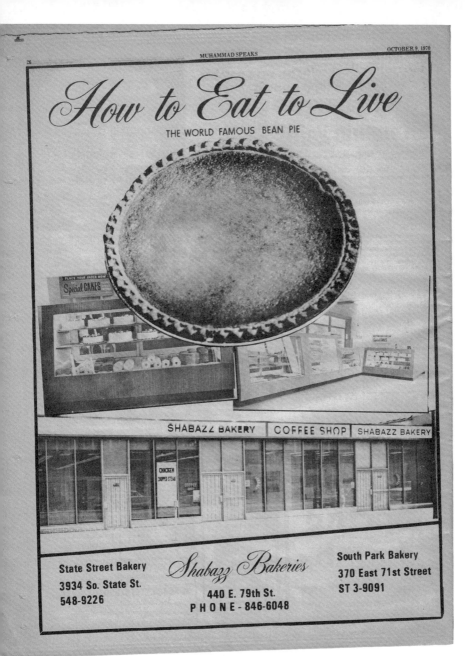

273

CHRISTOPHER JOSHUA BENTON

This economic empowerment also extended to women, despite the Nation of Islam's patriarchal vision of a Black nuclear family with a father who worked, a mother who kept the home, and children who learned Black Islamic values in NOI schools. Women in the NOI were trained in "pink-collar" work like housekeeping, sewing, cooking, child-rearing, and other domestic skills.[40] It was a decidedly American individualist fantasy, absorbed from dated Protestant social mores, rather than the more collectivist extended family models found in Muslim Arab, South Asian, and North African households.[41] Considering the NOI's androcentric worldview, it is seductive to think of the bean pie as a technology that extended the group's patriarchal aims. After all, it's not hard to imagine women constrained to the home, tending to the gendered work of preparing and baking bean pies, while men dominated the social sphere, selling the dish on the streets. In reality, both men and women made pies at home and in bakeries. Furthermore, many of the NOI bakeries were women-owned and -operated—often run by some of the first women entrepreneurs in the wider Black community. So what if we reframed the bean pie as a feminist foodway that subverted the group's own retrograde treatment of women? After all, a successful woman-led bakery presents a paradox: women could simultaneously be hierarchized as secondary to men and also function as the family's primary breadwinner. This economic power shift reorients the NOI's sexist gender dynamic. If entrepreneurism is really a force of economic emancipation (as NOI members believed), then the bean pie offered up a surprising, if uneven, version of female liberation on a plate.

40
Dennis Walker, "Elevating the Family in the Nation of Islam: Discerning the 'Gnostic' Factor," in *The Gnostic World*, ed. Garry W. Trompf, Gunner B. Mikkelsen, and Jay Johnston (Routledge, 2018), 556.

41
Curtis, *Black Muslim Religion in the Nation of Islam*, 127-128.

274

Religion is the living and breathing embodiment of practices, rela-
tionships, and moments of individual and collective meaning-mak-
ing. These beliefs and customs are elastic, gaining potency, weak-
ening, refracting, and distorting as practice is passed down through
oral tradition, crisscrossing cultures and continents. This is a lot like
the bean pie—a family recipe standardized but re-invented each time
it is re-made; written down, but prone to improvisation; colored by
personal family histories; and inherited through generations of love
and toil. By inspecting the bean pie as a piece of material culture, we
see how the Nation of Islam's sense of community, Black resistance,
spirituality, and economic independence were circulated and cod-
ified, ultimately living on through its members, music, businesses,
and artifacts.

For Elijah Muhammad, the diasporic nature of Islam is Black.
It was imperative for Muhammad to trace Islam back to the African
continent (in his view, Africa was part of Asia, the original home to
Black Muslims) to legitimize the religion as a Black one.[42] In fact, ac-
cording to Muhammad's cosmology, the original man on Earth was 275
a Black Muslim.[43] It is therefore ironic that Elijah
Muhammad failed to trace the roots of the bean
pie to its African beginnings. Just last year, a new
origin story has emerged laying out an alternative history of the
bean pie. In the family memoir *The Bean Pie: A Remembering of Our
Family's Faith, Fortitude, and Forgiveness,* Tiffany Green-Abdullah
makes a bold claim: the bean pie is not only an improvised version of
the sweet potato pie—it is a recipe derived from the African diaspora
that was created by her family.

[42] Elijah Muhammad would consider Af-
rica to be East Asia, in his conception
of the "Asiatic Black Man."

[43] Curtis, *Black Muslim Religion in the Na-
tion of Islam,* 11.

Green-Abdullah describes a story about how her great grand-mother Daisy (not Lana Shabazz or W.D. Fard, as popularly un-derstood) invented the bean pie out of her love of the Nigerian dish *moi-moi*, which had been passed down in her family for generations. While the original *moi-moi* is a savory dish made from mashed beans that are rolled into a ball, Daisy crafted a remixed version that accom-modated her own sweet tooth, the NOI's taste for canned white beans, and the practicalities of selling the product at her family bakery.[44]

Thinking about Daisy's formative bean pie recipe and its lost African provenance, perhaps we can reread the bean pie as a tal-isman that unwittingly connects the eater back to the food of the African continent. In this way, the bean pie is an interface that teth-ers the body to the epigenetic memory of a distant—but not lost—past. This also tracks with one of the foundational beliefs of the first Blacks in America. Enslaved peoples believed that death didn't send one to heaven; instead, it would send one back to Africa.[45] We are thus confronted with a final potentiality: if only for a few moments, eating a forkful of bean pie can send one back to the motherland—and for me, back to those sticky weekends in downtown Norfolk with my dad.

44
Tiffany Green-Abdullah, *The Bean Pie: A Remembering of Our Family's Faith, Fortitude, & Forgiveness* (Washington, DC: New Degree Press, 2021), 79.

45
Suzanne Smith, *To Serve the Living* (Cambridge, MA: Harvard University Press, 2010).

ANCESTRAL

A
CONVERSATION

INTELLIGENCE

WITH

STEPHEN

BURKS

STEPHEN BURKS is an industrial designer, whose innovative approach to design synthesizes craft, community, and industry. He has collaborated with artisans and craftspeople in over ten countries on six continents. His socially engaged practice seeks to broaden the limits of design consciousness by challenging who benefits from and participates in contemporary design. He has had solo exhibitions and led curatorial projects at the Studio Museum in Harlem (*Stephen Burks Man Made*, 2011), the Museum of Arts and Design (*Stephen Burks, Are You a Hybrid*, 2011), and the High Museum of Art (*Stephen Burks: Shelter in Place*, 2022). Most recently, in the fall of 2023, *Stephen Burks: Spirit Houses* opened at Volume Gallery in Chicago and *Stephen Burks: Shelter in Place* (November 18, 2023–April 14, 2024) traveled to the Philadelphia Museum of Art, where Burks became the first African American to receive the Collab Design Excellence Award.

NAJHA ZIGBI-JOHNSON (NZJ) I'm hoping, because I've gotten to sit with your work over the past few years and because we have had a lot of time to build together, that this interview can be more of a conversation. To begin, I would love for you to share your thoughts around creating these sculptural and architectural images. I know they were generated by AI. Can you talk a bit about that process?

STEPHEN BURKS (SB) We are in an AI moment. The whole world is exploring what it means to engage with early artificial intelligence that is both text-based and image-based, with software such as DALL-E, ChatGPT, and Midjourney. As a designer, my immediate instinct about AI was, "It's going to take over." But we might also see it as a tool. I'm interested in the transformative power of craft techniques that challenge the limits of new technologies within industrial production. I believe in using the hand and the machine where they are most use- 281
ful. Even today, there are still things hands can do that machines cannot. Making these AI-generated images was a dialogue between Malcolm X's digital residue—images readily available online—and images of handmade objects from my body of work called "Ancestors."

I believe that all designers are, in some sense, collectors. We're moving through the world fascinated by objects. The more time we spend with ob-

jects, the more we know about their role in cultural production. Nothing exists in isolation; nothing exists without making a presence. Even objects that are poorly designed—objects that have forgotten their humanity—are forced to engage with human presence and with the human body. From the perspective of design, I wondered: Who was Malcolm through the objects he owned, and how could we extend his legacy through object-making? Going through the Malcolm X collection with you at the Schomburg Center was like a cosmic awakening. In looking at all his archived photographs, we were faced with Malcolm's full humanity. We see him outside of the Nation of Islam as a curious, creative, emotional human being. We see the subjects he chose to photograph. We see his interest in the dignity of human life. We see the physical worlds he inhabited, from the type of camera he used to the particular shape of his body when seated in a chair. And, for me as a designer, the objects that help us understand Malcolm are windows into his world. We see the world through his eyes.

I think what's important about considering the role of AI in the future is the fact that, in a sense, it is related to this kind of collective intelligence—one that draws upon all of the information that it has access to. And it's supplying that wisdom to the subject matter and images that we fed into it.

1
See, for example, William Buller Fagg and Margaret Plass, *African Sculpture: An Anthology* (Dutton, London: Studio Vista, 1964).

In this way, AI also reminds me of "primitivism" within the context of design,[1] which, based on my own reading, gets at the idea that in certain "primitive" cultures, the artisan or the designer, if we could even use that term, is channeling various kinds of energies that are somehow derived from cosmologies that are much bigger than them to produce something that doesn't belong to them. And it's not about authorship, or even ownership: it's about being a kind of vessel for creation. Primitivism affirms that creation is born into the world and has the right to live in the universe along with everything else. What I find most interesting about AI is that there is this force—we don't have to consider it a life force, but a force that is on the verge of sentience—capable of offering creative input, capable of creativity that is beyond my control. I love that. In some sense, AI connects back to the ways in which my ancestors were making things, the ways in which my ancestors were bringing things into the world, by giving life and ideas form through materiality.

Malcolm was a traveler, and this part of his life resonates with me. I describe myself as both a traveler and designer. I recognize the ways in which travel has broadened my perspective and really awakened me to many other ways of living and being in this world. Coming from the Southside of Chicago, I never imagined I would one day work

283

STEPHEN BURKS

with so many creative individuals all over the world. I think, within Malcolm's global chapter at the end of his life, there's this moment when his mind and religio-political project completely expanded, because he was able to travel to Mecca, and because he was able to document all of these diverse people coming together through spirituality.

In many ways, I would like to think of this relationship with AI as a kind of "primitive" spirituality. We, of course, made many more images than the ones that I shared. But I think what's so powerful about the particular images featured in *Mapping Malcolm* is that, while they bear my touch, they hold my voice, they're so surprising. They also embody the image of Malcolm. So, there's this way in which, through the project, we've now offered Malcolm an "other" life in this almost incomprehensibly large digital world. Those images live out there in that world. And that source material lives out in that world. And who knows what can become of it?

NZJ: I'm really curious about the connections between AI and ancestry, and the expansions that you as a Black American industrial designer are building through the creation of "Ancestors." What does the project offer to the field of industrial design?

PREVIOUS
Stephen Burks, *Untitled 1*, 2023. AI generated. Courtesy of the artist.

SB: "Ancestors" is, for me, simply about acknowledging, as a Black American, all of those who came before us, not just in protest but in essence. I could not be here sitting and talking with you today if it were not for the efforts of my ancestors. I feel very, very connected to my ancestors and to Malcolm X. The "Ancestors" project is really about what it means for African Americans to try to connect back to a homeland that many of us know nothing about, and to a homeland that we've been separated from and severed from through the violence of slavery. As a studio, we began this work through the collection of small African statuary and objects that we feel somehow represent the Motherland. We then modeled these objects, using them as starting points for a series of large-scale sculptural gestures.

It's taken me years to arrive at the point where I'm comfortable enough to place ancestry on the table as a subject that I feel must be explored in design. So many aspects of our humanity are denied particular design attention. If we think about design as tools for how we'd like to shape our lives, we have to consider all aspects of identity. We have to consider our spirituality; we have to consider our history; we have to consider how that history is defined by design. Quite recently, through the Black Lives Matter movement, we saw history uprooted. I don't believe in rewriting history: I believe in taking history, building upon it, moving it forward.

and giving it form and giving it place. In many ways "Ancestors" is about giving form to what lives quietly in most African Americans.

As you described in the essay you contributed for my solo show *Spirit Houses* at Volume Gallery in Chicago,[2] we build upon a myriad of West African and Asian religio-spiritual practices that affirm the dead as active, everyday participants in our world-making process. I'm reminded of my grandmother and how she would say "those people" in reference to our unknown ancestors and affirming how they live among us.

It's much easier to take an iconic figure like Malcolm X, who had such a public life and such a public impact, and say, "Okay, this is clearly an ancestor that the world has recognized." Malcolm had radical ideas that favored and foregrounded Black liberation. Even today, these ideas are controversial, as Black bodies and Black liberation still pose a threat to a white supremacist society. Of course, we, as Black Americans, recognize his contributions to our individual and collective lives. What's much more difficult as a designer is to give form and voice to our unknown ancestors. In a lot of ways, design gives us the permission and authority to acknowledge a range of people known and unknown. I want to acknowledge the people who I am centuries removed from, but who still exist within me. This is what "Ancestors" is about. This is what I feel

2
Najha Zigbi Johnson, "On New Cosmologies: Stephen Burks Approaches the Sacred," exhibition text for Stephen Burks's *Spirit Houses*, Volume Gallery, Chicago, September 8, 2023–October 28, 2023, http://wvvolumes.com/wp-content/uploads/2023/09/On-New-Cosmologies_-Stephen-Burks-Approaches-the-Sacred.pdf.

287

STEPHEN BURKS

design is perfectly suited for—bringing various representations of our ancestors into physical form, into everyday life, and into a living relationship with other people.

If one were to categorize the world in terms of population size, the majority of people on earth would be living in Asia, Africa, and South America, meaning that Western Europe and North America would be in the minority. Instead of the fraught "Global South" versus "Global North" binary, we could imagine a more expansive geographic classification that reflects the majority of voices currently not taking part in the global conversation. This project is very much about getting the powers that be to acknowledge these majority influences in design. It's about who we consider to be designers, and what we consider to be design? These are the kinds of questions we began to ask through the process of creating "Ancestors."

bell hooks, who became a dear friend and mentor of mine, made the point that "we've been raised in a culture that tells us design has nothing to do with Blackness. And so, if you participate, you participate as an exception. You don't participate as if this is a natural playing out of culture."[3] She believed that the African statues that are often sold by street vendors, that we collect as Black folks, are all designed objects. Yet, they are still perceived as less valuable. If we believe, as bell teaches us, that aesthetics are

3
bell hooks, "Critique and Complexity: bell hooks in Conversation with Stephen Burks," interview by Stephen Burks, in Monica Obniski, *Stephen Burks: Shelter in Place*, catalogue for show of the same title at High Museum of Art, Atlanta, September 16, 2022–March 5, 2023; and Philadelphia Museum of Art, November 19, 2023–April 14, 2024 (Atlanta: High Museum of Art, 2022).

PREVIOUS
Stephen Burks, *Untitled 2*, 2023. AI generated. Courtesy of the artist.

4
bell hooks, *Belonging: A Culture of Place* (New York: Routledge, 2008), 3.

more than a philosophy or theory of art and beauty, that aesthetics are a way of inhabiting space, a particular location, a way of looking and becoming,[4] then we could also accept that the person who made these statues is a designer.

NZJ: I love your way of thinking about "Ancestors." Part of my deep interest and belief in the importance of your work is that, as an industrial designer, you are thinking about, responding to, and creating the built environment that we all live in. And we know that the built environment has been overdetermined by structural white supremacy, classism, ableism, and a particular attention to Western hegemony that's left out people of color across the globe, or in "the majority world" as you have articulated. Through invoking the spirit of our ancestors, I believe your work also necessarily expands what has been deemed important in the twenty-first-century world and built environment. As an industrial designer, you are reprioritizing and recentering the importance of ancestral veneration, earth-honoring traditions, communalism, and the experience of the majority world as central to our ability to live and thrive and get in right relationship with the Earth.

For me, your project "Ancestors" has emerged as a design imperative for the Western world—if we are to seriously grapple and attempt in the ways

that we can, to remedy what we've created... or what white people have created. It's not hyperbole to say that this sort of work and intervention and expansion into the world of design is necessary. I love that about "Ancestors," which also affirms that Malcolm X's political work and legacy is a necessary framework in our survival and ability to build more equitable and sustainable relationships.

SB: Yes. This is the direction the world needs to be going. I can't help but think about *Mapping Malcolm*, the title that you've given to this book project. I think it points to how much he transformed throughout his life, and reminds us of our own capacity to transform. How do we sit with, reframe, and engage with the problems that the "minority world" unleashed upon the rest of us?

I came of age on the Southside of Chicago and grew up very poor. I struggled to understand myself and my family in that neighborhood, which has historically been full of violence toward Black bodies. When I was a teenager, I received a collection of essays by Malcolm X from my Uncle Roger, titled *The End of White World Supremacy*.[5] Until that point, I'd never thought about white world supremacy. I'd never considered that there was a larger structure in place designed to hold us back. I never imagined that single individuals like Malcolm X, though extremely important and brilliant, were capable of changing

291

Malcolm X, *The End of White World Supremacy* (New York: Arcade Publishing, 1971).

STEPHEN BURKS

that structure. My design journey began in the white world—through the Bauhausian and modernist lens of Chicago. I didn't see a place for myself in design as a Black American. I had no examples or role models. I proceeded as if I were just another designer, not a designer of African descent. But the reality of the world is that you're immediately confronted with your identity. If I can use Isabel Wilkerson's words, "You're placed back into this rigid system from which you are expected not to break free."[6]

Malcolm X's journey toward spirituality began through incarceration. Prisons have to be the most structurally racist design project in America. And yet, he comes out proclaiming the right of Black Americans to sovereignty and also the right to self-defense. And when we think about the later Malcolm, the Malcolm that visited Mecca after leaving the Nation of Islam, we can see how he began to see the world differently. He abandoned his belief in violence and in separation. And I think that, for me, this kind of spiritual awakening is something I can very much relate to. What does it mean for us to become wise? And how do we begin to manifest the importance of putting our truest selves out into the world? So, in a sense, I guess "Ancestors" is not just necessary for the world, and not just necessary for design, but necessary for me—it's very necessary for me as an individual, inseparable from others.

6
Isabel Wilkerson, *Caste: The Origins of our Discontent* (New York: Penguin Random House, 2020).

NZJ: I want to pause on this question you've just posed: What does it mean for us to become wise? This feels especially important in the context of our conversation around AI. I don't know what this technology's increasing centrality in our lives means yet, but I am beginning to understand that it might offer a way to understand our past, present, and future. That said, I'm worried about the economic and ethical implications of AI as it moves toward increased sentience. I wonder how this new cognitive machine will view the world and how AI is already seeing, or will continue to render and confirm, racism and hegemony.

SB: You're absolutely right. I mean it's inherently biased depending on who is using it and programming it. If we think about AI as a container, full of references, full of images, and full of, let's say, the "world's knowledge," it's important to ask: Who has been in control of that knowledge thus far? Who has contributed to that so-called "knowledge" thus far, and what parts of the world have been contributing to this databank of what the world knows thus far? It has been inherently biased. But this is why I feel strongly that people of color have to be at the forefront of AI, have to move from being, for example, in the majority of people policed and surveilled by it and instead be in the majority of those crafting and contributing to what AI "knows," what images it references, and toward what ends. Our work is a small gesture so far, in terms of what

293

STEPHEN BURKS

we've done with Malcolm and "Ancestors." But the more that these images centered around the Black experience go out into the world, the more this tool—whatever it becomes—will understand this as normal, as human, as our diverse reality, which is the reality of the world. I wouldn't want to fear or shy away from these new technologies, because if we're not using it, someone else is. The more that we engage with AI, the more we're able to first understand it and secondly subvert its biases.

NZJ: I really appreciate that framing, and I agree that Black, Brown, and Indigenous folks need to be leading the employment of AI if this is to be our reality. I'd also like to return to how you use the words "primitive" and "primitivism" to talk about a certain type of design. I'd love for some clarification in terms of what they mean to you. These words are entangled in a deep colonial history.

SB: Right, of course. It's very easy to think of the primitivist reference as related to "unevolved" or "underdeveloped" cultures. But, in fact, it is a reference to a way of being and kind of essentialism, or a way of ontologically approaching the world. So, rather than passing a judgment when I use the term "primitive," I'm referring to a scholarly description of a way of life, a kind of lifestyle, which is definitely in reference to other cultures outside of the West.[7]

7
See, for example, Bert Flint, *Afro-Berber Planet: The Trans-Saharan Arts of the Tiskiwin Museum, from Marrakech to Timbuktu* (Paris: Zamân Books, 2021).

NZJ: I appreciate your framing. I still think the word, for me, is too fraught by its history and its anthropological use within the colonial imagination in regards to Indigenous folks, Black people across the African Continent, and people across the Global South, broadly speaking. The word is so embedded within a particular white supremacist history, and it's hard to disentangle that history from our understanding of the people that may be believed to be part of "primitivist" cultures. But I'm also interested in how you or other Black designers inspire a new design lexicon. How do we talk about the wisdom, lifeways, and the cosmological world views of the majority world? Your work begs this question. And maybe it can help us create a new understanding that evolves beyond how primitivism is used within design.

SB: Yes. I use the word "essential," because it says something about primary forms. It suggests, to me, starting points for a kind of anthropological understanding, and also for understanding how we define form in relation to humanity. When I say "primitive," I'm thinking about starting points for all of humanity, which, of course, has its origin in places like Africa, in the Global South, in what is definitely considered "the majority world" beyond a Western context—

starting points that are essential to all of us for understanding who we are as people and how we describe each other and our life.

NZJ: Parallel to that, I think about your design process and your approach to design as, in some sense, being equally important to the designs that you create because of your connection to this global world and community. I think that craft-based design means you're pulling from, learning from, and collaborating with people across the globe. I'm really interested in what process-based design means for you within the world of craft-making.

SB: All design has a process. When we talk about process-based design, we are describing a workshop-based practice, which means a practice that steps outside of, or beyond, the traditional Western studio.[8] The idea of the artist in a studio isolated from their surroundings, isolated from their collaborators, separate from the other means of cultural production and development is historically how Western thinking has described the artist and designer. The twentieth century was wrought with designers who were only making drawings, designers who were totally disconnected from the factory, from manufacturing, from production, and from society. When I encountered that model as a student, having come of age at the turn of the millennium, it became clear

8
I am thinking of Bruno Munari's statement: "Today it has become necessary to demolish the myth of the 'star' artist who only produces masterpieces for a small group of ultra-intelligent people." Bruno Munari, *Design As Art* (New York: Penguin, 1971).

STEPHEN BURKS

to me that it was necessary to find another way to engage in design. I needed a framework that was more relational—one that could include the relationships I was developing with people who were not considered "traditional designers" or "traditional consumers"; people in other parts of the world, working outside of the Western notion of design; people who were making things, who were connected to their societies, who were invested in material exploration, and who were practicing age-old handcraft traditions. These collaborators had so much to teach me. I really believe my design education is ongoing. It has never stopped and has been greatly enhanced and expanded in my interactions with artisans in other places in the world.

I started my industrial design career in furniture in 2000, making my first pieces for very well-known Italian manufacturers. By 2004, I was struggling to feel connected to the work. It was very clear to me that I could never afford any of my own work. I started to wonder: Who are my designs for? My modernist Bauhausian background, which was also rooted in a kind of democratic ideology, didn't make sense in this context where I was designing things only for the rich. This is still a problem that I struggle with.

But then I made my first handmade objects and was invited to work in other places across South Africa, Peru, Senegal, Rwanda, Kenya, Ghana, Indonesia, the Philippines, India, and Mexico, and

on and on. In each country, I met people who were very deeply rooted in community, whose work was informed by the needs of the particular community, producing things that weren't necessarily being called design objects but that, in my opinion, should be. It was through these varied experiences that I came to the conclusion that design is a Western concept. In all these other places in the world, people are making objects that directly respond to the societal, individual, and communal needs (even if those needs are about pleasure or aesthetics), and aren't simply produced for consumers.

I wanted to find ways to combine my education and my work in Europe and the United States with this new education and these communities that I'd found elsewhere. So this became our ethos. My studio was renamed Stephen Burks Man Made with the intention of bringing the hand to industry. As a practice, we are still looking at ways to engage communities around the world in hand production in service of contemporary culture and design. It's difficult to talk about because when we say "contemporary," we often conflate this with Western. How do we build bridges between what's considered the "majority world" and the "minority world" so more people and communities can participate in design today?

NZJ: Thank you so much for that context around your evolution as a designer, and as someone increasingly committed to articulating a particular internationalist and global value ethic in how you work. I think that when we are in right relationship with ourselves and the universe, which is hard, because of life's ebbs and flows, we become conduits for the ancestors who live alongside us and guide us. I think that all humans are able to be guided by our ancestors and become conduits for this worldmaking project that we've all been tasked to do. And it's really beautiful to see you as this conduit that sits between the profane, insentient industrial design world and the world of our African ancestors and our global ancestors who have so much wisdom to give us. You're becoming this spiritual instrument, and it's the realest shit ever. And I'm honored to enter this world with you, because I'm so deeply committed to creating a more just world. For me, the world of art and design increasingly feels like the space in which we actualize our freedom dreams and where we get to live in total freedom. We may never physically exist in utopia. Maybe that's not even the point; maybe the point is this process. I don't fully know, but I'm vibing. I love the world of Stephen Burks Man Made. It feels like a really good place to live.

SB: Thank you, thank you so much, Najha.

MALCOLM

AND

ME

JOSHUA

BENNETT

JOSHUA BENNETT is a professor of literature and Distinguished Chair of the Humanities at MIT. He is the author of five award-winning books: *Spoken Word: A Cultural History* (Knopf, 2023); *The Study of Human Life* (Penguin, 2022); *Owed* (Penguin, 2020); *Being Property Once Myself* (Harvard University Press, 2020); and *The Sobbing School* (Penguin, 2016). For his writing, Joshua has received fellowships and awards from the Guggenheim Foundation, the Whiting Foundation, the National Endowment for the Arts, and the Society of Fellows at Harvard University. He lives in Massachusetts with his family.

It's a Saturday morning in early October, and my wife Pam, our son August, and I are in the car together on the I-95 South to Tangerini Farms, 305 a sprawling campus in Millis, Massachusetts, that features both a well-reviewed contemporary American restaurant—you can't get more farm-to-table than this place—and complimentary hayrides for patrons. To get there, we have to drive past MCI–Norfolk, a medium-security facility once known as Norfolk Prison Colony,

which is most famous for being the prison where Malcolm X was incarcerated in the 1940s. One of the epigraphs in my most recent book, *Spoken Word*, is a line from a letter that Malcolm wrote to his brother, Philbert, during his time there: "When you think back over all of our past lives, only poetry could best fit the vast emptiness created by men."[1]

Where to begin? The part about *all of our past lives* is the most obvious place to start (who knew Malcolm was working from this kind of cosmology back then?), but, of course, there's also the matter of *the vast emptiness created by men* (on Earth, or inside themselves?), as well as the claim that poetry, among all available instruments, is the only way to repair it. In my book, I use the line to set up an argument about the social role of poetry in general, and spoken word in particular. But right now, as we drive past MCI-Norfolk, I'm just thinking about Malcolm in his cell, alone, writing that sentence. I'm wondering what he was reading at the time—what poems and poets inspired such transcendent language, and if any of those writers ever learned that their words meant so much to the man in his moment of great need.

In his essay "The Fire of Life," Richard Rorty recounts a family conversation that took place in the first months after his diagnosis with pancreatic cancer.[2] During the exchange, he's asked what forms of literature, if any, have brought him comfort during such a difficult time. His cousin, a minister, wonders whether Rorty's mind has turned to religious concerns; his son inquires as to whether he's discovered any newfound uses for the philosophical works he's studied for decades. Rorty pushes both ideas aside in short order, offering a response that initially surprised me: "Poetry." I recommend this essay to anyone interested in making a compelling case

1
Malcolm X, letter to Philbert X, February 4, 1949, quoted in Joshua Bennett, *Spoken Word: A Cultural History* (New York: Alfred A. Knopf, 2023), 3.

2
Richard Rorty, "The Fire of Life," *Poetry* (November 2007): 129–131, https://www.poetryfoundation.org/poetrymagazine/issue/71444/november-2007.

as poets are sometimes asked to, for the inherent value of poems. This story is on my mind right now, because I think Rorty is saying, years later, something akin to what Malcolm is saying, while he is likewise confronting the specter of death and incalculable despair.

In the wake of Malcolm's assassination in 1965, Dudley Randall and a host of other poets collaborated to compose an anthology of elegies, *For Malcolm*, to mourn their fallen hero, comrade, and friend.[3] One of the poems, Etheridge Knight's "The Sun Came," imagines Malcolm as a messiah: "The sun came, Miss Brooks.— / After all the night years. He came spitting fire from his lips. / And we flipped— We goofed the whole thing."[4] Rorty's essay also gestures toward the messianic, though in a different direction, citing these lines from the English poet, Algernon Swinburne:

ley Randall and Margaret G. Bur-
hs, eds., *For Malcolm: Poems on the
and Death of Malcolm X* (Detroit:
dside Press, 1967).

ridge Knight, "The Sun Came," in
*Malcolm: Poems on the Life and Death
alcolm X*, ed. Dudley Randall and
garet G. Burroughs (Detroit: Broad-
Press, 1967).

rnon Charles Swinburne, "The Gar-
of Proserpine," in *Poems and Bal-
First Series* (London: William Heine-
n, 1917), 172, quoted in Rorty, "Fire
e," 130.

> *We thank with brief thanksgiving*
> *Whatever gods may be*
> *That no life lives for ever;*
> *That dead men rise up never;*
> *That even the weariest river*
> *Winds somewhere safe to sea.*[5]

307

Both poems refuse resurrection. *Dead men rise up never*: the death of the hero is irresolvable, final. This reality is positioned as a great relief in the Swinburne poem, and as a singular tragedy in Knight's. On the drive to the farm, my mind rests at their intersection. I'm thinking about what it means to be moving, right now, past the prison that held Malcolm—the very same place where he discovered his love for the art of debate. In his own words: "Debating, speaking to a crowd, was as exhilarating to me as the discovery of

knowledge through reading had been."[6] Here, we bear witness to the moment Malcolm discovers yet another of his truly phenomenal gifts—and this, yet again, under extraordinary circumstances and hardship. We know he will go on to

6
Malcolm X and Alex Haley, *The Autobiography of Malcolm X* (New York: Ballantine Books, 1964), 184.

use this gift to transform the world as we know it, even though his life will be cut short. The Malcolm we see in this passage—this young, incandescent genius—is surrounded, outnumbered, but hopeful, and still honing his talents. How such unkillable optimism was possible—even while held under lock and key, legally considered the living property of the state of Massachusetts—is a question I wrestle with even still. Yet the facts of the matter remain. Malcolm did not only make it through; he emerged from the fire transformed.

I am on my way to what I'm sure will be a beautiful farm with a lovely restaurant and hayrides for my wife and son, my wife's cousin, her cousin's fiancée, and their little girl. All this while thousands of men still reside there behind those prison walls, obscured from view by barbed wire and brick. I am a man in a sensible family car, out on a family trip, thinking of Malcolm, who was much younger than I am now when he was released from prison for the last time. He was only twenty-seven years old, already eloquent, pure possibility. He would live to be thirty-nine, five years older than I am as we speed past MCI-Norfolk and the maple trees dotting the side of the highway that runs parallel to it, like another life.

For the past two years, I've been writing a fictionalized version of Malcolm into being. First in the form of a novella, then a scripted adaptation of it by the same name: *The Book of Mycah*. There, Malcolm

comes back from the dead in 1965, an event that alters the trajectory of the modern world. One of the witnesses to his resurrection, a neurosurgeon named Coleridge, founds a cult that imagines him to be the Divine expressed in human form. In this alternate historical timeline, Malcolm is elected to the US Senate—to represent his home state of Nebraska, no less—and uses federal funding to create a utopian community in the state for Black people from all over the globe. Fifty years after this sequence of miracles, a teenage boy named Mycah is likewise raised from the dead after being shot at a block party. The larger story, as both a novella and adapted screenplay, traces the way that the lives of these two figures eventually overlap and intertwine. My collaborators and I realize that Mycah should be, in some sense, a mirror of Malcolm in his twenties, the man nicknamed "Detroit Red": a vessel of unlimited potential in search of higher purpose, a young person who makes a series of destructive decisions and is ultimately rescued not by his preternatural charisma, but by his willingness to search for meaning beyond what he can easily see.

It's early November now. I'm working on the script on my way back from teaching an "Introduction to Poetry" class on Dartmouth's campus, where we have a building named for Malcolm: the El-Hajj Malik El-Shabazz Center for Intellectual Inquiry (*Shabazz*, for short, which is what most of us call it). It serves as a dormitory, a study hall, a museum, and a space for Black students across the campus to gather. Inside, there are multiple murals of Malcolm X on the walls—*The Temple Murals*, to be precise, painted by Florian Jenkins in 1972 to celebrate Malcolm's visit to the campus in January 1965, one of his final public appearances in the weeks before his assassination. The Center itself was among the concessions won by Black students at

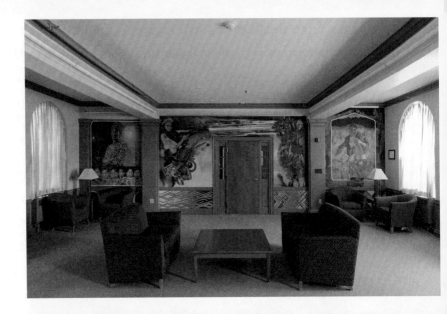

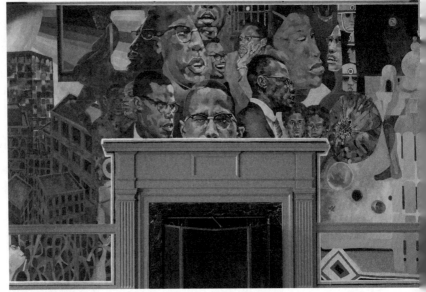

O. Florian Jenkins, *The Assassination*, panel four from *The Temple Murals: The Life of Malcolm X*, 1972, acrylic on canvas adhered to the wall, 76 1/2 × 169 1/8 in., 19 1/2 × 62 in., 191/2 × 39 in. (overall). Courtesy of the Hood Museum of Art, Dartmouth. Commissioned by the Afro-American Society, Dartmouth College; P.972.231.4. © Rev. O. Florian Jenkins.

O. Florian Jenkins, *Malcolm, A Lifestyle*, panel six from *The Temple Murals: The Life of Malcolm X*, 1972, acrylic on canvas adhered to the wall, 84 1/2 × 172 in. (overall). Courtesy of the Hood Museum of Art, Dartmouth. Commissioned by the Afro-American Society, Dartmouth College; P.972.231.6. © Rev. O. Florian Jenkins.

Dartmouth after the Black Studies uprisings of the late 1960s, three years after Malcolm's death, on campuses across the country. After a series of high-profile acts of protest at peer institutions—an armed rebellion at Cornell, a high-ranking administrator held hostage at Columbia—Dartmouth's administration offered its students the opportunity to rename a presently existing dormitory, Cutter Hall, in honor of Malcolm. It remains a beacon of light, a reminder of the importance of our ongoing pursuit of racial and economic justice.

Everywhere I've worked or lived, Malcolm is there, almost always in some vivid, unexpected fashion or form. Everything about my interest in Malcolm connects to how I got here; how I developed this voice, these fears and commitments, this state of mind; how I first entered the language of love and justice, debt and repair; and how it's shaped the way I dream. It's connected to my older brother, who was locked up as a teenager in Spofford Juvenile Detention Center (which has since been shuttered and is now, remarkably, a group of luxury apartments), when I was still just a boy. It's connected to the first students I ever taught in a classroom, who were also incarcerated: the group of twelve boys on the youth side of a men's prison in Philadelphia, scheduled to be moved to the other end the day they turned eighteen. It's connected to the class of four girls not too far away, in a women's prison that did not separate those living there by age. What I know of myself as a poet, a reader, an educator, and a little brother feels tied to Malcolm, not only as a flesh-and-blood historical figure but also as a metonym, a representative of the good and the terrifying, the pendulum swing between seemingly infinite promise and the threat of early death. Was he always, in some way, meant to become what he became? In what ways did the visibility or invisibility of his promise shape the trajectory of his early life?

JOSHUA BENNETT

Think here of a younger Malcolm, in seventh grade, top marks in his entire class, elected class president in a predominantly white school in Nebraska. What did he imagine for his future? We know, from his autobiography, that young Malcolm dreamt of becoming a lawyer one day. What did the world around him have to say about that? His favorite middle school teacher, Mr. Ostrowski, was clear on the matter: "You've got to be realistic about being a nigger. A lawyer—that's no realistic goal for a nigger."[7] *You've got to be realistic.*

I think of this framing often. I recognize its echoes in the lives of the people I love. It is a kind of open secret, held in common: You

7
Malcolm X and Haley, *Autobiography*, 36.

know what you are. You know what's yours. *You know all that beauty just isn't for you.* And yet, somehow, even after a sequence of tragedies—the murder of his father, his mother being torn away by the state, incarceration in the prime of his life—Malcolm persisted. He transformed over and over and over again. He changed his mind when exposed to new information. He became a husband, a father to six daughters, and a singular orator in a tradition whose shimmering core is the dance between page and speech, sentence and song.

It wasn't so much that Malcolm's voice was a gate I had to pass through on the way to finding my own, though that might also be true. Rather, it sometimes feels as if he is one of the presences that has always walked beside me, though it was difficult to recognize him or fully reckon with the weight of his witness, what his radical vision meant for the way I should live my life. Better to be opaque and unthreatening, I thought. Better to speak in screen-tested tones that won't set off alarms. To be accent-less. A Black man in a tailored wool suit who, as my father once put it, lovingly, *talks like a book.* But also, after years, finds his way to the beginnings of a moment like this, where the light can start to break through.

At the conclusion of Spike Lee's 1992 tour de force biopic *Malcolm X—*
yes, the movie that I will argue with anyone should have garnered
Denzel Washington his second Oscar in three years—there is a scene
that expresses a phenomenon that has long fascinated me, what the
poet and scholar Michael Harper calls *a continuum of consciousness.*[8]
For our purposes, we can think of it as a kind of shining thread that
connects the living and the dead, maintained through the stories
we pass down from generation to generation, the plays we act in as
children, the poems and lines of prose we take the time to commit
to memory.

 In the film, directly following Ossie Davis's recitation of the
eulogy he wrote for Malcolm X three decades earlier, his resound-
ing baritone (and accompanying historical images of Malcolm
alongside Black people all over the globe in the present-day holding
photos of him) gives way to a teacher, played by Mary Alice Smith,
standing at the front of a classroom. The words inscribed on the
hunter green chalkboard behind her tell us that we are in Harlem,
New York, at P.S. 153, on May 19th. It is Malcolm X Day. As the cam-
era pans away from her and toward the audience she says, "And so
today, May 19th, we celebrate Malcolm X's birthday because he was
a great, great Afro-American. Malcolm X is you, all of you. And you
are Malcolm X."[9]

 This moment precedes fifteen seconds of cinema as fresh in
my mind as any I have ever watched. One by one,
the students stand up and declare "I am Malcolm
X!" in rapid succession. The classroom in Harlem
becomes a classroom in South Africa. The chil-

8
Quoted in Major Jackson, "'We Will Not
Give Up on Each Other': A Conversation
with Major Jackson," interview by Chard
deNiord, *World Literature Today* (Sum-
mer 2019), https://www.worldliterature-
today.org/2019/summer/we-will-not-
give-each-other-conversation-major-
jackson-chard-deniord.

9
Spike Lee, dir., *Malcolm X* (New York:
40 Acres and a Mule Filmworks, 1992),
201 min.

313

JOSHUA BENNETT

dren standing in Harlem become the children standing in South Africa, their shared chant like a baton cast across the ocean from one hand to another. Nelson Mandela stands at the front of this new classroom. He cites Malcolm directly, saying: "As Brother Malcolm said, 'We declare our right on this Earth to be a man, to be a human being, to be given the rights of a human being, to be respected as a human being, in this society, on this Earth on this day, which we intend to bring into existence..." The screen flashes, and it is no longer Mandela standing before us, but grayscale footage of the man himself, El-Hajj Malik El-Shabazz, reciting what is perhaps his most well-known phrase: *"by any means necessary!"*[10]

10
Original quote from Malcolm X, speech at the founding rally of the Organization of Afro-American Unity, June 28, 1964, published on *BlackPast*, October 15, 2007, https://www.blackpast.org/african-american-history/speeches-african-american-history/1964-malcolm-x-s-speech-founding-rally-organization-afro-american-unity.

Malcolm X was the first film I ever watched in a theatre. I was seven years old. Once the credits rolled, I asked my parents how I could learn more about the man at the center of its story. Though I had seen Denzel elsewhere at this point—the 1989 Civil War film *Glory* was a favorite in our home, alongside classics like *Polly* and *Sister Act*—his embodiment of Malcolm onscreen felt to me so vivid, so memorable, that I wanted to understand as much as I could about this hero whose name I had heard before but whose life I knew so little about. My parents gave me a copy of Alex Haley's *The Autobiography of Malcolm X*, which I read in the following weeks. Eventually, it became a kind of talisman. I carried it with me everywhere.

Looking back, it makes a great deal of sense that my introduction to both the world of cinema and the world of "books for adults" (autobiography in particular) was through the life and times of Malcolm X. He was part of a much larger pantheon of Black writers, Black teachers, orators, and freedom fighters who've been with me ever since I first learned to read. My parents introduced me to signif-

icant figures—Benjamin Banneker, Mary McLeod Bethune, George Washington Carver, Lewis H. Latimer, Harriet Tubman—through children's books, always with the explicit aim of teaching me a history that I could use as armor in an unjust world. But my first encounters with Malcolm required a more honed sort of attention, coming as they did via a two-and-a-half-hour film and a 544-page tome it took me months to work through with the help of the large red Webster's dictionary I kept next to my bed. Mom, to her credit, was never one to abide questions about what some of the more difficult words meant. She enjoined me instead, at every turn, to "Look it up, young man."

From Malcolm, I gained a new vocabulary for the world around me. The pages of his conversations with Alex Haley helped provide some of my first insights into mass incarceration, mental health diagnoses as a weapon of the carceral state, and the Black social scene of Harlem in the 1960s. I knew nothing at the time about the conditions under which the book was produced. But I did know something, even then, about the importance of genre. I regularly read the King James Bible and the *Chronicles of Narnia*, and was consistently writing my own short stories based in part on the television shows I watched at the time (*Power Rangers, Transformers*, that sort of thing). What I was reading in the *Autobiography* was distinct from all of that. I hadn't turned to it for moral lessons, or for an escape into a fantasy realm. I carried the book with me to learn something new about myself as a human being. This learning was inextricable from the way my parents spoke to me about the terror and indomitable beauty of being Black in the *here and now*, why it was important for me to know that I came from a long legacy of people who saw value as something that was not assessed primarily in terms of what one owned or possessed, but what one did for others, what one *gave away*.

JOSHUA BENNETT

In giving me Malcolm—and allowing me to learn about him on my own terms, at my own pace—my parents provided me with an exemplar. They were teaching me something about the transformative power of literacy, about collective empowerment, and about the importance of living with the courage of one's convictions, even and especially if those convictions changed in public and at great cost. The lesson was not simply that I should take pride in our history, but that I should allow that history to *make me brave*, and, in doing so, join that unbounded chorus singing that we, too, are Malcolm X, now and forevermore.

X

JOSHUA

BENNETT

As you are both Malcolm's
shadow & the black unknown
he died defending, I praise

your untold potential, the possible
worlds you hold within your body's
bladed frame. I love how you stand

in exultation, arms raised
to welcome the rain, the bolt,
whatever drops from the sky's slick shelf

without warning, as all plagues
do. Miracles too. & bombs that fall
from planes which hold men with eyes

aimed through long glass tubes. Tubes
that make a civilian's life look small.
Small enough to smoke. X marks the cross

-hairs, & the home an explosion turns to blur.
X marks the box on the form that bought
the bombs, paid the triggerman, sent

the senator's son off to school
without a drop of blood to temper
his smile, stain leather

boots, mar the occasion.
X: every algorithm's heart
-beat, how any & all adjacent

quantities bloom. A kiss.
How a signature knows
where to begin its looping

dance. Two hands balled
into fists, crossed
at the wrist, repping

the borough that gave
us B-boys, the Yankees,
my mother's left

hook, swift enough
to knock any living
thing off its feet

like a cartoon villain
bested by banana peel
or spilled oil, his eyes

now two black x's,
denoting absence.
The wrong answer

on a test. How
my great-great
grandfather,

who could not read,
signed his name,
as if an homage

to his own opacity,
as if to say, *I contain
the unthinkable*, or, *I abstain.*

LOVE IS WHY

IBRAHEM
HASAN

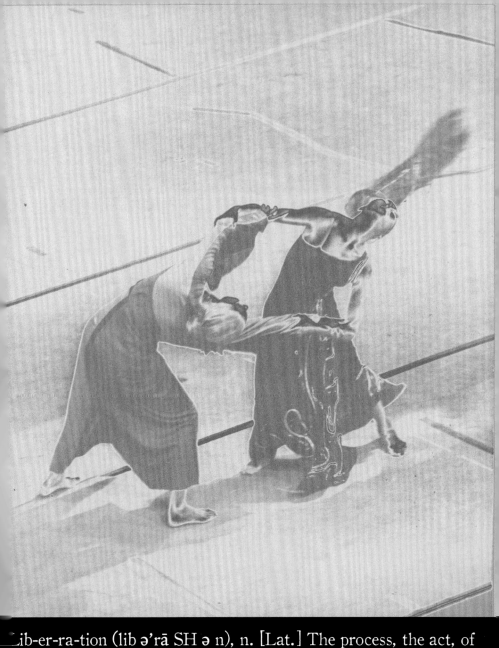

Lib-er-ra-tion (lib ə'rā SH ə n), n. [Lat.] The process, the act, of
being liberated; the varied ways in which we exist to move
through to freedom; (e.g., 'without community, there is no
liberation' Audre Lorde) alt. the process of getting what you
need to decide for yourself how you want to live.

FREEDOM

JUSTICE

EQUALITY

ISLAM

I want my share of gold

Malcolm X's (Al-Hajj Malik El-Shabazz)
Letter from Mecca, Saudi Arabia
April 26th, 1964

I have just completed my pilgrimage (Hajj) here to the Holy City of Mecca, the hollyiest City on earth, which is absolutely forbidden for non-Muslims to even rest their eyes upon. This pilgrimage is the most important event in the life of all Muslims, and there are over 226,000 who are here right now from outside of Arabia. From Turkey came the largest contagion, around 50,000 in over 600 buses. This refutes Westerner propaganda that Turkey is turning away from Islam.

I know of only 2 others who have made the actual Hajj to Mecca from America, and both of them are West Indians who also converts to Islam. Mr. Elijah Muhammad, 2 of his sons, and a couple of his followers visited Mecca outside the Hajj season, and their visit is known as the "Omra", or Lesser Pilgrimage. It is con-

(Page 2) -sidered a blessing in the Muslim World even to make the "Omra". I very much doubt that 10 American citizens have ever visited Mecca, and I do believe that I might be the first American born Negro to make the actual Hajj itself. I'm not saying this to boast but only to point out what a wonderful accomplishment and blessing it is, and also to enable you to be in a better position intellectually to evaluate it in its proper light, and then your own intelligence can place it in its proper place.

This pilgrimage to the Holliest of Cities as been a unique experience for me, but o which as made me the recipient of numero unexpected blessings beyond my wildest dreams.

Shortly after my arrival in Jeddah, I was met by Prince Muhammed Faisal who informed me that his illustrious father, his Excellency Crowned Prince Faisal ha decret that I be that I The ruler of Arabi be his Guest. What has happened since the would take several books to described, but through the ***** of his Excellency I have since stayed in ***** hotels in Jedda Mecca, Mina – with a private car, a drive a religious guide, and many servants at disposal.

(Page 3)
Never have I been so highly honored and never had such honor and respect made m feel more humble and unworthy. Who would believe that such blessing could be heap upon an American Negro!!! (But) in the Muslim World, when one accepts Islam an ceases to be white or Negro, Islam recognizes all men as Men because the people here in Arabia believe that God i One, they believe that all people are als One, and that all our brothers and siste is One Human Family.

I have never before witnessed such since hospitality and the practice of true brotherhood as I have seen it here in Arabia. In fact all I have seen and experienced on this pilgrimage as force me to "re-arrange" much of thoughts pattern and to toss aside some

(Page 4)
of my previous conclusions. This
"adjustment to reality" wasn't to difficult
for me to undergo, because despite my firm
conviction in whatever I believe, I have
always tried to keep an open mind, which is
absolutely necessary to reflect the
flexibility that must go hand in hand with
anyone with intelligent quest for truth
never comes to an end.

There are Muslims here of all colors and
from every part of this earth. During the
past days here in Mecca (Jeddah, Mina, and
Mustaliph) while understanding the
rituals of the Hajj, I have eaten. From the
same plate, drank from the same glass and
slept on the same bed or rug – with Kings,
potentates and other forms of rulers – *******
with fellow Muslims whose skin was the
whitest of white, whose eyes was the bluest
of blue, and whose hair was the blondest of
blond – I could look into their blue eyes
and see that they regarded me as the same
(Brothers), because their faith in One God
(Allah) had actually removed "white" from
their mind, which automatically changed
their attitude and their behavior (towards)
people of other colors. Their beliefs in
the Oneness as made them so different from
American whites that their colors played
no part in my mind in my dealing with them.
Their sincere

(Page 5)
To One God and their acceptance of all
people as equals makes them (so called
"Whites") also accepted as equals into the
brotherhood of Islam along with the
non-whites.

16.5 x 11 cm

K, K, Klar

If white Americans could accept the
religion of Islam, if they could accept the
Oneness of God (Allah) they too could then
sincerely accept the Oneness of Men, and
cease to measure others always in terms of
their "difference in color". And with
racism now plaguing in America like an
incurable cancer all thinking Americans
should be more respective to Islam as an
already proven solution to the race problem.

The American Negro could never be blamed
for his racial "animosities" because his
are only reaction or defense mechanism
which is subconscious intelligence has
forced him to react

(Page 6)
against the conscious racism practiced
(initiated against Negroes in America) by
American Whites. But as America's insane
obsession with racism leads her up the
suicidal path, nearer to the precipice
that leads to the bottomless pits below,
I do believe that Whites of the younger
generation, in the colleges and
universities, through their own young,
less hampered intellects will see the
"Handwriting on the Wall" and turn for
spiritual salvation to the religion of
Islam, and force the older generation to
turn with them—

This is the only way white America can worn
off the inevitable disaster that racism
always leads to, and Hitler's Nazi Germany
was best proof of this.

Now that have visited Mecca and gotten my
own personal spiritual path adjusted to
where I can better understand the depth of
my religion (Islam), I shall be living in a
couple days to continue my journey into our
African Fatherland. Allah willing, by May
20th before my return to New York, I shall
have visited Sudan, Kenya, Tanguanyika,
Zanzibar, Nigeria, Ghana, and Algeria. You
may use this letter in anyway you desire,

El-Hajj Malik El-Shabbazz
(Malcolm X)

Malcolm's concept of

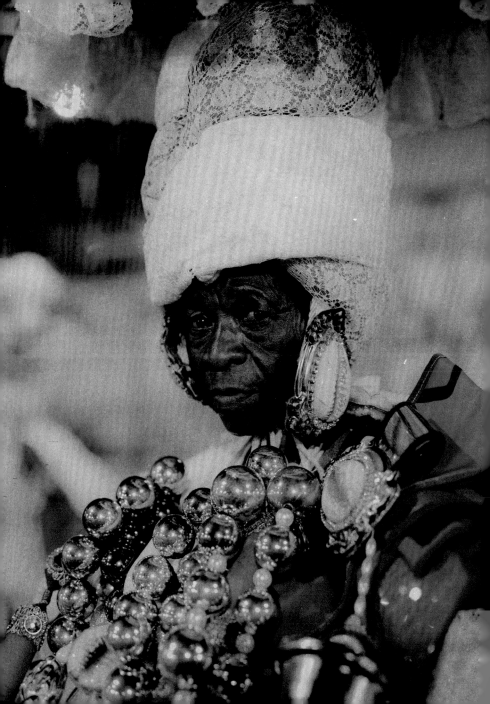

IBRAHEM HASAN is a Chicago-born artist of Palestinian descent. His work reflects a human-centered practice of finding connections between humanity and cultural nuances. In this vein, much of his work instills a child-like curiosity and sensitivity that highlights underrepresented narratives and identities.

IBRAHEM HASAN

ACKNOW

NAJHA
ZIGBI-JOHNSON

DGMENTS

There are no words sufficient to express the gratitude I hold in my spirit for all those who have worked to make *Mapping Malcolm* possible. But I will try...

NAJHA ZIGBI-JOHNSON

In the deepest sense, this project has been a collaborative effort, forged through collective ideation and a shared sense of care and responsibility. *Mapping Malcolm*, at its core, is an attempt to chart our future through a particular understanding of our past. And, indeed, it would be impossible to move forward without my community and their discernment, attention, and critical consciousness.

Firstly, thank you, Dr. Alade S. McKen, for your unending support and for planting the seeds of connection and possibility that would ultimately make way for *Mapping Malcolm* to exist. Without your persistence, vision, and thought, I would have never known the brilliance of Columbia Books on Architecture and the City. Modúpẹ́

To my co-conspirators, Meriam Soltan, Isabelle Kirkham-Lewitt, and Joanna Joseph, thank you for seeing me, believing in me, pushing me, and loving this project just as much as I do. In more ways than you know, you have healed me and helped me forge a path forward in this very turbulent and uncertain time. I have been made better by your unflinching political clarity, your intellectual brilliance, your humanity, and your tenderness. If we are to survive and possibly thrive, then we must heed the call you are sounding and actively engage in your worldmaking process. Being with you feels like being in right relationship with community. My deepest gratitude and respect.

To Ayem—Marcus Washington Jr. and Albert Hicks IV—I pinch myself every single day knowing that you have made space to join this project and take it on as your own. The Ancestors don't make mistakes, and it is kismet that you both have breathed life into our words and have created, with intention, each and every page of this book. From the tipped-in photograph of a smiling Malcolm on the

cover to your visual offering, you have created something magnificent and perfect. This project is a reflection of what is possible when we bend genres, exist beyond category, and strive toward wholeness and creativity. Thank you, thank you.

To each contributor who has shared their wisdom, love, time, energy, and care, it is because of you that this book exists. And I hope you feel that this project is as much yours as it is my own. I have learned and expanded through our conversations, your words and art, and I am humbled by your graciousness. You reflect the best of this tradition we strive to honor and exemplify. Thank you, Dr. Maytha Alhassen, Dr. Joshua Bennett, Christopher Joshua Benton, Stephen Burks, Lisa Beyeler-Yvarra, Guy Davis, Jerrell Gibbs, Ibrahem Hasan, Dr. Marc Lamont Hill, Ladi'Sasha Jones, Nsenga Knight, Akemi Kochiyama, Dr. Denise Lim, Dr. Jaimee A. Swift, Dr. James A. Tyner, and Dr. Darien Alexander Williams.

Thank you to Dr. Ilyasah Shabazz and the Shabazz family for always loving and stewarding Brother Malcolm's legacy and creating space for us all to find ourselves through your father. I am forever grateful and forever humbled. Thank you.

To my beloved parents and loudest cheerleaders, Kolu Zigbi and Darren Johnson, thank you for believing in me always and supporting each of my ideas with unending love. We did it!!!

343

I give thanks to each person who has offered thought, time, effort, and love. Named and unnamed, I extend my gratitude to you. And, most importantly, I pray my work reflects the will of my Ancestors, always.

"The arc of the moral universe is long, but it bends toward Malcolm. Peace after revolution."

NAJHA ZIGBI-JOHNSON

Columbia Books on Architecture and the City
An imprint of the Graduate School of Architecture,
Planning, and Preservation

Columbia University
415 Avery Hall
1172 Amsterdam Ave, New York, NY 10027
arch.columbia.edu/books

Distributed by Columbia University Press
cup.columbia.cdu

Mapping Malcolm
Edited by Najha Zigbi-Johnson
With contributions from Maytha Alhassen, Joshua Bennett,
Christopher Joshua Benton, Lisa Beyeler-Yvarra, Stephen Burks,
Guy Davis, Ossie Davis, Ibrahem Hasan, Albert Hicks IV,
Marc Lamont Hill, Ladi'Sasha Jones, Jerrell Gibbs, Nsenga Knight,
Akemi Kochiyama, Denise Lim, Jaimee A. Swift, James A. Tyner,
Marcus Washington Jr., and Darien Alexander Williams.

ISBN: 978-1-941332-83-2

Library of Congress Control Number: 2024932050
Graphic Design: Ayem
Lithographer: Marjeta Morinc
Copyeditor: Grace Sparapani
Printer: die Keure Printing and Publishing
Paper: Arena Ivory Smooth 100gsm
 Magno Gloss 135gsm
 Colorplan Claret Sandgrain 270gsm
Type: Wremena, Typefaces of The Temporary State
 Family, Kilm Type Foundry

This book has been produced through the Office of the Dean,
Andrés Jaque, and the Office of Publications at Columbia University
GSAPP.

Director of Publications: Isabelle Kirkham-Lewitt
Assistant Director: Joanna Joseph
Assistant Editor: Meriam Soltan

Endpapers: OAAU, Inc. seal. Collection of the Smithsonian National Museum of African American History and Culture.

MAPPING

COLUMBIA BOOKS ON ARCHITECTURE AND THE CITY

MALCOLM

EDITED BY NAJHA ZIGBI-JOHNSON

WITH CONTRIBUTIONS FROM

ISBN 978-1-941332-83-2

COLUMBIA BOOKS ON
ARCHITECTURE AND
THE CITY